THE WATERCOLOUR EXPERT

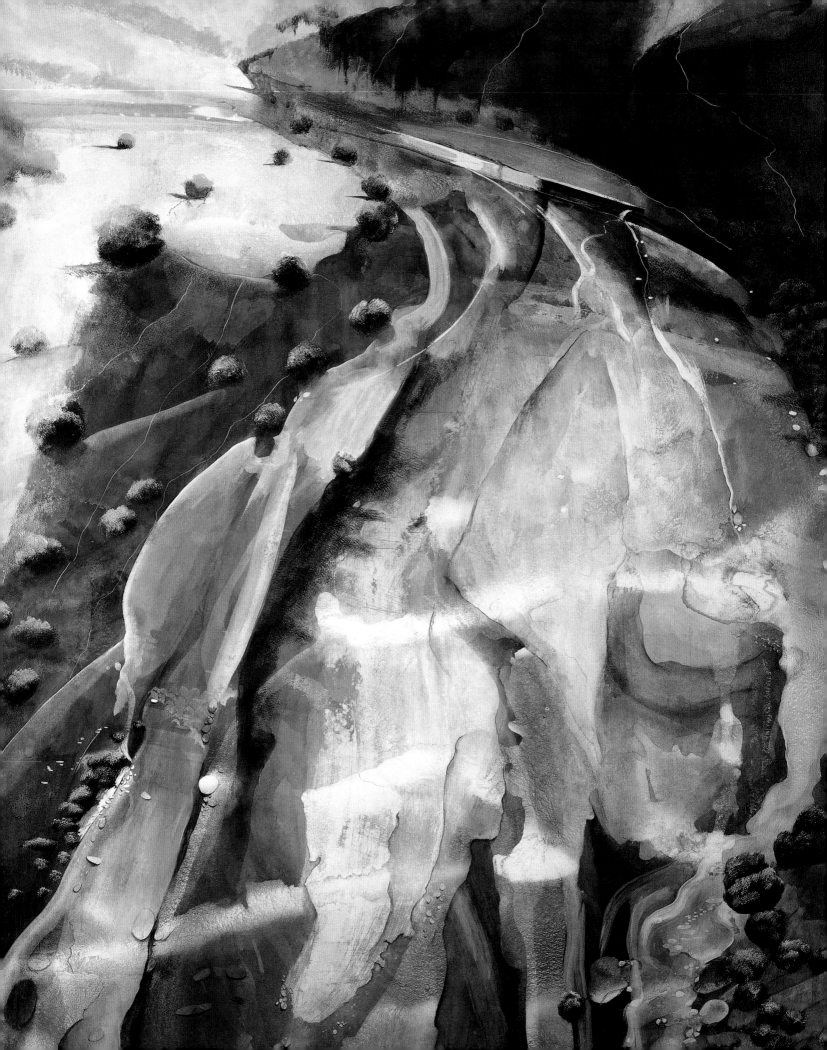

THE WATERCOLOUR EXPERT

CASSELL
ILLUSTRATED

CONTENTS

TITLE PAGE: David Firmstone, *The Riverbed* (2001),
watercolour, 170 x 137 cm (66 x 54 in).
LEFT: David Brayne, *Low Tide* (2001), watercolour,
pigment and acrylic gel, 64 x 86.5 cm (25 x 34 in).

FOREWORD

As the current President of the Society, I welcome a book that explains in some detail how contemporary Members resolve the practicalities of picture making.

Watercolour is a portable and flexible medium that has many advantages, not least its readiness for use. It can also be used in many ways, its versatility well illustrated in the works shown and discussed in this book.

Ever since the mid-18th century, various companies have provided materials and aids to assist the watercolour painter in his or her work. Portability was and still is the driving force behind many of the products. Watercolour is the only painting medium that can be slipped into a coat pocket and not be too bulky, messy or volatile in nature; it has the added advantage that it dries quickly with no pungent odour.

When Francis Bowyer, the previous President of the Society, was asked if he could envisage the RWS Members providing information for a book that would illustrate their work and describe each Member's working practices, he was adamant that it should not be another 'how-to-do-it' book. The aim should be to find a different approach, one that would be both informative to the interested general reader and to artists, and perhaps also be advantageous to the Society's Members.

His perseverance, and faith in the Members' enthusiasm for the project, is reflected in the variety of work illustrated in these pages and the variety of topics discussed. I believe this book will be an inspiration to many readers, and to anyone wishing to know more about the elected Members of the Society and what they do.

It seems appropriate that proceeds from this book should be used to further the charitable aims of the Society, particularly heritage and education.

Trevor Frankland
President, Royal Watercolour Society

OPPOSITE: Eileen Hogan, *Shadows* (2001), acrylic and watercolour on paper, 71 x 53.5 cm (28 x 21 in).

THE ROYAL WATERCOLOUR SOCIETY

Simon Fenwick, Archivist, RWS

By the end of the 18th century, the watercolour drawing had advanced considerably from the coloured sketch to being a finished work of art in its own right, and artists who chose watercolour as a medium sought both recognition for their art and an outlet for their work.

However, when watercolour drawings were shown at the Royal Academy – the only significant public gallery of the day – they were hung either in dark corners or in a room in which the light reflected on the glass in such a way that it was almost impossible to appreciate the works at all. Despite these handicaps, there was great interest in their pictures and there was obviously an opportunity for an exhibition devoted solely to watercolour. To that end, a group of ten watercolour artists met in a coffee house in Oxford Street on 30 November 1804 with the intention of setting up a society in order to organise such an exhibition. This meeting marked the foundation of what was in time to become the Royal Watercolour Society. In April 1805, in Tresham's Rooms in Upper Brook Street, the Society of Painters in Water Colours (the SPWC) opened its first ever exhibition. The show was a wild success, and much of fashionable London came, at a shilling a head, to look and buy.

Most of the pictures on exhibition at that first show were of landscapes, a fact which was part of the reason for the low esteem in which watercolour was held. The contemporary view promoted by the Royal Academy was that history painting stood at the top of the artistic hierarchy; after this came portraits, pictures of animals and gentlemen's houses, and only then landscape and – lowest of all – miniatures, which were also often painted in watercolour. This view was in itself beginning to appear old-fashioned, however. Among the Founder Members was John Varley, a 26-year-old drawing master and highly successful landscape painter. (His enthusiasm for painting was such that he was said to have once instructed a footman in a house where he was teaching the mistress to paint.)

In the early years of the Society, war with Napoleon was making access to Europe virtually impossible for everyone and travel was restricted to the British Isles. Artists like Varley were obliged to find their inspiration in the more picturesque parts of the kingdom – Wales, the Lake District, Derbyshire, North Yorkshire and Scotland. As watercolour and its typical subject matter, the British landscape, became closely identified with one another, so watercolour was seen as a very patriotic medium: people attended the Society's exhibitions and what they saw was, by and large, pictures of the British Isles. Furthermore, the fact that the artistic advances being made in the early years of the 19th century were taking place while the country was cut off from Europe brought weight to the conviction that watercolour was a particularly national art, an idea which has been sustained until the present day.

An example of just such a typically British work can be seen in Varley's *Cader Idris, North Wales* (1822). Although the picture still follows the classical, Claudean rules of composition, Varley is an artist true to the spirit of the age. *Cader Idris* is imbued with a romantic feeling that was, almost at the same time, being expressed by the Lake Poets. The Welsh landscape of lake and mountains depicted here, although largely empty of people,

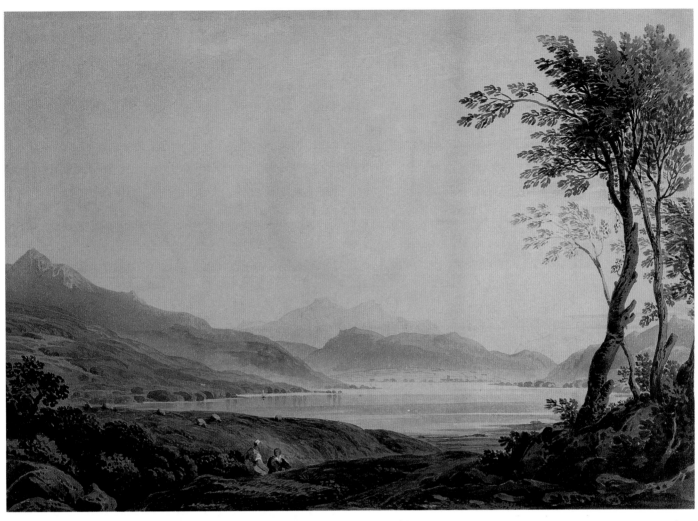

Simon John Varley (1778–1842), *Cader Idris, North Wales* (1822), watercolour, 24.2 x 35 cm (9.5 x 13.8 in).

is benign and protective: 'Nature never did betray the heart that loved her' (William Wordsworth). A tiny boat floats on the lake, sheep graze and a couple of figures nestle in the foreground of the image.

After its initial success, the Society failed. Its most successful year was 1809 when 22,967 visitors came to see the show and, after expenses, a surplus of £626 11s 0½d was left for distribution among its Membership. After this date visitor numbers and sales declined until, in 1812, a majority of Members decided that an exhibition solely dedicated to the sale of watercolours was no longer viable. (A rival Association of Painters in Water Colours collapsed altogether.) They refounded themselves therefore as the Society of Painters in Oils and Water Colours, but with war on two fronts – against Napoleon and the United States of America – and a subsequent post-war depression, this Society too lasted only a few years. In November 1820, the Society was refounded yet again as the Society of Painters in Water Colours, and in 1823 it moved to a newly built gallery at No 6 Pall Mall, where it stayed until 1938.

While the Society began to prosper once again, Varley's financial incompetence – brought about by his great generosity to others – led him to destitution. Desperate to make money, he repeated himself, turning out 'pot-boilers', often of little merit, and it was left to others to advance the art of watercolour. Samuel Palmer's *Shady Quiet* (1852) and William Henry Hunt's *Jug with Rose and Other Flowers and Chaffinch's Nest* (c 1845) show just how far watercolour drawing had progressed from the delicate washes of the earlier artists to the much more highly finished works of the middle of the 19th century. Palmer, who had strong religious instincts, is best known for his apparently visionary – and rather naïvely drawn – early work, but if his later *Shady Quiet* is less intense, it is no less beautiful. First exhibited at the Society's exhibition of 1852, where it sold for ten guineas, it was bequeathed to the Society in 1885 and is now one of the most important pictures in its collection. In comparison with *Cader Idris*, so much more is happening within Palmer's picture. The composition is less conventional, the trees, figures and sheep are more alive, and, although this is a pastoral setting, the receding views and the figures, walking and sitting, give a slight

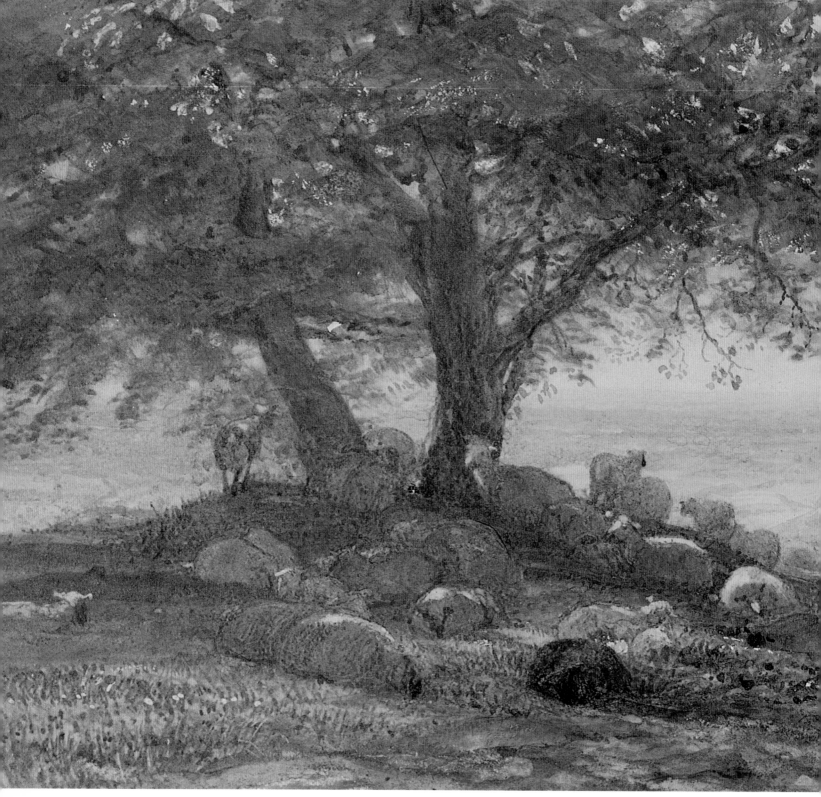

Samuel Palmer (1805–1881), *Shady Quiet* (1852), watercolour, bodycolour and gold leaf, 18.7 x 41.2 cm (7.4 x 16.2 in).

suggestion of a narrative. For Palmer, as for Turner, light itself was a subject for painting, and here the warm, autumnal light of *Shady Quiet* is brought out by touches of bodycolour and flecks of gold leaf.

William Henry Hunt's work changed considerably during the course of his career, and probably no other contemporary Member of the Society understood how necessary it was to progress in order to survive – those who did not, like John Varley, were likely to fail. In fact, as a young man Hunt was apprenticed to Varley, and his early works exhibited at the SPWC, topographical drawings in muted colours, were done under his influence. The character sketches and scenes of human interest of his second period (from around 1830) are very different. *Jug with Rose and Other Flowers and Chaffinch's Nest* is typical of his final period, which began in about 1845, and is much more detailed than his earlier work.

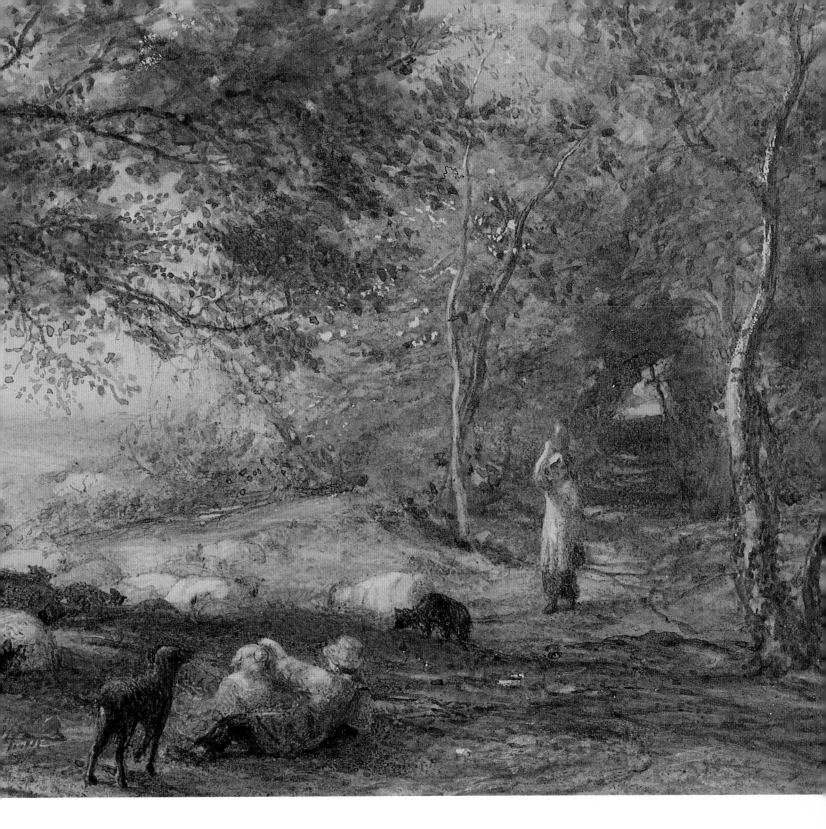

Hunt was renowned for the finish which he achieved on his pictures, particularly for the bloom on his fruit; he also concentrated on the arrangements of flowers, fruit, nests and birds' eggs which brought him the sobriquet 'Birds' Nest Hunt'. Ruskin kept a still life by Hunt in his bedroom at Brantwood, where he described it as hanging above the fireplace 'amongst the Turners like a brooch'. On his death in 1864, the obituaries were generous: 'the art of Titian in colour and of the Dutchmen in finish', and declared him one of the greatest artists of the century. Within a few years his pictures were selling for hundreds of pounds – up to 750 guineas at an auction in 1875. This, however, was the high watermark of his reputation. The technique Hunt employed during his last period was enormously influential and his work can be seen as a precursor of the Pre-Raphaelites as well as of artists such as John Frederick Lewis, Frederick Walker and Miles Birket Foster.

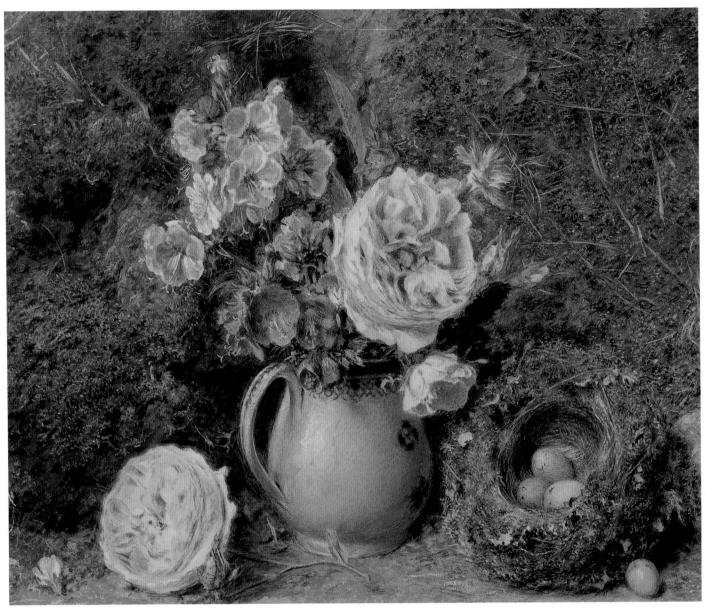

William Henry Hunt (1790–1864), *Jug with Rose and Other Flowers and Chaffinch's Nest* (c 1845), watercolour and bodycolour, 23.2 x 28.4 cm (9.1 x 11.2 in).

Helen Allingham was born in 1848, nearly fifty years after William Henry Hunt, but, by way of artists within the Society such as Walker and Birket Foster, she belonged to the same tradition which saw truth in nature. As can be seen from *Feeding the Fowls, Pinner* (1880–90s), her vision of nature is domesticated and subtly sentimental. Allingham was painting for the middle classes who were now living in developing suburbs such as Pinner, and who appreciated quaint old buildings full of character. But this is not the pastoral of *Shady Quiet*: the cottages in *Feeding the Fowls, Pinner* were now accessible to her on the bus from Hampstead where she lived.

There were also developments in the Society, a deeply conservative institution. Having been patronised by the Queen for many years, in 1881 the Society of Painters in Water Colours was at long last allowed to call itself the Royal Society of Painters in Water Colours, a much desired recognition. (Members and Associates were also now able to style themselves RWS and ARWS.) The Queen also agreed to sign the Society's Diploma. Then in 1890 Allingham became the first woman since the Society's earliest days to achieve full membership instead of just belonging to a category called 'Lady Members'. Many of the older Members were indignant at this development and the President himself, Sir John Gilbert, feared that the Society would become full of women shrieking at their meetings. It would, he said, cause the break-up of the Society. The world was changing.

While there were some artists like Helen Allingham who painted the world as they saw it, or felt that their public would like to see it, there were others such as Edward Robert Hughes who

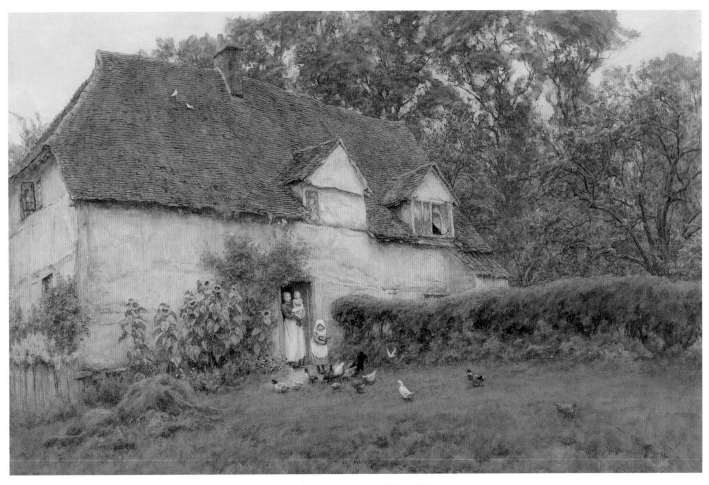

Helen Allingham (1848–1926), *Feeding the Fowls, Pinner* (1880/90s), watercolour, 32.8 x 50.7 cm (12.9 x 20 in).

turned to the world of the imagination for inspiration. Like much of Hughes's work, his Diploma picture, *Oh What's that in the Hollow* (c 1895), is an illustration to a literary theme. Paradoxically, although the end of the 19th century was a time of great progress in many fields, there was also a prevalent obsession with morbidity and the very processes of bodily decay which we see here. Hughes's inspiration is Christina Rossetti's poem 'Amor Mundi'. Two lovers, in their pursuit of worldly pleasures, encounter warning portents – including a corpse:

'Oh, what's that in the hollow, so pale I quake to follow?
Oh, that's a thin dead body which waits the eternal term.'

The picture is a masterpiece of the *fin-de-siècle* Symbolist decadence.

The Royal Watercolour Society's Diploma Collection began in 1860 when William Collingwood Smith suggested that each Member give a picture on his election to the Society, his 'Diploma work'. By the end of the century, the Collection contained some 200 works either given by the artists themselves or otherwise donated or bequeathed. When in 1897 the works were individually insured by Agnew's, Hughes's macabre

watercolour was considered the most valuable of all. But Symbolism as an artistic movement was short-lived and barely survived the turn of the century. After his death, a retrospective exhibition of Hughes's work was held by the RWS in 1915, but by then his work was considered tired and out of date, and 'deficient in pictorial quality'.

John Reinhard Weguelin was a near-contemporary of Hughes. The son of a Sussex clergyman, he spent some of his childhood in Italy before starting work as a Lloyd's underwriter. He became a professional artist after training at the Slade under Sir Edward Poynter and Alphonse Legros; his work is also very much influenced by the worldliness and sensuality of Sir Lawrence Alma Tadema. Weguelin painted many nymphs and nudes – the women he depicts here in *Venetian Gold* (1897) may well be courtesans, lost to the pleasures Christina Rossetti so abhorred. No city has been more dedicated to material pleasure than Venice, and within an atmosphere of heat and bleached light, Weguelin painted a world within a world: three women, their maid, and a monkey on a chain foraging in a bag. When *Venetian Gold* was exhibited in the Summer Exhibition of 1894, the catalogue included an explanatory note:

Edward Robert Hughes
(1851–1941), *Oh, What's
That in the Hollow...*
(c 1895), watercolour,
scraping and gum
arabic, 63.2 x 93.3 cm
(24.9 x 36.7 in).

15

John Reinhard Weguelin (1849–1927), *Venetian Gold* (1897), watercolour, bodycolour and gum, 53.8 x 72.5 cm (21.2 x 28.5 in).

ABOVE: John Singer Sargent RA (1856–1925), *Bed of a Glacier Torrent* (1904) watercolour and bodycolour, 35.5 x 50.7 cm (14 x 20 in).
OPPOSITE: Charles Ginner (1878–1952), *Pimlico* (c 1940), watercolour and Indian ink, 37 x 26.8 cm (14.6 x 10.6 in).

'The ladies of Venice, in the 16th century, suffered martyrdom to produce their celebrated red hair. They sat on the flat roofs of their houses for a certain time every day. Their tresses dyed and spread out in the sun over the broad brims of their crownless hats. They wore a particular loose gown for the purpose, called Schiavonetto.'

Unlike Hughes, Weguelin had no moral agenda or message, no story to tell. The picture is controlled, restrained, detached, and, for all that its subject matter is historical, unexpectedly modern for it is purely decorative – art for art's sake.

The sheer pleasure Weguelin so evidently derived from painting in watercolour can also be felt, albeit in a very different way, in John Singer Sargent's *Bed of a Glacier Torrent* (1904). Sargent's oil paintings of prosperous members of late 19th-century and Edwardian society, portraits full of glamour and confidence, were a mirror of their age. In his leisure time, however, Sargent preferred to paint in watercolour, and, since he travelled constantly, the implements of the watercolourist were particularly convenient. Eventually he more or less gave up portraiture for watercolour and in 1904 he was elected to the RWS. Already a Royal Academician and a member of the New English Art Club, he did not need another outlet for his work, but it was as if membership of the RWS gave him recognition for this new development in his art. Sargent is one of the greatest of all watercolour painters. In his Diploma work, Sargent appears uninhibited by any notions of formal picture-making. *Bed of a Glacier Torrent* is not so much a stream in the Val d'Aosta but a study – seemingly effortless and spontaneous – of the effects of light and water. What more suitable subject could there be for a watercolour painter than water itself?

Contemporary critics thought that Sargent's work so overwhelmed his fellow exhibitors at RWS exhibitions that his pictures should be hung separately; yet when he died in 1925 his pictures too seemed *passé*, not least because the social connotations of his portraits were too problematical in a post-war era. The developments of the previous decade within the art world could not be ignored and the loosely handled watercolour of Sargent and other artists was derided as 'blob' and 'swash'. Within the RWS itself, the division was not so much between progressives and conservatives as between painters and draughtsmen. Among the latter was Charles Ginner and, although only a very short period of time separates his work from that of Weguelin and Sargent, Ginner's aesthetic was a world away from either artist.

In 1911 Ginner was a Founder Member of the Camden Town Group. In its manifesto he affirmed his commitment to Modernism and the new century: 'Realism, loving life, loving its Age, interprets its Epoch by extracting from it the very essence of all it contains of great and weak, of beautiful and of sordid.' Just as Walter Sickert, the leading Camden Town Group artist, had found interest in music halls and lodging houses, so for Ginner there was beauty to be observed in run-down houses in London. In the neat, painstaking drawing of his picture *Pimlico* (c 1940), Ginner's early training in an architect's office is also evident, and the work intentionally recalls the coloured drawings of the early watercolourists who predate the foundation of the Society itself.

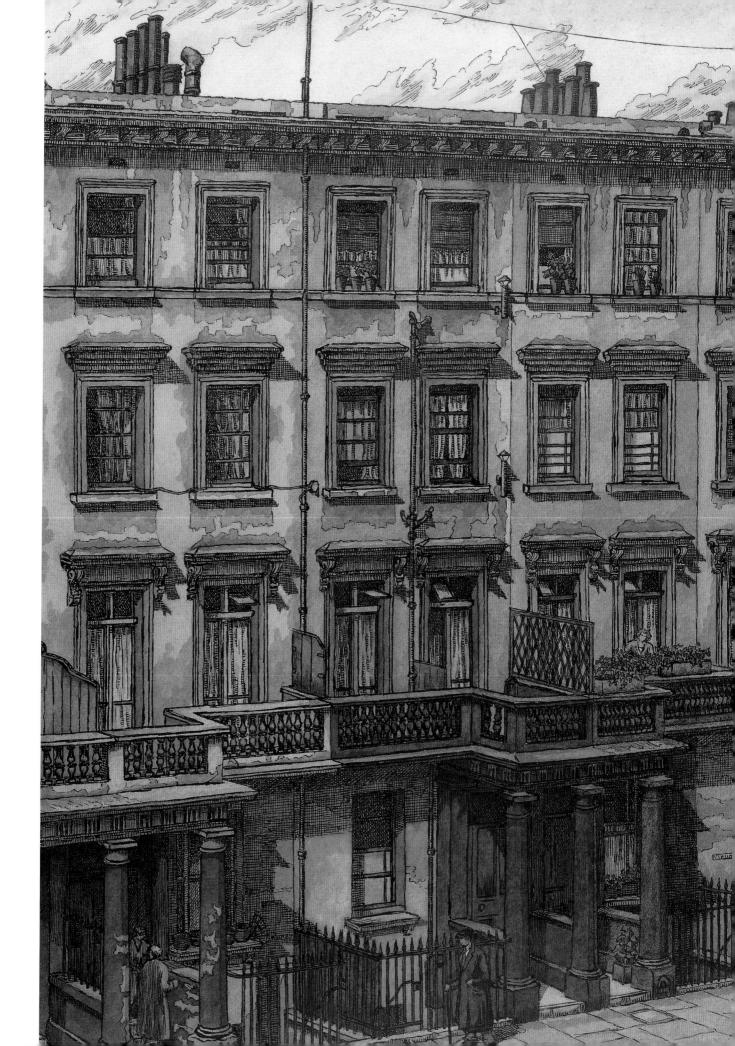

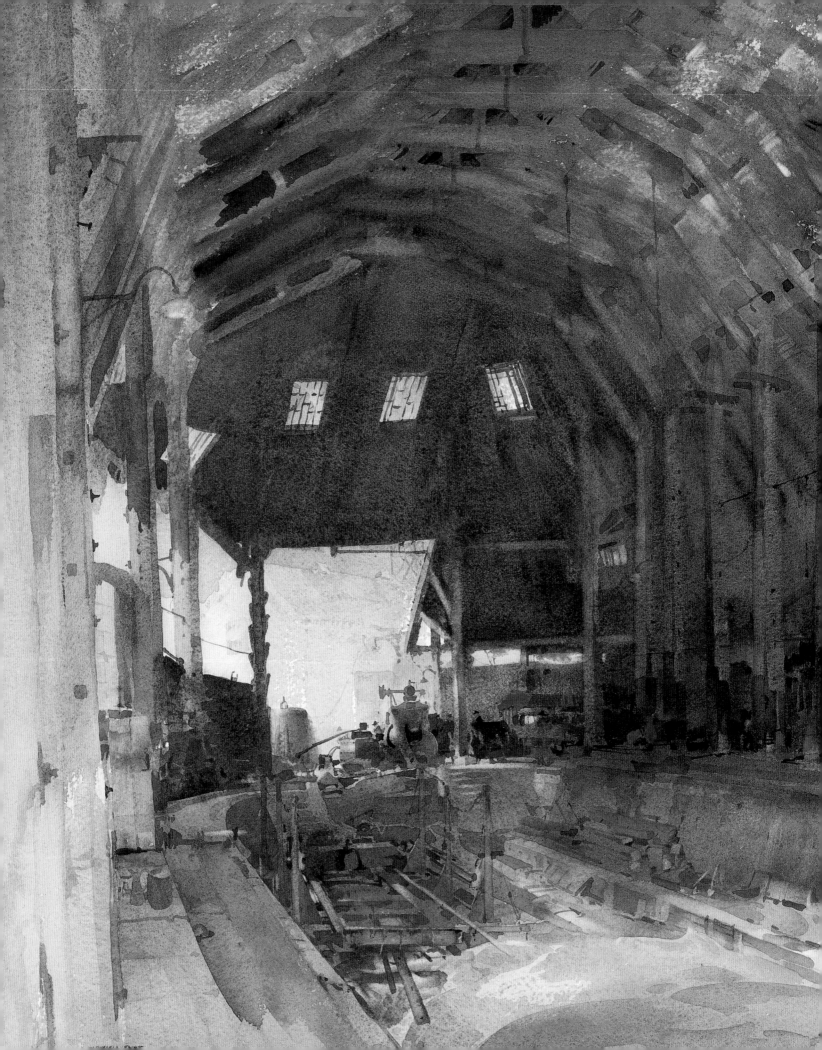

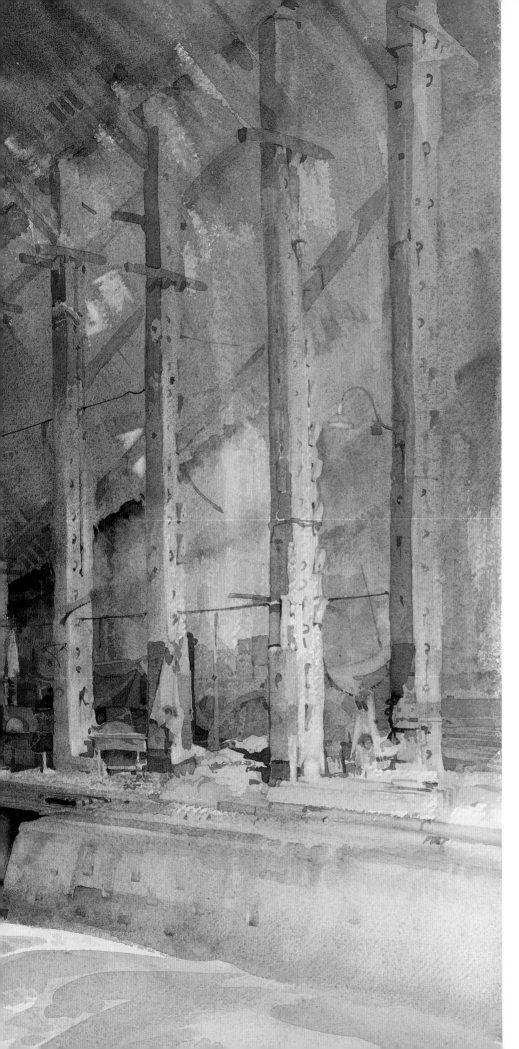

Sir William Russell Flint (1880–1969), *No 1 Slip, Devonport Dockyard* (1941), watercolour, 49 x 66.5 cm (19.3 x 26.2 in).

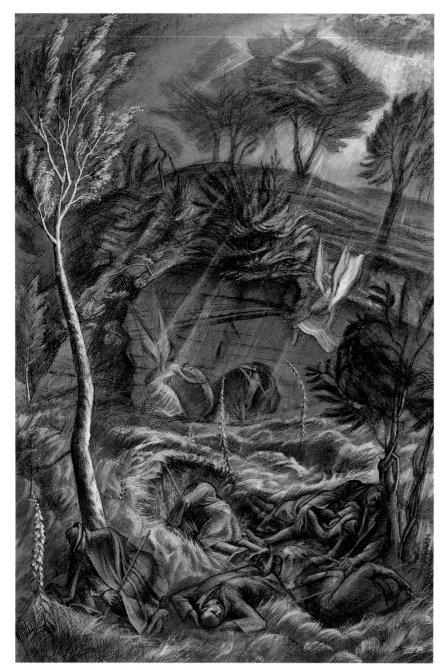

Alan Sorrell (1904–1974), *The Resurrection* (1943), pen and ink, pastel and bodycolour on brown paper, 50.6 x 34.4 cm (19.9 x 13.5 in).

In 1936, Sir William Russell Flint was elected the 20th President of the RWS. In 1938, the Society was obliged to surrender the lease of its Pall Mall premises and moved to 37 Conduit Street (a former night club) where it was to stay until 1980. The Depression had made the 1930s a bleak decade for all artists and Members struggled to find buyers for their work. Although the new President was one of the most successful artists of his time, Flint's repetitive and affected nudes, which brought him such financial rewards, have done lasting harm to his artistic reputation. As a draughtsman and landscape artist in watercolour, however, he can be seen at his best in his Diploma

work, *No 1 Slip, Devonport Dockyard* (1941) which is a *tour de force* of painting by any standard. For a period during the war Flint was living in Devon and a naval friend was able to gain access for him to the closely guarded dockyard at Devonport one Sunday when it was closed. In his picture Flint invests the austere industrial structure with the silence and solemnity of a medieval cathedral, but with so very different a purpose. A note on the back of the original frame read: 'Painted February 1941 just before the great three-night bombing attack.'

The low point in the Society's fortunes was the Spring Exhibition of 1941 when only 14 pictures sold. Then, unexpectedly, the Society in the depth of the war began to prosper. No doubt as a diversion from the grim world outside, the public flocked to the new galleries, and more sales took place than there had been for many years. As in the early years of the Society during the Napoleonic Wars, many of the pictures exhibited were landscapes – particularly British landscapes. Among the younger Members was Alan Sorrell, a painter whose work was influenced by the Neo-Romantics, a movement greatly influenced by a revelatory exhibition of works by Samuel Palmer at the Victoria and Albert Museum in 1926. Neo-Romantic art is imbued with nostalgia as well as with a patriotic feeling for a landscape endangered by war and an awareness of history's continuity. This consciousness of the past is particularly strong in the work of Sorrell whose drawings and

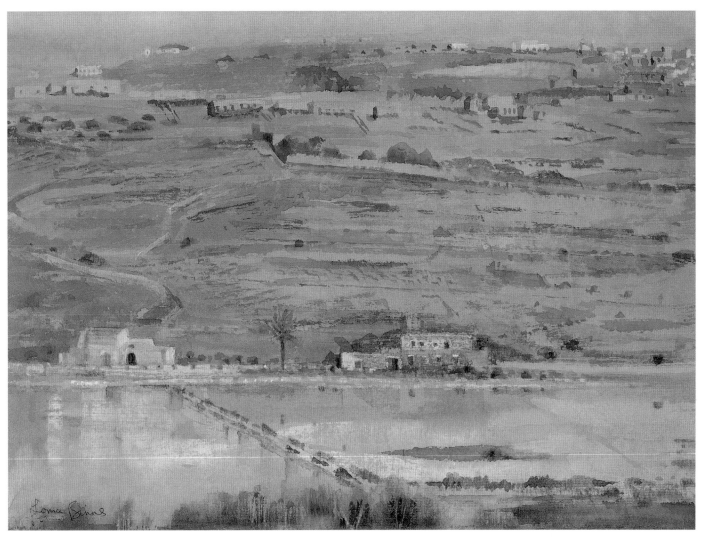

Lorna Emily Binns (1914–2003), *Salina Bay, Malta* (1992), watercolour, bodycolour and graphite on tinted paper, 25.5 x 37 cm (9.8 x 14.6 in).

reconstructions of archaeological sites appeared in the *Illustrated London News*; subsequently he became well known for the large-scale aerial views which he produced for Government Departments. His 1943 picture *Resurrection* is exceptional in that it is a religious piece (one of the few religious works in the Society's collection) but its emotional response to the land is typical of the Neo-Romantic movement, as are the low, subtle colours. This is an eerie, wartime resurrection, a message of hope during the Blackout in a land where street lighting was extinguished on 1 September 1939; the angels in Sorrell's picture seem to be lit by searchlights and flares – and the nuclear age on the horizon.

Neo-Romanticism was another relatively short-lived artistic movement, and was over by the mid-1950s. From America came Abstract Expressionism and, although some artists like Charles Bartlett were excited by it, the Royal Watercolour Society itself did not elect any purely abstract artists until Catherine Ducker in 1997 and David Whitaker in 2001, by which time the Society had moved from Conduit Street to Bankside Gallery on the South Bank. Many of the Society's Members bring a greater or lesser degree of abstraction into their work, however, while retaining a figurative element. Lorna Binns, who died in September 2003, always said that she required reality as a starting point to inspire the imagination; structure was necessary in her work to understand a subject, not to portray it, for her interest never lay in straightforward representation. After eliminating as much as she could from her pictures, only the essentials were left – always colour but also the effects of movement and light. Her Diploma work, *Salina Bay, Malta,* was painted *en plein air* during an RWS expedition to Malta in 1992. The muted colours inspired by the arid landscape are exceptional (Binns's colour was often very vivid) but this is an extraordinarily subtle and delicate piece of work. 'Intense watching when working on the spot gives me the core of life in my paintings,' she wrote at the time. It is a remark true for many of the Society's Membership during the course of its history, and one that could have been made by John Varley nearly two centuries earlier.

Watercolour Materials

WATERCOLOUR MATERIALS

Richard Sorrell

A long and heated debate has been continuing around the question: 'What is watercolour?' After much discussion, the RWS has settled on a definition: 'A painting in a water-based medium on a paper-based support'. The virtue of this definition is that it is inclusive of traditional 'pure watercolour' and of the many (and growing) combinations of this and other media, and new media altogether.

'Pure watercolour' is a method of painting using transparent watercolour on white paper, where the white of the paper itself is used as the highlights. A contemporary example of a pure watercolorist is Liz Butler (see page 33). This way of working demands great skill in drawing and a foreknowledge of where things are going to go. It is the reverse approach from oil painting, and it does not suit every artist's temperament. For example, since it is difficult to remove paint that has dried, it is not a very suitable medium for improvisation, and some artists would find this a great handicap in their work. A skilful painting in pure watercolour has the great advantage of almost limitless delicacy. In the hands of a master, it is a most beautiful medium.

Since the white of the paper is used for highlights and lighter passages, some artists use masking fluid, wax and other resist methods to preserve the paper from a watercolour wash. Masking fluid avoids the necessity of laboriously painting around the edges of an area of light, and in some cases a laboriously painted passage would destroy the rhythm of a picture. The disadvantage of masking fluid is that it produces rather hard edges. It is often a good idea to draw it on with a dip-pen, as it can ruin brushes.

The addition of white to the colours in a watercolour box greatly increases an artist's scope. Watercolour mixed with white is known as 'bodycolour' because it has 'body' or weight as opposed to the transparent colour. With bodycolour it is possible to 'cool down' or 'warm up' areas of a painting. A light translucent coat (mixed with white), painted over a darker base colour, will tend to give an effect both duller and cooler (ie verging towards blue);

this is called a scumble. A glaze is the opposite – a darker transparent colour painted over a light base – and this will give a warmer effect. Knowledge of these effects and their skilful use can help an artist to achieve harmonies with fewer colours: it is also useful in the rendering of such phenomena as misty distant landscape and certain qualities of living flesh.

Gouache is an opaque medium. All colours have been mixed with white (except for black) and the method of painting is, as in oil painting, a build-up towards light.

Gouache and watercolour are often used together. The pigment – the raw powdered colour – is mixed and ground with gum arabic to make the paint. Watercolour is normally painted with brushes – large sable or bristle brushes or sponges for broad washes, smaller brushes and tiny ones for detail, which is often painted with less diluted paint. Some artists use a nearly dry brush, which allows more control, and approaches a drawing medium. Ken Howard is an example of an artist who uses rather dry colour (see page 43). Watercolour can be used with pen and ink or with a dip-pen loaded with liquid watercolour, which will make coloured lines and sharp marks. It can also be used with pastels, and when pastel is washed over with water it can become nearly indistinguishable from watercolour. Raw pigment can be mixed up on the palette with gum arabic or with an impasto medium and used with watercolour.

With acrylic, the pigment is mixed and ground with poly-vinyl-acetate (almost always in the paint factory). Acrylic is a water-based paint that dries waterproof. This, with its quick-drying quality, makes it an excellent medium for glazing and scumbling, because the undercoat does not lift off. If acrylic is used very diluted with water, it behaves rather like pure watercolour or bodycolour. Its disadvantage is that it can make rather insensitive-looking hard edges, and since it dries water-proof, it is not possible to rub out areas with a sponge. However, its quick-drying properties make it a very good medium for improvisation; areas of a picture that need changing can be painted out and painted over.

OPPOSITE ABOVE: *Charles Bartlett's work as a printmaker has had a marked influence on his watercolour approach (see page 30). This painting (detail shown) has been well planned in advance: it was known ahead of time where everything was going to go. Areas of masking fluid have been applied with the full knowledge of the way they will appear in the finished work – the reed bed and the distant stretch of water. In contrast, the sky is painted in a soft, watery way.*

OPPOSITE BELOW: *Gregory Alexander (see pages 26–29) uses strong saturated colour, which gives his work (detail shown) great symbolic power. He uses dishes of liquid watercolour, and even paints with fabric dyes to achieve his rich colours, and contrasts these with bold patterns and shapes.*

ABOVE LEFT: *Sonia Lawson's grand and powerful painting (see page 46) uses strong but subtle colours and pattern-like repetition of motif. This picture (detail shown) is painted in a robust way with transparent watercolour and raw pigment mixed with an impasto medium, and laid on with a palette knife.*

ABOVE: *In this breathtakingly skilful work (detail shown), Leslie Worth (see page 42) has used washes of watercolour with bodycolour in an almost calligraphic way. The icy pond in the foreground appears to have been painted with one bold sweep of a brush. The misty distance has used a wet-in-wet technique and a certain amount of scumbling with bodycolour. There seems to have been some lifting out and scratching back to the white of the paper.*

STAINING AND DYES

Gregory Alexander

For me, the experience of painting brings me closer to the world. I sit and work in the place I am painting about, and my senses are stimulated: the feel of a place – hot or warm, windy or still; the smells and tastes – the salt in the air, lavender in France, goats in Cyprus, food in Vietnam; and the sounds – chanting in Japan, church bells in Italy. All these senses are as important to my sense of place as the visual experience of them.

I draw on these senses, consciously or unconsciously, as I work. When I work *en plein-air*, these experiences become embodied in the work as I paint – sometimes literally as when, working on the beach in a high wind, sand can stick and mix with the paint. Back in the studio, I support myself with recordings of sounds and artefacts I have collected, and draw on the power of sensory memory.

One of the ways I begin is by careful attention to colour. I believe that colour can convey mood and memory very directly – much as the madeleine in Proust's *A la recherche du temps perdu* was able to transport the character back to his childhood in an instant. My painting of the French village, *Callian* (see opposite above), is predominantly orange and reflects the fact that I was extremely hot as I painted it. Whereas the view of *The Cuillins, Isle of Skye* in Scotland (see opposite below) has a much cooler mood – it was indeed cool and I spent at least half the time in the car hiding from the rain. Both these paintings were produced *en plein-air* and convey a mood through colour.

For me it's important to observe colour keenly, but also to allow other influences to colour my interpretation. I recall the lesson which Paul Gauguin gave the post-Impressionist painter Paul Sérusier at Pont Aven in 1888. 'How do you see these trees?' Gauguin asked him. 'They are yellow. Well then, put down yellow. And that shadow is rather blue. So render it with pure ultramarine. Those red leaves? Use vermilion.' In this way, the colour is heightened and made specific to place.

One of the beauties of watercolour is the fact that the paint literally stains the fibres of the paper. It inhabits and transforms the paper, sinking in like a dye. I like this quality and often mix my paints with water in separate containers so that I have lots of pigment to apply to the paper. Occasionally I have actually used fabric dyes to paint with, often pouring or pooling the colour on to the paper. In particular I use this method for my paintings of subjects from Africa and Asia, as in my painting *Mowgli Learns the Ways of the Villagers*, based on a scene from Kipling's *Jungle Book* (see following pages). The staining echoes the strong colours and quality of fabrics found on these continents, whilst the colour creates a hot and exotic mood. I am a great believer in using methods and materials to suit my purpose.

I believe that the fundamental role of colour is its expressive force – it creates mood in a painting. As the viewer approaches a painting, even before they can identify its subject, a mood or feeling is conveyed. It is this deceptively simple fact that continues to fascinate me in my watercolour painting.

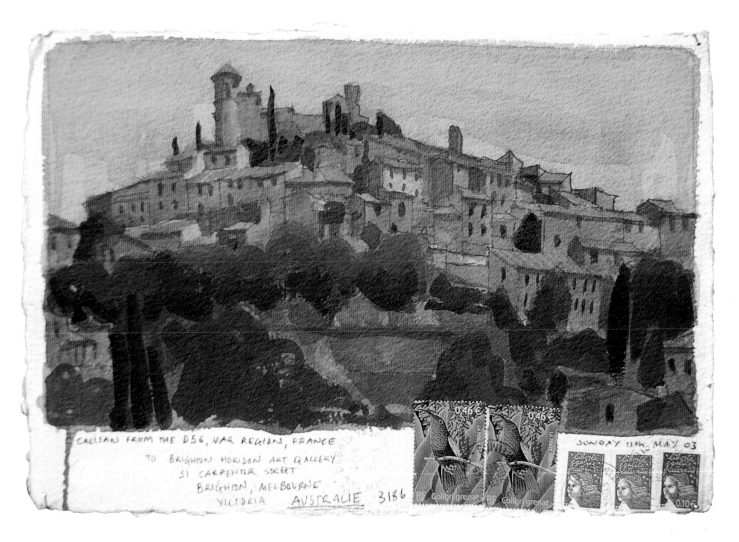

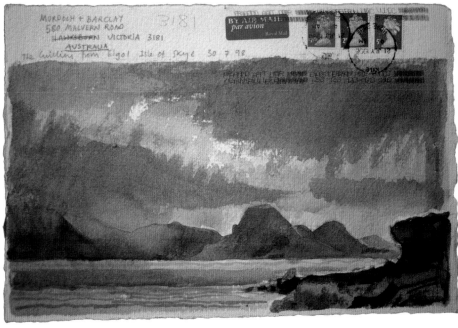

ABOVE: *Callian, Var Region, France* (2003), watercolour on Arches paper, 19 x 29 cm (7.5 x 11.4 in).

LEFT: *The Cuillins, Isle of Skye, Scotland* (1998), watercolour on Arches paper, 19 x 29 cm (7.5 x 11.4 in).

FOLLOWING PAGES: *Mowgli Learns the Ways of the Villagers* (1990), watercolour and Procion dyes on Arches paper, 49 x 75 cm (19.3 x 30 in).

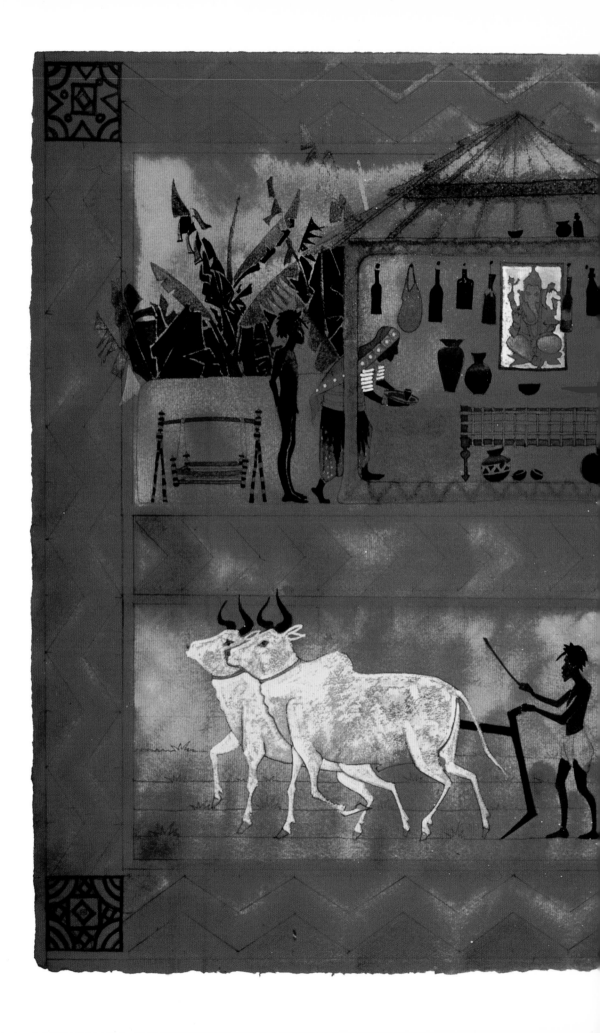

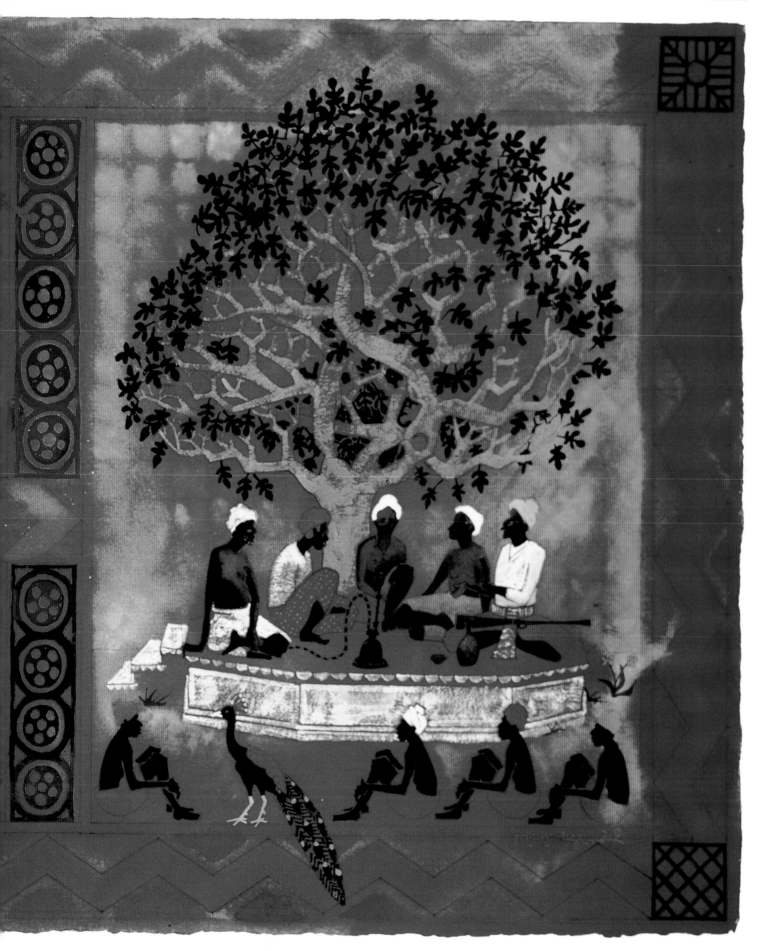

USING RESIST

Charles Bartlett

I expect it is true of most artists that they paint what they feel and how they react to an idea or subject. I have a special love of the sea and the coastline of East Anglia, and these form the basis of a lot of my work as a painter and a printmaker.

I have sailed various boats since I was a boy and know the landscape and coast both from the sea and from endlessly walking the seawalls and marshes. However, I do not paint on the spot or simply from a topographic viewpoint.

I suppose I try to understand the poetry behind the elements and my reaction to the landscape. I make notes and studies in my sketchbook and then return to the studio. There I decide whether the subject should be large or small, horizontal or vertical, predominantly dark or light, warm or cool. Usually I sort out and lay in my composition lightly in charcoal.

In this small watercolour, *Lower Lockgate* (see below), I was fascinated by the light water leading (escaping) to the sea via the old lock, and the light and movement on the reeds. This was countered by the stark geometry of the dark sea wall and the sea beyond. The colours I selected to express the feeling were fairly low tone. I used masking fluid to retain the white paper for the water and to create a texture on the reeds. You can always layer colours by rubbing off the masking fluid and painting over the exposed surface. The use of masking fluid (resist) is not a trick, it is part of the watercolour artist's equipment, part of composition. It avoids having to paint a dark colour meticulously around a lighter area or it can be used to create a designed texture. It can be used very broadly or in a detailed way.

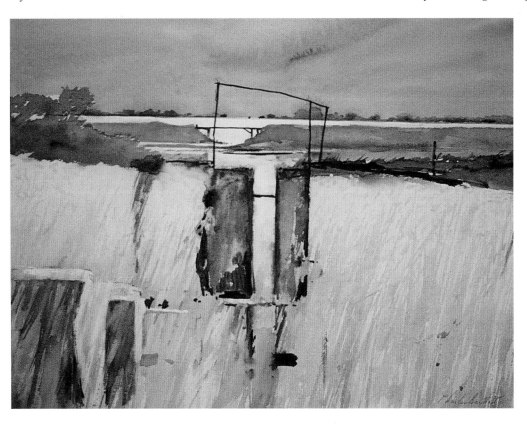

Lower Lockgate (2000), watercolour, 33 x 44 cm (13 x 17.3 in).

USING OPAQUE WHITE

William Bowyer

When I was elected to the RWS, Robert Austin, the President, was very influential in the Society. It was generally frowned upon to use opaque white (bodycolour) in watercolours, as I did, but I was elected by the President's casting vote.

I look upon drawing as tremendously important to my work in describing the forms, and the use of white helps me in emphasising the subtle shapes, reworking and sorting out the inter-relationship of the planes to one another: the distance, middle distance and foreground.

The painting *High Tide, Chiswick Mall, Under Snow* (see below) evokes snow and the relationship of the water to the road and the trees, and back again to the ground plane. It was the first painting I had done in my retirement and I look forward to doing many more such paintings. It stimulated in me a sense of excitement. I would never sell it.

I have always stretched watercolour paper with gum strip because it gives a very taut surface. I draw the whole thing in with cerulean blue – I have always done it this way with all my watercolours – because it disappears once I apply the tone and colour.

I painted this picture from the back of the car, sitting on the tailgate in the snow. It was bitterly cold and I had to work very fast. It was a very intuitive painting. I was excited by the shapes and forms that had been altered by the elements, creating a sense of abstraction across the landscape. I used the white bodycolour to emphasise the shapes, creating a counterbalance between the snow, the water and the sky. This was a familiar view under unfamiliar conditions. In a painting which is intuitive there is always an element of risk; it is that risk and excitement that give me the 'buzz' to paint.

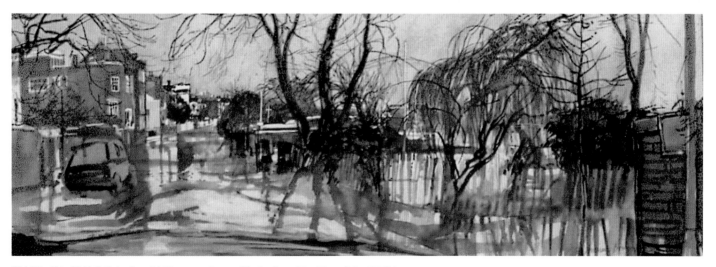

High Tide, Chiswick Mall, Under Snow (1982), watercolour and bodycolour, 25 x 72 cm (9.5 x 28.5 in).

PAPER AND WASH

Michael Chaplin

Like many RWS members I enjoy teaching, and this watercolour was painted during a trip to Ortygia – the old part of Syracuse in Sicily. Our first day brought all the excitement of new places; an early-evening storm scudded in from the west, bringing dark skies which threw the light on the Duomo into sharp tonal contrast with all the drama which tone brings to colour.

I enjoy working from classical architectural subjects. I try not to be solely topographical and hope to show some of the sense of the place.

The lack of far distance in *Piazza Duomo – Syracuse* (see below) brings its own challenge in subtly showing recessive space. I am always very aware of the relationship between warm and cool colours in showing this space, and I often use warm tinted papers with cool transparent washes laid very quickly and very wet. Speed allows the pigment to settle in its own time to give textured washes which don't go 'muddy'.

The paper for this painting was specially made for me by Two Rivers Paper Company for watercolour handling sheets for the Thomas Girtin Exhibition at Tate Britain in 2002. It is a beautiful gelatine sized paper with a gentle textured surface containing minute coloured fragments. The paper already seems to have a depth to it, and wet paint sits on the surface long enough for me gently to manipulate, lift and add pigment to the washes.

The painting is constructed with a variety of pace. To the left, the buildings are very understated with light gestural marks to sum up their main features. The Duomo to the right is more architecturally explained with much denser texture, stronger tones and more vibrant colour. Figures move within the composition to give a sense of scale and gentle narrative.

The painting occupies the whole area of an imperial sheet of paper (51 x 76 cm/20 x 30 in; unstretched) and was painted in the studio from several studies – linear, tonal and colour.

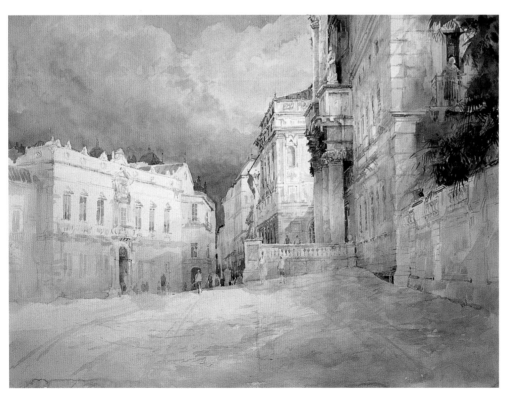

Piazza Duomo – Syracuse (1953), watercolour, 51 x 76 cm (20 x 30 in).

BRUSHES

Liz Butler

I use fine detail to draw the viewer into my small landscape paintings, so that they can step inside them and inhabit the space I have created.

In order to be able to work in this way, I have found the practice of careful studies made from nature, and in particular plants, very helpful. They require the same way of seeing, an analytical process of observation, very controlled hand/eye co-ordination and observation of colour, light, transparency, translucency and opacity in nature.

Observing the natural phenomena that occur in nature is very helpful; it can become the subject of a painting in its own right. I am often so excited about the alteration of mood brought about by the changing light, that several studies of the same scene can produce radically different paintings.

I particularly enjoy working in gardens. There is something strange about the taming of nature which creates an almost theatrical mood. Especially interesting is a garden uninhabited

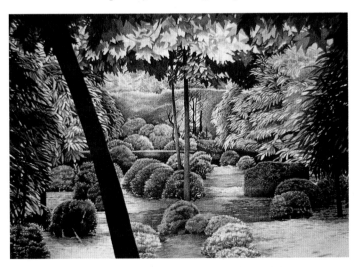

Citrus Garden, Landriana (2004), watercolour, 14 x 21.5 cm (5 x 8.5 in).

by people: the absence of activity in a scene can create an eerie calm that suggests an incident just missed or about to happen.

Many people are surprised when they learn that I use rather large brushes for my work. Generally I use a No 8 or 10 da Vinci Maestro made from the tail tips of Kolinsky sable. These have an excellent and hard-wearing point for use in fine detail, yet still hold a considerable reservoir of paint, so one does not waste time going back and forth from the palette when putting washes down. They are also very flexible, allowing one to draw with the brush.

I am very enthusiastic about the transparent colours in the watercolour range, although opaque and translucent colours are important too. When using the transparent colours, one can layer them to develop incredibly rich dark tones which have an extraordinary velvety quality. This can be achieved by initially laying down washes and then stippling over the surface of them. Working in this way you can exaggerate the textures and tones and move beyond pure observation into the surreal.

The Louha Valley on the island of Zakynthos was an amazing discovery, on a tour I had been making of the island. Although it is one of the greener Greek islands, it was extremely arid in late September with golden, sun-scorched, honey-coloured grass and stark limestone scenery, with dry river valleys here and there. As I came over the brow of a hill, I found myself in the Garden of Eden. The Louha Valley was like an oasis, with incredible rich greens in the woodlands along the valley walls. The floor was planted with verdant vines, grown for wine. Although vibrant

and green, somehow it still had the warm, characteristic light of Greece. So when I decided to paint what I had seen, I was trying to keep the element of magical surprise that I had experienced when I discovered the valley.

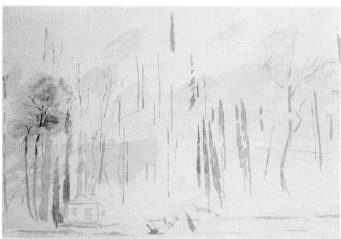

1 *I covered my paper with a pale golden wash (cadmium lemon with a touch of transparent red oxide), which I would try to maintain as the glowing light behind objects in my landscape. I wanted to keep warmth in much of the shadow areas, so I chose a pale purplish wash (winsor violet, permanent rose and cobalt blue) to start drawing, then used brush and wash to draw in the trees and position the grape pickers' stone shelter. I used a da Vinci Kolinsky sable No 10 brush.*

2 *I further established the positioning of the trees, mapping out the composition. I added more yellows (yellow ochre and cadmium yellow deep) to foliage areas. I used a da Vinci Kolinsky sable No 8 for some of the finer line work.*

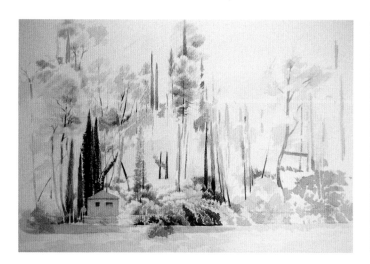

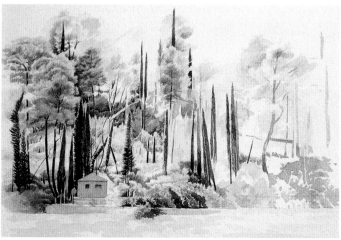

3 *Using pale flat washes, I introduced cooler colours (cobalt turquoise, cobalt and prussian blue), strengthened the shadows, still trying to maintain some warmth in them within the woodland and on and in front of the shelter (red oxide, permanent rose and cadmium yellow deep). I began to establish strength and depth of tone for the cypresses, using the tip of the brush (hooker's green deep, prussian blue and burnt sienna), and aiming to interpret their velvety texture. I firmed up the composition, using pale wet washes in the foreground area.*

4 *Using flat soft yellowish washes (yellow ochre and a touch of cadmium red), I established the remaining trees. After they had dried, I worked over the top with the tip of the brush to accentuate shadows behind the trees (winsor violet, cobalt blue and burnt sienna), and on the trunks and branches.*

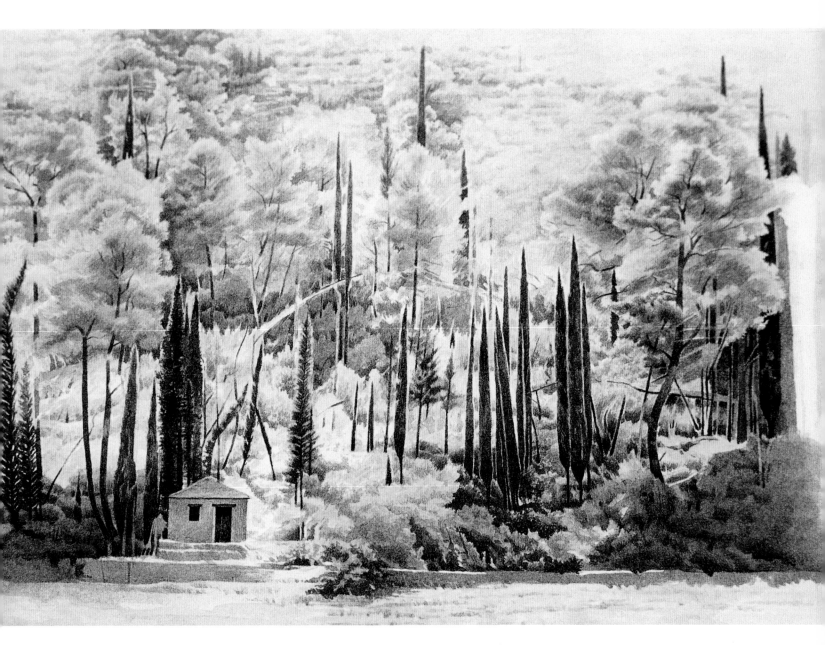

5 *I could now establish the whole woodland, stippling warmer colour into the shelter area and the left side of the woodland. I strengthened the cypresses and trunks of all trees and the window and door of the shelter. Finally, I developed the foreground texture further, and stippled more warm colours into both shadows and light areas. By now I felt I should stop and put the piece away for a few days. After reviewing it, I decided not to work on it further. I had managed to capture the rich verdant quality of the valley, yet retaining the warmth of the Greek light and was in danger of overworking the painting.*

USING ACRYLIC

Alfred Daniels

Ever since I was a student at the RCA, my work has always been centred around such diverse subjects as markets, sport and architecture, and more recently around industries such as fishing, transport, steel and whisky production.

The paintings are mainly concerned with people at work and play, locations in London, Oxford and Cambridge, and particular events. Originally, I worked mainly in oils, and these works also formed the basis of the murals and easel pictures I was commissioned to do.

Narrative painting, for me, is about communication as well as decoration. I try to involve people with how I see and feel about the world. This allows me to take an imaginative and whimsical, personal approach. The only aspect I take seriously is how I put the painting together, ie composition, form and colour. Here watercolour can play an important part in composing a painting: a means to an end, not an end in itself. Water-colour is a speedy way of making studies for a painting, and for visual research using wash and Conté crayon; I keep these studies in a sketchbook.

Three unexpected events made me revise and develop my interest in watercolour. Firstly, in 1967, there was a shortage of oil paintings for an exhibition called 'Vanishing London', showing landmarks and

locations which were being wantonly destroyed. It was suggested I show my watercolour studies, suitably framed, to complement the oils. It made a better show.

Secondly, I was elected to the RWS, where I had to show my studies on their own and so compete with experienced practitioners of the genre. I needed to develop my limited approach to something

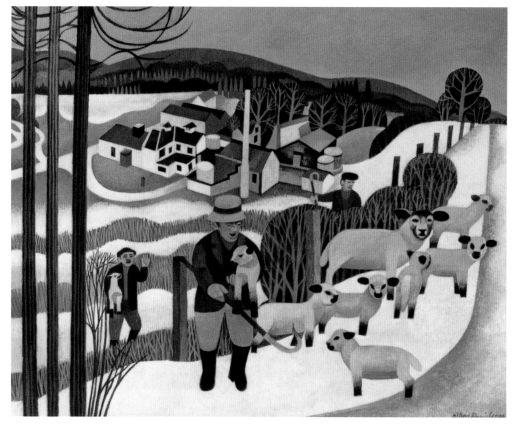

Craggan Moor Distillery, Ballindelloch, Speyside (1999), acrylic, 40.6 x 50.8 cm (16 x 20 in).

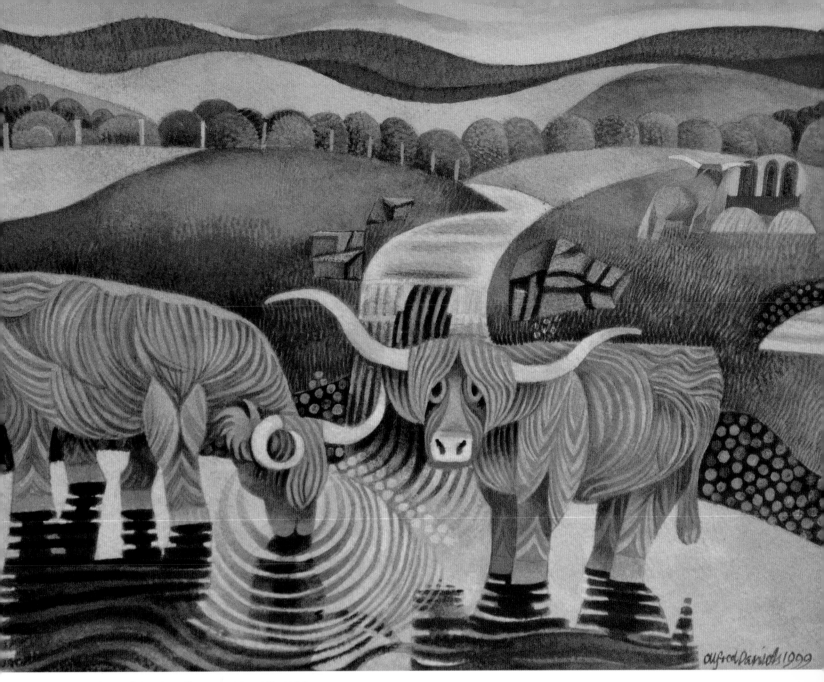

Highland Cattle, Speyside (1999), acrylic, 40.6 x 50.8 cm (16 x 20 in).

more substantial. This meant more study and more practice. Something which never ceases if you want to grow.

Finally came the discovery that acrylic, a water-based paint I had used for murals, was also capable of being used exactly like pure watercolour, but with numerous advantages. On a good watercolour paper (I use a 300 lb Bockingford or Waterford, so do not need to stretch it), acrylic made just the same washes as watercolour, with the advantage that if the washes went awry, and they often do, I could white out the errors with a wash of transparent white acrylic and start again. Acrylic dries quickly and does not pick up like watercolour white. It means that I can prolong the work without losing the freshness that is so characteristic of watercolour.

WATERCOLOUR AND WHITE GOUACHE

John Doyle

All painting and drawing are governed by disciplines, rules and conventions. Once these have been digested, they are only there to be broken. Without them there would be nothing to break. Because we do this in our own way, none of us are the same. What is right for John Doyle may be wrong for Francis Bowyer; what is right for Francis may be wrong for Jacqui. In this brief entry I can only say how I proceed.

I have developed two differing techniques: a free atmospheric approach generally done with watercolour and white gouache on tinted paper, and a tighter method where line plays a more significant role. Both are based on drawing upon a framework of careful design and an awareness of reality that only drawing can bring. Sometimes, in a happy moment, I can marry these two styles, combining the carefully detailed drawing and the free brushwork that gives atmosphere and sparkle. When this happens, it produces in me at least an exhilaration beyond description.

Technically, either gouache or Chinese white are opaque while watercolour depends for its beauty upon transparency: the reflection of light passing through pigment and being reflected back from the paper. Watercolour can be applied wash upon wash, each adding a little more richness to the tone. But if the opacity of white paint is combined with the transparency of watercolour, very exciting contrasts arise. Highlights in white gouache will sometimes jump and seem crude, and can become heavy and quite literally chalky – for that is what white paint is, basically, chalk. But if one considers these heavily applied areas of white as reflecting surfaces, then by putting watercolour over them, the brilliance is restored. But beware! The white must be bone dry, the wash instantaneous, one swish with a soft loaded brush. Anything more than that will lift the white and a mess will follow.

Watercolour, however, is far more versatile than most people realise. If a mess does arise, or a wet wash runs into its neighbour and causes havoc, then turn to the toilet roll! A disaster can be lifted off the paper in seconds by a roll of toilet paper pressed onto the surface, and it can also serve as a mild sponge to soak paint off an overloaded brush.

I have never been able to tell the difference between all the tubes of white gouache on offer, but I think I generally use permanent white. When I use this and watercolour together, I find it best to use a toned paper. There are many toned papers on the market, or one can tone white paper with washes of tea or simply wash the paper black or brown before starting. Tea gives a beautiful warm tone and has the great advantage in that it is possible, using a razor blade, to scratch out areas and get back to the white paper. This technique is also very useful if one needs to correct a painted surface where the rubber is useless.

Once again, though, everything depends on drawing. One can do this with a brush (as Liz Butler has ably pointed out when discussing brushes), a pencil, charcoal, chalk, or a pen; here I advise using watercolour in the pen as it is more sensitive than ink, and it is easier to modify the tone.

A final word on composition. I am no innovator, I find my compositions by exploring – literally by moving about until the right picture appears. One can alter a few things – move a tree, add figures, rearrange a vase, but I have always let nature be my guide. If you look, the answer is always in front of you – but oh, how often we don't look!

OPPOSITE ABOVE: *Windsor from Eton* (1987–88), watercolour and gouache, 20.3 x 32.5 cm (8 x 12.8 in).
OPPOSITE BELOW: *School Yard, Eton College* (1987–88), watercolour, 40.6 x 61 cm (16 x 24 in).

USING BOARD

Ernest Greenwood

My own technical method of painting has taken many years to evolve. This is because I was searching for a way of achieving a luminosity and richness to the painted surface which the more traditional methods could not give.

I found that two things were needed: firstly, a rigid surface that I could manipulate the paint on, and, secondly, a surface which did not cockle. These requirements I found in high-quality acid-free board. Why did I need something different from the established ways of working? Because my pictures were produced in the studio, I seldom completed a design on location but worked from drawings, usually quite a number in one work. This method often required me to select studies from more than one sketchbook, with the help of tracing paper. The board on which I now work takes acrylic white very well; this I use as a basis (ground) for some areas of a picture, producing a non-absorbent result. When several applications of watercolour or waterproof inks are floated over the acrylic, a highly reflective base, a richness and luminous density result, especially if the process is repeated. In some cases as many as twelve or more layers are sandwiched between the acrylic white. This method is admittedly a slow one, but serves my purpose, particularly when working on a large picture. For me, topographical considerations are a relatively unimportant element now. I prefer to let the visionary, sometimes magical side come to the fore and enrich the content.

In this context, drawing has always been an essential part of my life. My many sketchbooks, spanning some seventy years, contain jottings as well as complete statements, and provide the material from which my paintings are constructed. Now that I am less able to work

outside, these drawings have become more important, forming a bank of almost inexhaustible material for me to use and re-use.

Time, in the creation of a work of art, is of no consequence. It is the quality and variety of what we achieve that matters and by which we are eventually judged.

In *A Kentish Idyll* (see opposite), I have attempted to summarise my experiences during the time I have lived in the village of Broad Street – nearly 45 years. My daily walk with a sketchbook on the North Downs has provided material for some of my most satis-actory pictures. The countryside here has remained unchanged for many years, and this gives it a distinctive character. When I

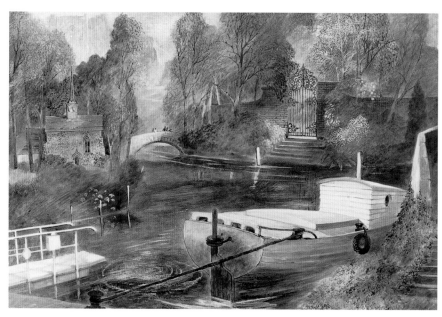

Mooring by the Château Gate (1996), watercolour and acrylic, 58 x 76 cm (23 x 30 in).

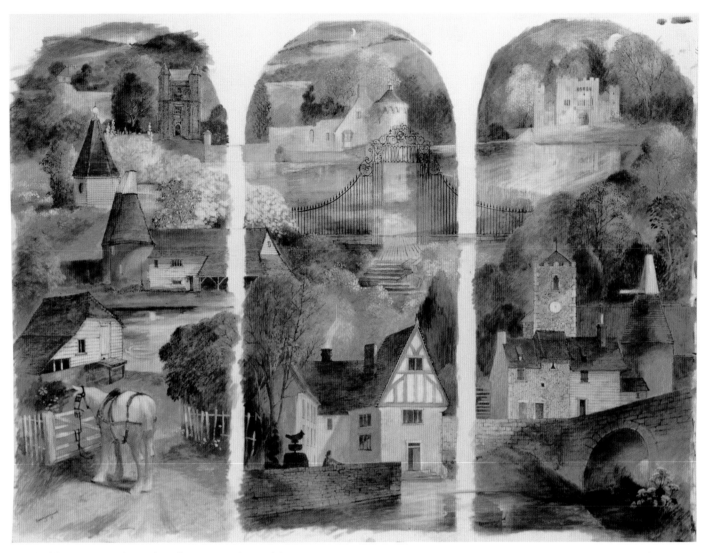

A Kentish Idyll (1996), watercolour and acrylic, 76 x 99 cm (30 x 39 in).

began to visualise and plan the *Kentish Idyll*, I knew it would have to be a lyrical interpretation and not a dramatic one. The first step was to choose a limited colour scheme and adopt an even tone throughout. The importance of some repetition was also necessary in a divided format. For example, the related architectural elements seen in the castles at the top of each panel, and the water associated with them, help to unify the three sections.

The water that flows from top to bottom also serves to link the various components. The finished work was preceded by a full-scale cartoon. The tryptych has very little depth; the interest is carried up and down, and across from side to side, rather in the manner of a mural decoration. If the picture is looked at in this way, as a whole, the unrealistic relationship of things disappears.

A FREE MEDIUM

Leslie Worth

Watercolour, that most beautiful and expressive of all painting media and, to some, the most maddening. Ranging, as it does, from the small and lyrical to the dramatic and powerful.

Watercolour has its own inherent language, its structure and dynamics. A celebration of not only what is said, but also how it is said: active versus passive, density versus translucency, and so on. It is also the one medium *par excellence* for suggesting movement, or arrested movement, and conveying the passing of time. I think it is essentially a small-scale medium, addressing itself to an intimate audience, and is often at a disadvantage in our more clamorous exhibitions. I confess that my own methods are unorthodox, although rooted in the time-honoured Romantic tradition of the English landscape, but not exclusively so.

I am often contradictory in the use of tools and materials, and use any paper which I think can work. My brushes would shock the purist and I will use any device which seems appropriate – at the same time keeping an attentive eye on what the medium is suggesting. It has its own *raison d'être*.

I have done a lot of work out of doors, but nowadays most of the work is done in the studio, from notes, drawings and photographs – the latter being treated very freely. It is a very private activity and I don't like talking about it; the work should be its own advocate.

Ideas have come from a variety of sources, sometimes not from a visual experience at all. I have drawn inspiration from literary sources, music, and on occasions painted from listening to storms or seas breaking on the shore.

Winter Afternoon on the Downs (1988), watercolour, 40.9 x 62.9 cm (16.1 x 24.8 in).

MIXING MEDIA

Ken Howard

I liken working in watercolour to playing a single musical instrument, whereas working in oil is like trying to conduct an orchestra, pulling the parts together into one whole.

The connection between the painter and his subject is much more immediate in watercolour. Whereas in oil I am concerned with values, in watercolour my only concern is to arrive at a visual equivalent for the sensation that I have experienced.

Having said that, it has always been my wish to break down the difference between oil and watercolour. In oil I want to enjoy the transparency, the glaze, which is the equivalent of the transparent wash in watercolour. In watercolour, when working with Chinese white, I want to get the effect of the opacity of oil paint and the opportunity to rework areas as in oil. One of the greatest water-colourists after Turner, Girtin and Cotman was Hercules Brabazon Brabazon, and he used Chinese white to wonderful effect.

A great friend of mine used to say 'watercolour is like pushing a puddle around'. But to me it is much more like drawing, thus the term 'a watercolour drawing'. For this reason I want my painting to be reasonably dry when I am working on it. In order to achieve this I work on two watercolours at the same time, one on each side of the board. Thus, while I am working on one the other is drying. For this reason I like to sit to work, and grip the board (usually no bigger than 30 x 36 cm/12 x 14 in) between my knees, rather than having an easel. When I then turn the board over, the wet side doesn't touch anything. Another advantage of this process is that, when you turn the board over, you don't see the watercolour for some minutes and on returning to it you see it freshly and in relation to the other one you have been working on.

My watercolour technique has developed over time from being concerned with keeping the colour transparent and pure (see *San Marco, Morning*, below), to using a limited amount of Chinese white, and finally I have developed a technique where I have added both gouache and pastel (see *Grand Canal, Sparkling Light*, following pages).

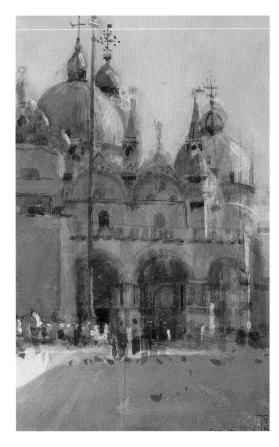

San Marco, Morning (1986), watercolour, 27.9 x 22.9 cm (11 x 9 in).
FOLLOWING PAGES: *Grand Canal, Sparkling Light* (1996), mixed media, 22.9 x 30.5 cm (9 x 12 in).

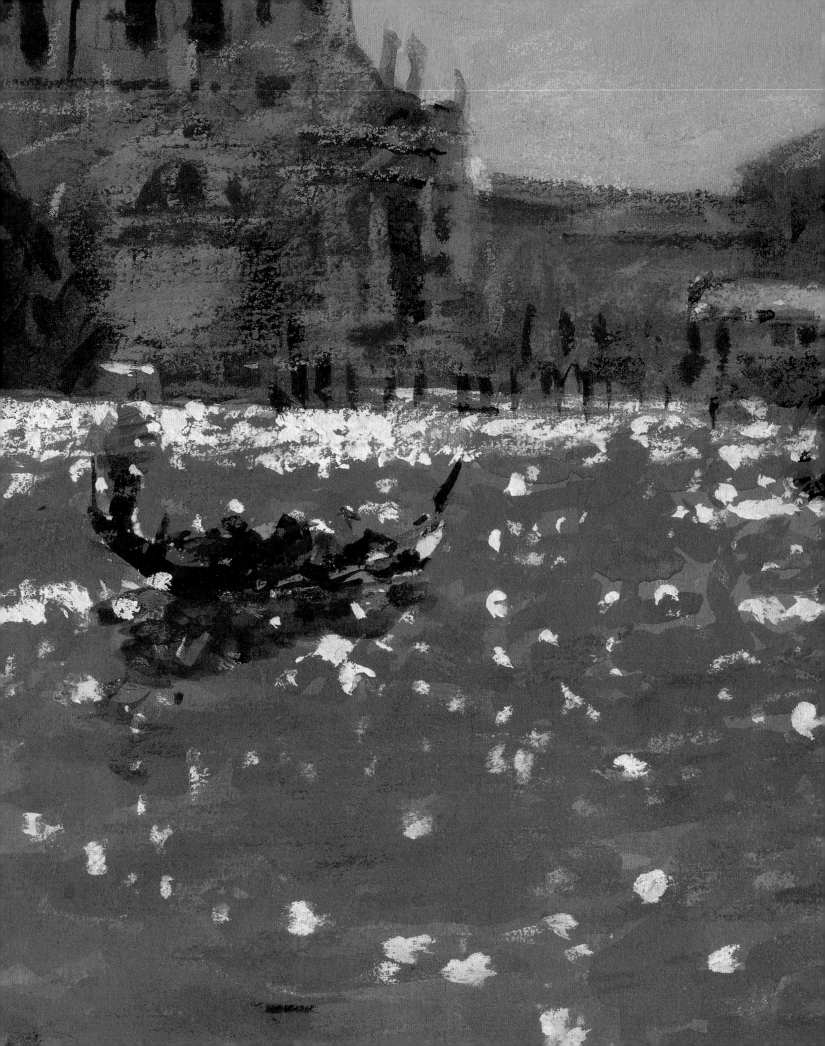

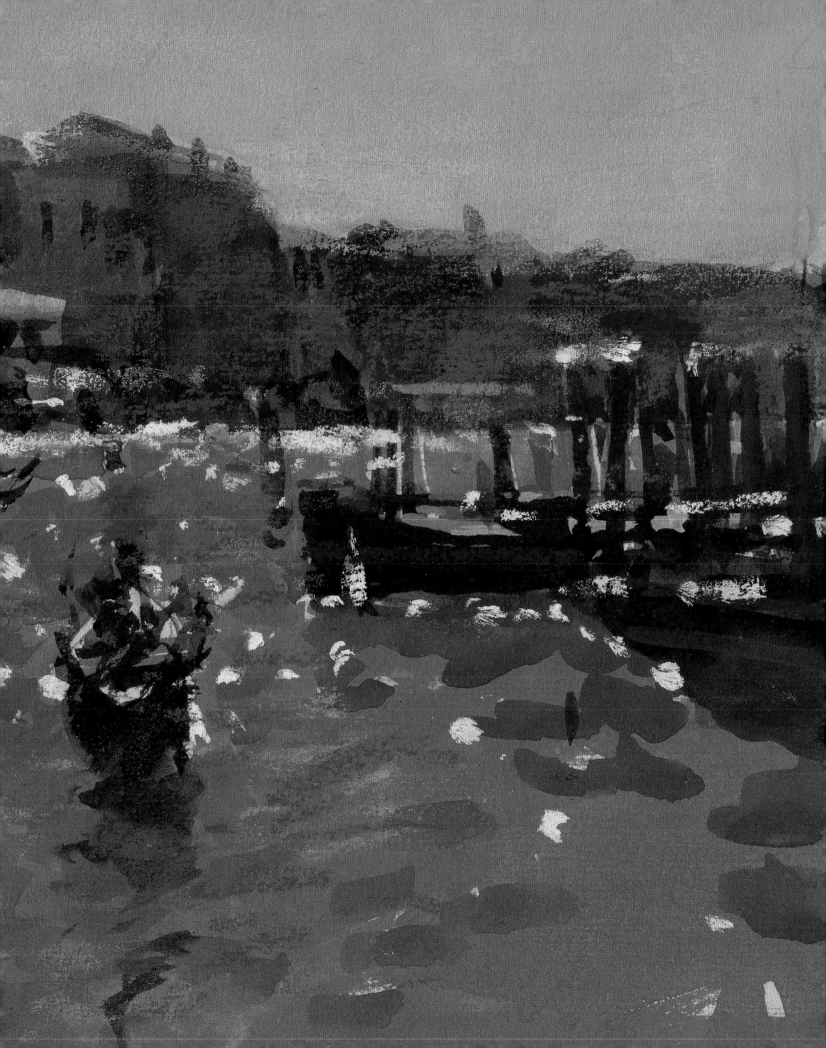

TRANSFORMING SIMPLE MATERIALS

Sonia Lawson

I salute Girtin, Turner, de Wint and Cotman, to name a few true alchemists who showed how to make simple materials into something precious and pure. The sound of their names is a nurturing mantra.

Periodically, I need to visit the print rooms of the British Museum, Tate Clore or Ashmolean to handle original works on paper by some of these gentle giants. Their watercolours are modest in size, yet packed like little grenades with a palpable enthusiasm, monuments to craft and ideas, crisply energising.

Coming as I do from the Northern Dales, I am among accepted watercolour painting country. My *Western Sky, Castle Bolton, Wensleydale* (see opposite) adheres to standard practice. In more recent times I have been seeking clarity via minimalism. This is an ongoing process, although subject matter dictates approach. Clean-cut rocks are different from trees or figures, so I adjust to subject and mood.

Today cannot and should not compete with yesterday. These days, the discipline of working from light to dark can be eschewed when using gouache or acrylic media, so I enjoy some adventure and experiment using mixed methods, especially if employing a stalwart Watman paper. This will withstand scrubbing in the shower or, *en plein air*, a trouncing in river or sea. Other papers, Saunders/Waterford 356 g and Somerset are lovely to work on. Sadly, the original David Cox paper is no longer made; this was a pale buff colour, mildly absorbent and didn't buckle when wet. I get on with quality print papers: Arches or Rives are slightly absorbent though don't stand up to scrubbing. I sometimes tint white paper with a wash, and then, when it is almost dry, I begin work with sables Nos 1–10.

My current work (see detail right) involves the combination of watercolour, raw pigments plus impasto medium, often applied with a palette knife. This method gives body, and allows incising, scraping and 'engraving' into the mass, while some areas of the same painting demand a pure watercolour approach. This duality is exciting.

ABOVE: *Signs of Life* (detail) (2002), watercolour, raw pigments and impasto medium.
OPPOSITE: *Western Sky, Castle Bolton, Wensleydale* (1973), watercolour, 44 x 38 cm (17.3 x 15 in).

WATERCOLOUR AND ACRYLIC

Richard Sorrell

'Cryla' colour was invented by Rowneys in the early Sixties, and I was able to use some of this very first acrylic paint before I became a student. I have used acrylic for forty years. Acrylic has the advantage of being a quick-drying paint that is water-based, but waterproof when dry. This tends to mean that it is all too easy to make hard edges, and that tones especially are hard to control. The way around this, I have found, is to work in glazes and scumbles.

A glaze (a thin coat of darker colour over a light base) warms up the colour, whereas a scumble (a thin light coat, mixed with white, over a darker base) has a cooling effect. Both break down the typical hard edge, which is often the unattractive quality of the medium. The great advantage of acrylic is that it can be altered easily. If one is absolutely dissatisfied with a passage of a picture, it can be painted out with white and a fresh start made. This allows a great deal of improvisation in painting: an image can develop and grow, progress and regress and sometimes completely alter during the course of painting.

Watercolour is a less forgiving medium. With watercolour one needs to know what is going there before it goes down. However, watercolour has the advantage of being an infinitely subtle and beautiful medium. I read recently that the great American painter Thomas Eakins used to make oil sketches for his watercolours, and I have found that making watercolour versions of acrylic studies is a good plan that allows for improvisation and adjustment. One ends up with two pictures.

The paintings illustrated here are two versions of *Reception Line*. The smaller, in acrylic, was painted first. It started as an abstract arrangement of shapes using a viridian/orange colour axis. The shapes on the left seemed to move across towards those on the right, which were static and anchored the movement. This suggested an idea that has interested me for a long time: a higher-class woman condescendingly greeting a person of inferior status. The class system in England makes such meetings, with their minor embarrassments, a common occurrence. In this composition, the three shapes on the left became the inferior guests, and the two on the right, the loftier hosts.

When I decided to make a larger version of this picture in watercolour, the main working out of the shapes was already done, as was the scheme of the colour. I painted the figures with an underpainting of dullish orange, and the background with a generously mixed dish of green. I overpainted this on the right with a thin scumble of greyish-white bodycolour of about the same colour as the ceiling. The pilasters and the ceiling coving were painted in heavier bodycolour over the background. There was some sponging out on the figure of the larger woman on the left. This painting was more technical than the other; subtle changes were made in the composition, and the larger size of the watercolour was, I believe, an improvement.

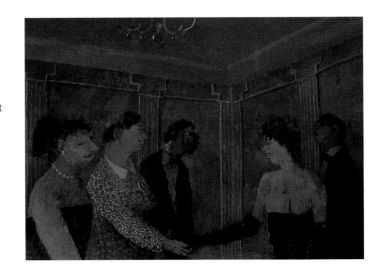

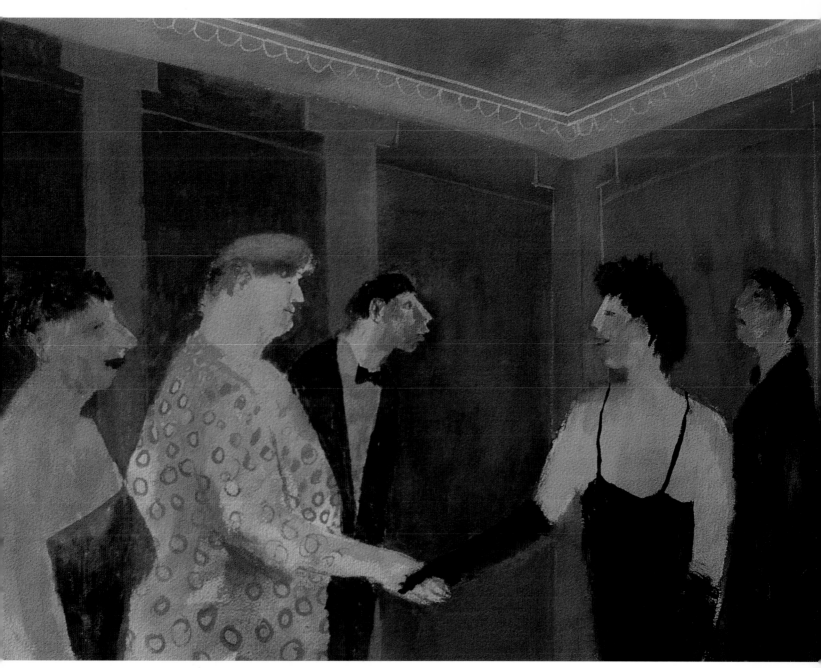

ABOVE: *Reception Line – in the Green Room* (2003), watercolour, 51 x 71 cm (20 x 28 in).
OPPOSITE: *Reception Line* (2002), acrylic, 20 x 26 cm (8 x 10 in).

Drawing

DRAWING

Richard Pikesley

Drawing, as part of the business of making a watercolour painting, can take many forms. It seems to me that it's a part of the process of taking an image from the perceived world and organising it into a two-dimensional form.

Many factors will contribute to the way in which an individual artist will choose to do this: they include temperament, subject matter and what strikes the artist as being fundamental to the subject, the chosen medium and materials, and the painting situation – is there time before everything changes to make a highly detailed study?

Part of the drawing process may never be spelt out as marks on paper as the artist draws in his or her head, planning how high to pitch a horizon or where to reserve white paper. It is sometimes a matter of rehearsal, learning a new subject which may be unfamiliar by painstakingly recording it or grabbing a first impression. For many, the hard-won ability to draw well from observation is the foundation upon which later achievements may be built. Drawing makes you pay attention; you may think you have seen something well enough, but drawing it makes you understand and remember. As Philip Shepherd says (see page 71), 'Studies are working drawings never to be parted with, a library of reference.'

In the following pages you will see that there is no single right way to draw in the context of watercolour painting. For some artists, it is essential to get all the drawing settled before careful transferring the design onto watercolour paper and starting to paint; for others, drawing is completely integrated within the process.

David Firmstone's account of his working procedure (see page 63) is an evocative description of the latter tendency, where the need to make drawn marks emerges out of the process of recording large-scale landscape subjects in which neither the subject nor the artist's perception of it is static.

For the novice painter, it can be helpful to adopt a technique which separates the drawing stage from the consideration of colour and tone. By drawing with Indian ink, which once dry won't be removed by subsequent washes, or with pencil which will give a more discreet guideline, the whole composition may be considered, drawn and adjusted until you're happy that the drawing is right. Washes may then be handled with much more freedom and fluency because they are underscored by the

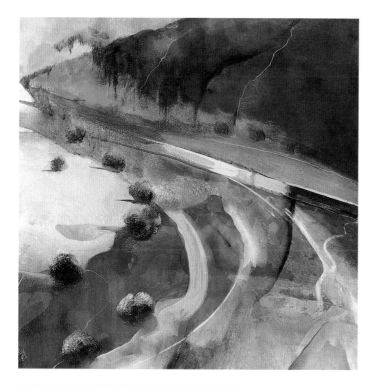

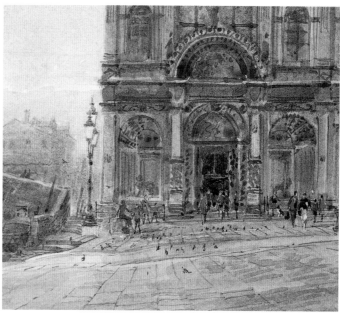

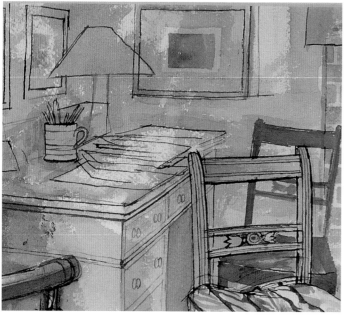

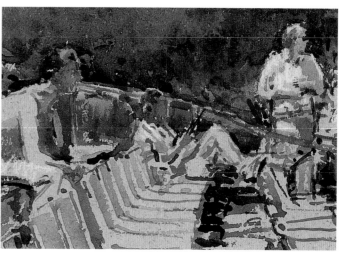

drawing. With accumulated experience, the artist is then likely to develop the ability to set out with less planning and adopt a more spontaneous approach or to fully exploit a rigorous drawing by developing it further into watercolour.

A fascinating aspect of the artists' remarks in this chapter is that selection of brushes, pencils, pens, paper and all the working paraphernalia is intimately bound up with the way that each artist works. Different materials will make the processes of drawing and painting proceed very differently, and it's an important part of the learning process to discover what works well for you.

OPPOSITE: *Peter Morrell (see page 66) draws directly in watercolour. Fluid washes spreading into each other or drying to form a sinuous edge, define the spatial complexity of his evocative landscapes.*

TOP LEFT: *In David Firmstone's work (see page 63), drawing is integral to the painting. Edges of washes, directional marks, etc, define the drawing from within. His unconventional marks use a variety of ways to push the paint around.*

TOP RIGHT: *Philip Shepherd (see page 71) makes detailed studies which he can store and use later as the basis for a number of watercolours.*

ABOVE LEFT: *In this interior by Richard Bawden (see pages 58–59), acutely observed lines are drawn with watercolour loaded onto a pen, and link seamlessly with the broader washes he puts on later*

ABOVE: *By drawing this study of cricket spectators with the brush, Tom Coates (see page 60) defines the whole of the image. The brushes make a variety of characteristic marks which feed back into the way the artist sees his subject.*

LEAVING THE LINE

Diana Armfield

I count on observation of the visual world to enrich my powers of imagination and to increase my knowledge of how things look. Drawing with pen, chalk and above all pencil in a sketchbook is the surest and most enjoyable means of achieving this. Observing teaches me to draw and makes me check my judgments; the act of drawing enables me, you might say forces me, to observe what I might otherwise miss.

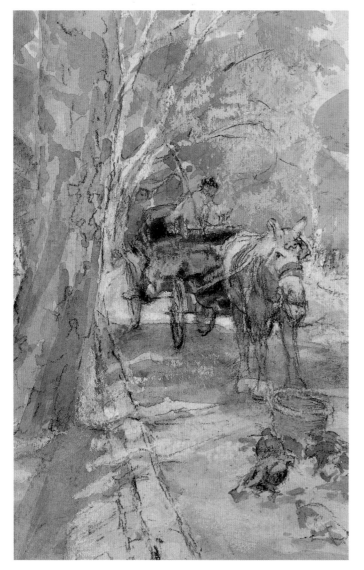

Central Park, New York (1992), chalk and watercolour, 18.4 x 10.8 cm (7.3 x 4.3 in).

The process of observing also develops my visual memory and adds to my vocabulary, and with the changing seasons and life's experiences these become constantly renewed.

Drawing and direct observing are fundamental to my painting in any medium, but in watercolour I have to make a decision early on as to whether the drawn line remains overt and dominant or whether the watercolour shall take over. Without a decision the two can spoil each other; repeating the statement can cause congestion of the surface, also appearing indecisive in intention.

In *Central Park, New York* (see left), I wanted to reveal the scene by the shapes and colours with watercolour, keeping the chalk drawing subordinate, there just to clarify the concentrated area around the horse and trap and the edge of the road, only allowing a few strengthening lines elsewhere.

I have painted *The Vine House, Old Vineyard Country* (see opposite) in oils as well as in watercolour, in solid luscious paint. I wanted to develop it as drawing. This meant selecting and elaborating from my sketchbook drawing, tightening the composition by noticing and emphasising the geometry inherent in the scene, but only half realised in the drawn note in the sketchbook. I needed to develop the drawing from visual memory, imagining myself back in France in the vineyard. This would not have been possible for me if I hadn't gained knowledge of vines by trying to draw them many times. The watercolour was this time secondary, there to enhance the tonality and as an embellishment.

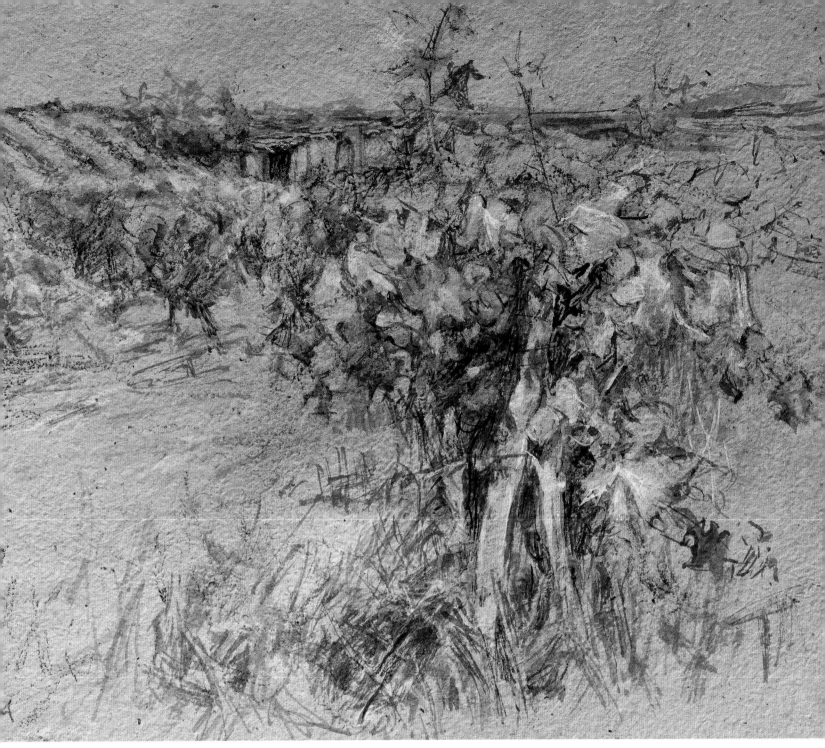

The Vine House, Old Vineyard Country (2003), chalk drawing and watercolour, 17.8 x 22.2 cm (7 x 8.8 in).

SKETCHBOOKS

Bernard Batchelor

The big wide world beyond the studio is always busy and on the move – nothing remains still, the light is constantly changing (as Monet and Turner well knew). The clouds gather and the rain pours down, people form interesting shapes and groups and then disappear in minutes – the painter can't keep up with it!

But it is possible to make notes in a sketchbook with a pen and a couple of pencils and with the help of your memory. On your return to home or hotel, out come the watercolours and you add the colour notes to the sketches or even paint some of them again (small-scale) to substantiate those that could do with clarification.

Notes of tones can be written by adopting a simple numbering system of one to five (high to low). I always work like this because things change so rapidly. You can be sitting outside doing your watercolour, only to find a car parks right in front of you, or a tug arrives and tows away those two lovely rusty old trawlers you were so enjoying.

Later in the studio is the time for composition and deciding what you want to say from the notes and sketches. Mostly, of course, it is fairly straightforward, but at other times it can be something that on reflection is quite different – perhaps something more creative and designed rather than just a transcription of the notes.

The time factor does have an influence, of course, and the more thoughtful compositions do take time. I quite often mix the colours on old bits of watercolour paper, using it as a sort of palette which sometimes (as a sort of by-product) can be turned into ideas for a future painting. The painting of *Raising Steam* (see below) was done in this way, with much sponging and adding darker washes as it slowly dried.

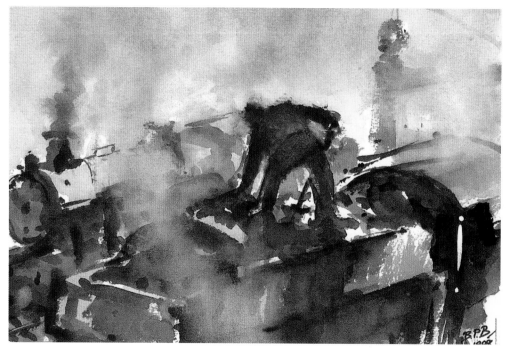

Raising Steam (1999), watercolour, 21.6 x 29.2 cm (8.3 x 11.5 in).

USING A PEN LINE

Richard Bawden

Firstly I have to think about what I want to do. If it is a commission, such as a house or a garden, then having looked around and felt the character and atmosphere of the place I talk to the owner, who might want something particular to be included, such as for instance a boring piece of wall built by Napoleonic prisoners. This process can take an hour or two.

If I am painting for myself, the process can be even longer because I am not just trying to do a picture of a place where instinctively I feel it is right or wrong. This is a painting from life and, having sat down, I then analyse everything that is in front of me in terms of shape, colour and design. This in itself is inherent in the idea which, although pictorial, is also abstract.

When on a painting holiday with my father, Edward, in Cornwall, we would go to a place and look around for ages, and often select the same point of view. Then he would plunge in with great speed and finish a painting in two sittings. I find it is quite nice to paint with someone else even if they are 200 yards away. You have this sense of serenity at being together. On one occasion I sensed his painting was not going well, and at that point a man came up and said 'Good morning!' 'I don't think so,' was the answer!

The way I work is more often with a pen line which holds the form, particularly if it is architectural where the tension of a crisp line is important. I don't use ink; never waterproof ink either. This is because ink is too 'hard' and stains the paper. I mix up a warm blue-grey or ochre and feed my old 'post office' pen from a brush. This means I can use a bold line with a wide nib but using a *pale* colour. I find this way of working is easier than painting straight off with a brush, because the form is held by the line and the colour is applied directly and freshly. When doing an illustration or card with cats and people, I prefer the incisiveness of line.

There are times when persisting, using layer upon layer of transparent washes, is delicious as long as the end result is not overworked and dead. It is the vibrant, soft, velvet richness of

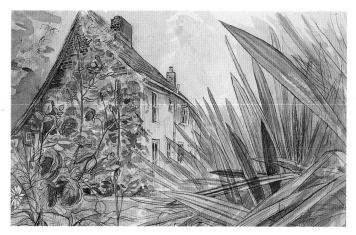

Bottengoms Farm (2003), watercolour, 40 x 53 cm (15.7 x 21 in).

some colour and the atmospheric granular effects of ultramarine that can work completely without any line to hold it together.

When stretching paper, many people think that they have to thoroughly soak and saturate the paper. Do not. It is best to sponge both sides or draw it through a sink of cold water. Remove the surplus immediately with a towel or blotting paper, lay the paper on a drawing board and stick it down along the edges with gum strip (not masking tape). It will be ready to work on in an hour. If you work on a watercolour without stretching it first, then you can do as follows at the end. Lay it face down on the board, lightly sponge the back and stick it down with gum strip. But leave it overnight to dry thoroughly before lifting.

The painting above shows Bottengoms Farm, an old Essex farmhouse set in a wild overgrown garden. For a long time it was

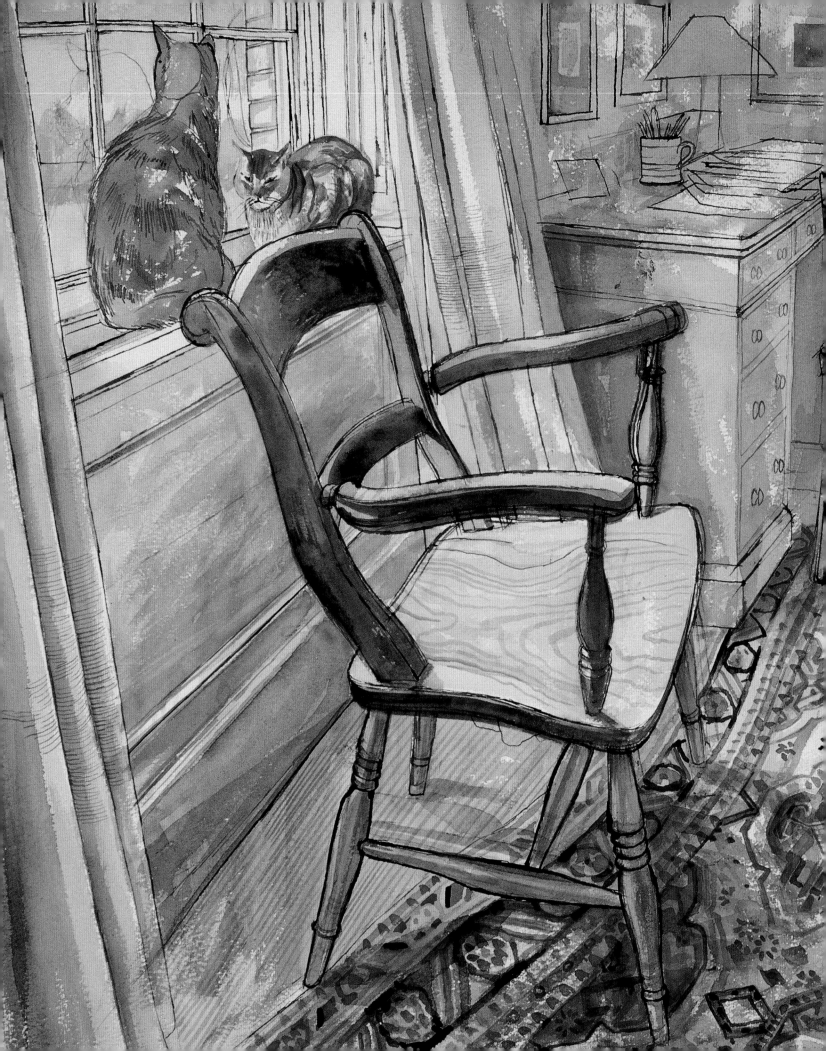

the home of John and Christine Nash and is now lived in by Ronald Blythe, the writer. I am very attracted to it because it has so much atmosphere, surrounded by large-leafed plants, willows and evergreen oaks. The rose in the foreground is named after John Clare, the poet.

The Dining Room (1991), watercolour, 40 x 53 cm (15.7 x 21 in).

DRAWING WITH THE BRUSH

Tom Coates

Meeting with a sitter, or tackling a composition containing lots of activities, perhaps sporting or musical, even important events, can often pose problems. An example during sittings is the interference of onlookers – family or partners. They are acting with the best of intentions, so ignore them at your peril. Take their advice, but stay true to yourself. Starting with a few sketches helps to break any tension that might build up. Have fun, show your skills.

Choosing a paper to suit the environment is so important. I have known papers, when damp, to lose their resistance and become like blotting paper. There are many weights of papers to suit the individual, and if you want the best results you have to pay. Don't be stingy, making a good mark or wash is rewarding.

The portrait of *Man With Beard* (see opposite) was done on heavy rag paper, handmade with bits of straw in it. While painting the head, I felt it needed to be larger, so I added an extra sheet. This technique is often used when you need to expand the size of your image. Even more bits can be added until it is really quite large. The Leonardo da Vinci Cartoon in the National Gallery, London, is studded with bits of paper, placed there for correction or other uses.

Brushes are a personal choice, but some such as the sables, or any of the soft hairs, make the life of a watercolour more fluid. I like to work with long-haired rigger brushes which give me line and quick movement, and help dexterity when handling colour and masses. I used this technique during the England cricket tour to South Africa (see right, *Final Day's Play, Jo'burg Test*). I used line and wash, and did all the drawing with a brush. To paint likenesses I concentrate on the structure, the anatomy of the person, their language, body movement and colour. I followed each player until I became familiar with their habits, movements and mannerisms.

Knowing when to stop often eludes people. The result is over- or under-worked, too blue, too red, too hot or too cold, or even badly drawn. It is nice when the commissioner says, 'Stop! I like it,

Final Day's Play, Jo'burg Test (2000), watercolour, 30.5 x 40.6 cm (12 x 16 in).

don't do any more.' The opposite of this is when you think it is finished and the client says, 'That's coming along nicely.' Oh, well!

Presentation of the final result can be the most satisfying moment. The processes of cleaning, mounting and framing give an extra polish to your work. If getting museum mounts and acid-free framing materials seems expensive, well, the only compensation is that everyone is beginning to appreciate artists' work.

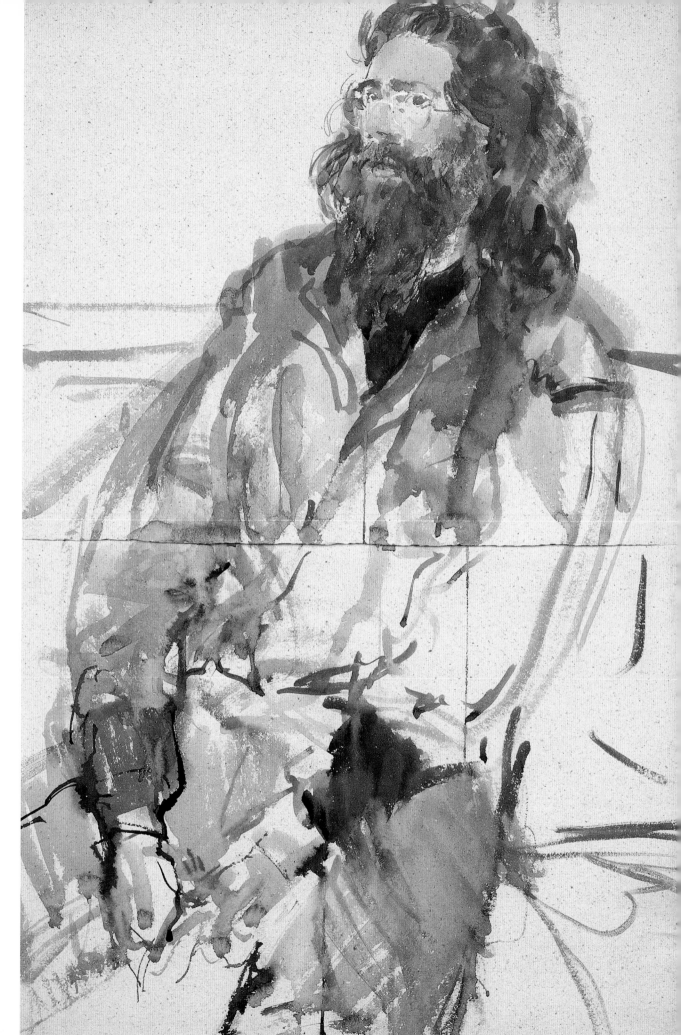

Man with Beard (2000),
watercolour, 97 x 62 cm
(38 x 25 in).

USING A TRACING

Harry Eccleston

Although I have painted a small number of watercolours on the spot, since then they have all been created in the studio from very detailed drawings, colour notes and photographs taken at the time.

I make a master tracing to design the picture. This is the most exacting part of the process because small figures or a mast against the sky will have to be stopped out with masking fluid before the sky can be painted, and this needs to be very accurate. I find it best to trace with a very soft pencil rubbed very hard into thin paper. The master tracing is then traced onto stretched paper, which allows me to choose a suitable paper for the subject.

When I stopped painting in gouache in the early 1980s, because all the subjects which interested me could only be painted in watercolour, this posed a real problem. I had no idea how to do this using watercolour, particularly as all the subjects were water-edge subjects, often with large areas of sea and sky.

It soon became apparent that, with my limited technique, the depth of colour and changes I wanted could only be achieved by laying wash over wash over wash, and drying each with a hairdryer. A dark colour could then be made with several versions of the same colour, each wash being very pale to avoid 'steps', each edge softened with plain water, particularly if I was going from light to dark. By this means I was able to create the light and atmosphere I sought. But as a single area could have over twenty washes, it meant that the work often took a very long time – the very opposite of how one thinks a normal watercolour should be painted.

I have always been fascinated by figures by the sea, and many of my water-edge pictures have included them. I have also felt that, however small they are, they should be real portraits. At the mouth of the river at Burnham in Norfolk, and on the beach there, I can find my perfect subjects: sea, sand, coloured boats, and the wonder of people coming, going – and staying!

The Beach at Burnham (1988), watercolour, 15.2 x 22.9 cm (6 x 9 in).

DRAWING WITH THE POUR

David Firmstone

I love painting huge land and seascapes. I'm keen to play with spatial relationships, which is why I enjoy working large-scale – it offers an even bigger playground.

Recently, I've discovered the seascapes of the Isle of Wight (see following pages, *Gulls over Foreland*). Last summer I'd just completed a painting and sat down to watch a programme on Turner, and found that he too had painted the very same view! I have two methods for these paintings. The first is to sit *en plein-air* for a week or two and paint directly onto six-foot handmade paper. I enjoy the direct, deep, sustained involvement; it makes me invent new ways to paint 'on the hoof' and I discover the fabulous mark-making qualities of rain, toilet paper and the end of my shirt. The second method is to gather information through sketchbook paintings and dozens of photographs which I collage together back at the studio; from these small beginnings, large watercolours emerge.

Technique is critical to my aesthetic. I constantly search for new ways to make watercolours, and some are the result of pouring paint and allowing it to run across the surface. As I turn and tilt the paper, so I'm 'drawing with the pour'. I love the illusion of movement that the mark of water gives – and there was a lot of it about when I was painting in Bali (see right) – on the local handmade paper which buckled differently each day in the heavy humidity. I'm not just interested in representation, in fact I'm always disappointed when only that takes place. Then I plunge the painting into the bath, or throw paint over it, spoil it, so I have to struggle with it all over again. And I can never quite remember my previous approach, so each painting is an act of learning to paint again.

The Riverbed (2001), watercolour, 170 x 137 cm (66 x 54 in).

Gulls over Foreland (2003), 100 x 122 cm (39 x 48 in).

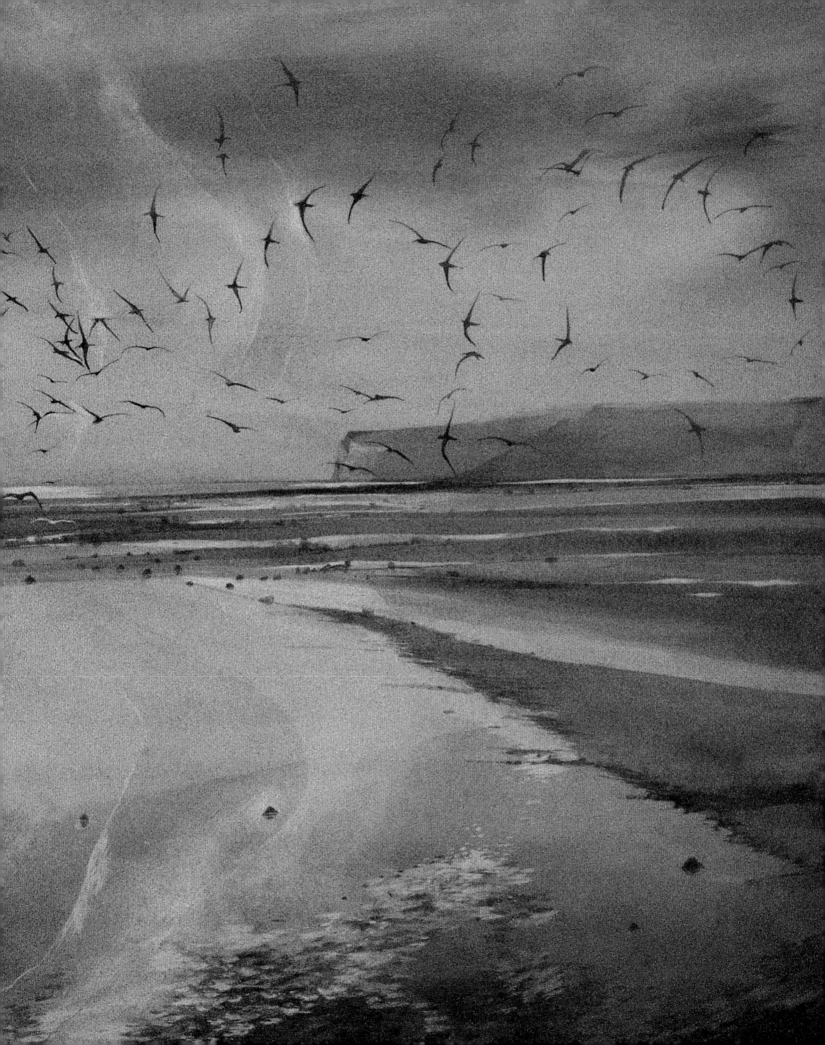

DRAWING WITH WATERCOLOUR

Peter Morrell

When I do watercolours, I like to get out into the landscape – oil painting keeps me in my studio and is a very different activity. I often walk long distances for my subject matter. I prefer desolate places such as Dartmoor, Scotland or the Thames estuary.

For me watercolour is a complementary activity to oil painting, for which I have another attitude, also it gives me a break from working in the studio. My work is very much in the tradition of English watercolour as exemplified by Turner, Towne, Cox, Cotman and Girtin. I have little interest in trying to make my watercolour work contemporary; it is, but only in the sense that it is made today. I like my watercolours pure, and go for one hundred percent watercolour.

Drawing is basic to all my work and underpins all I produce. In watercolour I draw in colour directly; it is essentially a fluid medium and states its characteristics straight away. I do no underdrawing, preferring to lose myself in what watercolour does best.

As my interest is landscape in certain atmospheric conditions, it is well suited to the fluidity of the waterborne medium and runs parallel to it. I work rapidly on a smallish scale in order to capture the fleeting effects of cloud, light and mood. Sometimes I use a wet approach, sometimes dry, according to demands of the subject. I have no fixed method or technique and have little time for a fastidious approach, often I break the rules. Turner's quoted habit of dunking his work in a bucket and giving it a good scrub, strikes a chord with me. I don't worry what brushes I use, I've even used rag before now and scrubbed my work with a handful of heather. I use good-quality Rough or Not Pressed paper, which contributes greatly to the work. I also like a tough surface that can take the knocks. I use tube colours put around an enamel plate, my water supply is from a can tied to a stick pushed into the ground. My portable mahogany easel, self-designed and made, does not always get used as I prefer to paint with a board on my knees or use some other convenient nearby object for support. I designed and made a balsa wood box containing a balsa wood board, which is very light to carry. Art is perhaps a kind of magic that we do, and for me that is a good enough reason for a life.

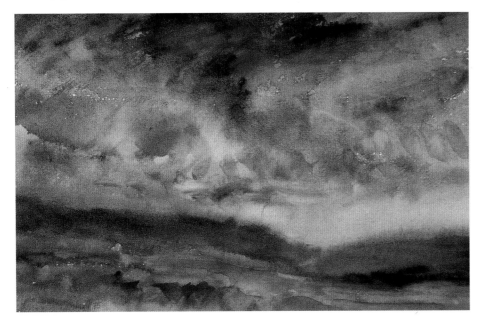

Drizzle on Dartmoor (c 1978), watercolour, 17 x 27 cm (6.7 x 10.6 in).

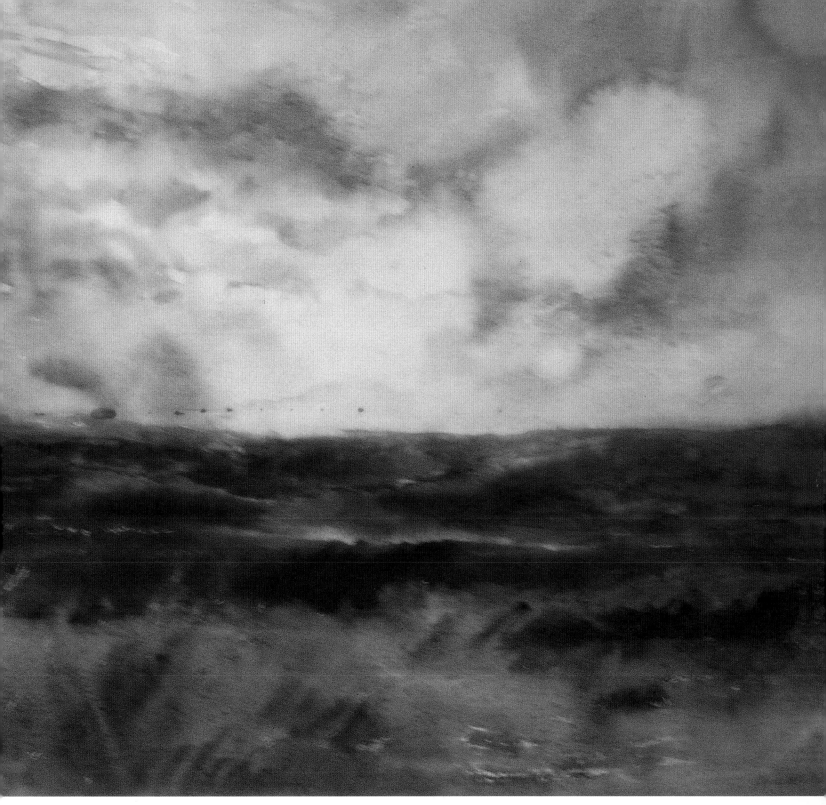

Mist towards Buckland, Dartmoor (c 1985), watercolour, 28 x 33 cm (11 x 13 in).

DRAWING AND REDRAWING

Paul Newland

*For me drawing is a matter of laying up stores to activate memory, and
(less often really, except as a self-imposed exercise) of understanding. I paint
too often from memory, then am unable to conclude and have to work over things
a lot. In these circumstances, rough sketches can provide an expedient
and help me to find a resolution.*

I can think of three processes in drawing: recording, exclaiming, and investigating. Their objectives are: statements of fact for reference; recollections of experience; and understanding (one hopes) phenomena.

Using line, tone, scribble, tick, stroke, scrape, scratch, slash, stab and drag – one mode alone or all together – I try to encompass a perception or an exclamation or an irritation or an investigation. Some hope of security is provided by amassing all these notes (whether in sketchbooks or on the backs of old letters found in my briefcase). A hope that later, when they are laid out at my feet or collected behind a large sheet of glass (little bulldog clips around the edge, each holding a note), this collection of energetic musings will provide the key to the painting being attempted.

I seldom undertake large drawings – and then almost as gingerly as when starting a picture – but they always become palimpsests. Sometimes it is an almost luxurious pleasure to rub out entirely the well-worked product of several sessions, leaving a smeary, scrubbed and by no means pristine surface.

Then the finely sharpened pencil, poised vertically and with pressure to make those few lines which will sum up (perhaps) the preceding efforts, transmits to the draughtsman as it crosses the grooves and turbulence of this surface a sense of his ability to accumulate and his ability to throw away.

The works illustrated evolved in different ways. In the watercolour (see below), drawing and painting were carried on simultaneously. In the larger work, *Evening* (see opposite), the problem was to give weight and reality to things which were on fairly flat planes in reality, within an image that is of course on an absolutely flat plane. The drawing was directed to this end and underwent many changes, including some made after this photograph was taken. Drawing issues such as proportions and placing were frequently reassessed.

Still Life with Many Objects (detail) (1999), watercolour, 46 x 58 cm (18 x 23 in).

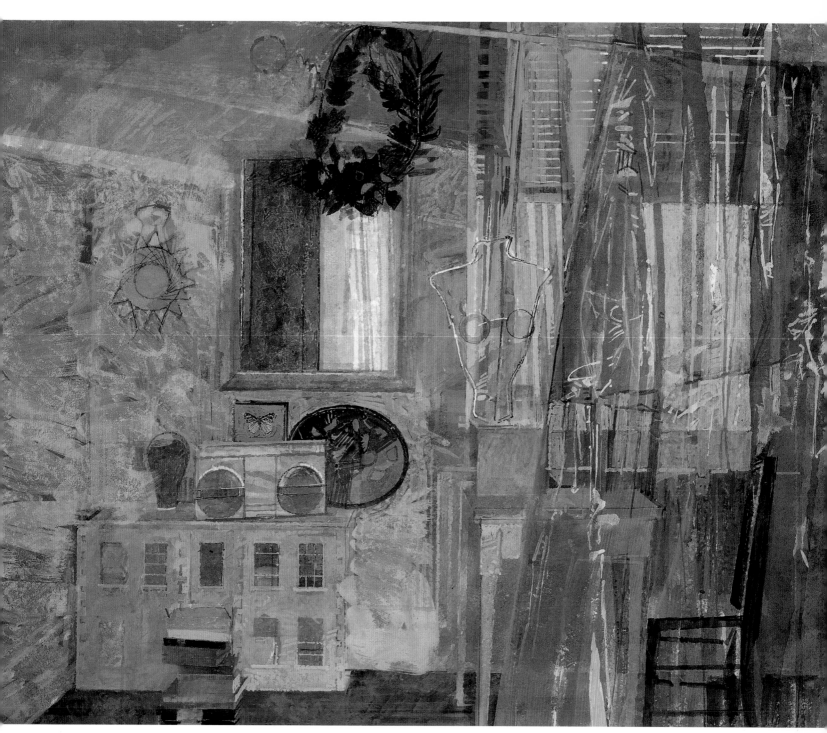

Evening: Dolls' House and Radio (2003), watercolour and gouache, 43.3 x 55.8 cm (17 x 22 in).

WORKING WITH TONE

Norman Webster

The way I capture light in my paintings may be due to the study I have made of the working practices of some of the landscape watercolourists of the 19th century who were influenced in various ways by the Pre-Raphaelite movement, especially those who had become members of the Royal Watercolour Society such as Myles Birket Foster, Henry George Hind, George Boyce and Alfred William Hunt, to name but a few.

These artists were all sound draughtsmen who were able to achieve brilliant effects of light in their paintings by using various methods such as elaborate stippling techniques and fine delicate brushstrokes, combined with sponging and scraping out plus enhancing of colour by the use of gum arabic and body-colour. It is this painstaking approach to watercolour painting, and in particular the dedication to sound draughtsmanship, that I believe has always characterised my work over many years, and to some extent my subject matter.

I have to admit that I have never really come to terms with painting watercolours directly in the open, but I do make small colour sketches for use whilst working in comfort in the studio on a painting based on one of my drawings. It has never been a problem for me to spend up to two or three hours making a very

detailed tonal pencil study of a particular view, because in that time I can usually get down sufficient information and detail to create a worthwhile painting.

After a faint linear outline of the drawing has been transferred to the stretched watercolour paper (I usually prefer a Not surface), I can gradually draw the structure of the composition by building up the forms carefully with a medium-size sable brush and emulating the tonal values, thinking of the painting as a drawing that must show depth, form and feeling. It is here that various techniques may appear, such as gently scraping and sponging out, along with the dry and fine brushwork and some introduction of bodycolour. This is a very slow process but an enjoyable one, where I feel the end result is worth all the time and labour spent.

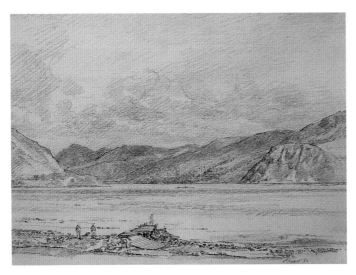

A detailed sketch at Ennerdale Water (1982), 25.4 x 35.6 cm (10 x 14 in).

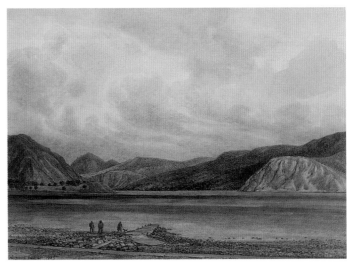

Ennerdale Water, Cumbria (1983), watercolour, 25.4 x 35.6 cm (10 x 14 in).

THE VALUE OF STUDIED DRAWINGS

Philip Shepherd

My approach is typically traditional with a bias towards the topographical, based on good freehand draughtsmanship.

My main interests are effects of light, atmosphere and aerial perspective on landscape and architecture. On-the-spot studies form the basis of 99 per cent of all my work. Making studies is a challenge to an artist's ability and patience. Sixty-odd years ago my art college tutor asked, 'How can artists hope to express themselves if they cannot draw?' Is the same question asked today? Leaning out of a high window in Venice, looking right and working in cramped conditions, produced a six-hour study. I almost gave up, but it was worth the effort – many watercolours followed. The one illustrated here is an example, executed in 1999, nearly twenty years after the original on-the-spot study.

Studies are working drawings never to be parted with, a library of reference. They lie dormant for years until by chance an idea prompts action. I not only sketch what I see, but also what I feel about the subject. I observe and retain much more and know instinctively what to retain, what should be altered or exaggerated for effect. Above all, I have the basis of the composition constantly under surveillance. Copious annotations usually litter the drawing and a retentive memory is a bonus. My method of working reduces studio working time.

I love the spontaneous movement of pencil when drawing on the spot. Lively sketches result, though it is much more difficult to achieve in watercolour. The finest and most brilliant watercolours are composed with minimal washes of such skill as to leave the rest to the imagination of the viewer, a very rare feat few artists have attained. Sometimes I am pleased with my work, but I fear what I hope for is unachievable.

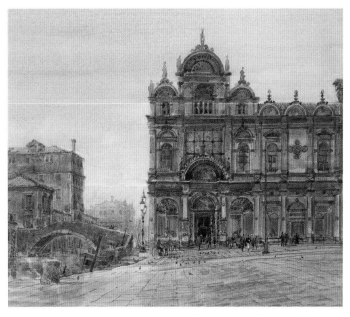

Venice: Campo SS Giovanni e Paolo (1999), watercolour, 22 x 24 cm (8.5 x 9.5 in).

On the following pages is a gouache of an oil rig, *Moonlight Magnus AMEC*. Access to the rig was denied, but a poor black-and-white photograph of the rig in a placid sea stirred the imagination and a flight of fancy produced this dramatic, forbidding seapiece in the English Romantic tradition. The power of man and the magnificence of nature!

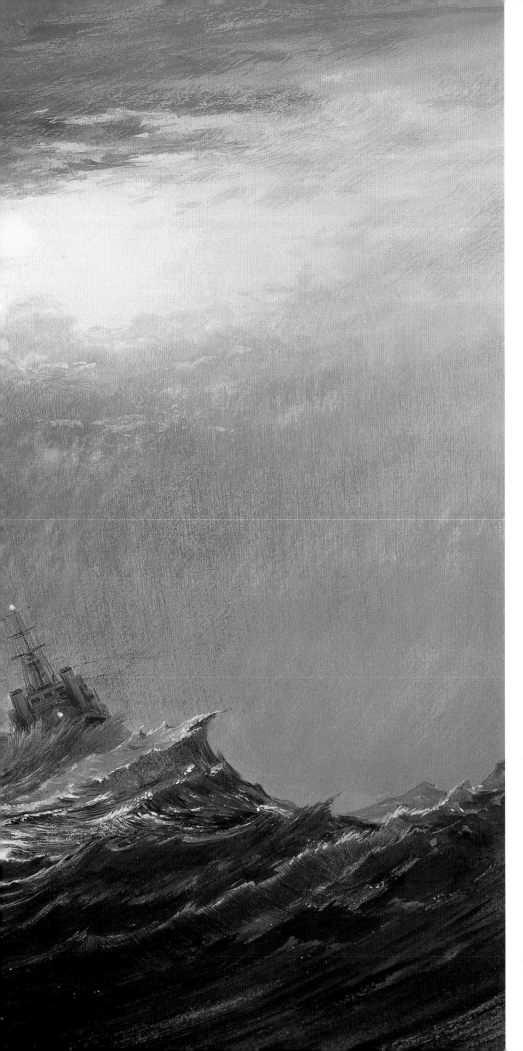

Moonlight Magnus AMEC (1990), gouache,
31 x 44 cm (12 x 17.5 in).

USING PEN AND INK WITH WATERCOLOUR

Neil Pittaway

My work relates present modernity in Western culture to a historical past. I often incorporate elements of 19th-century satirists' work and Gothic Revival architecture into a modern context. The link with the past is used often as a metaphor for the present.

In *The Eyes in the Sky* (see right and opposite, detail), a satellite image of Paris is shrouded by a dome to French and Parisian history with particular reference to Delacroix and Revolutionary France. Giant satellite dishes represent global communication. Placed within a rotunda, they become chandeliers hovering precariously over Paris. This elevates the modern metropolis into a metaphysical world where human achievement is celebrated and elevated to a godly status.

I use a variety of techniques. I sometimes apply the pigment directly or may mix colours carefully. I apply glazes in various stages, often with intricate detailed pen and ink drawing. I work using observed images and my own imagination.

In *And Hear the Music* (see right), colour is used to recreate the emotional drama and magic of the theatre. The physical structure of the theatre is drawn using pen and ink with watercolour washes, and adds an extra dimension and quality to the painting's surface.

The painting reflects the magical arena of the theatre environment that is sublime and peaceful: a 'giant awakening'. A ship drifts across, suggesting a start of a performance, the beginning of a mysterious journey, the sound gets louder and louder, the theatre awakens to its audience and the spectacle is complete.

My paintings draw on material culture: the works, predominantly architectural in nature, are visionary; the past lives within the present. The paintings follow multiple ideas and ideologies that are often chaotic, portraying an unclear world where imagination and vision of reality become inseparable.

TOP: *The Eyes in the Sky* (2003), pen and ink and watercolour, 68 x 98 cm (26.8 x 38.6in).
ABOVE: *And Hear the Music* (2002), pen and ink and watercolour, 74 x 106 cm (29.1 x 41.8 in).
OPPOSITE: *The Eyes in the Sky* (detail).

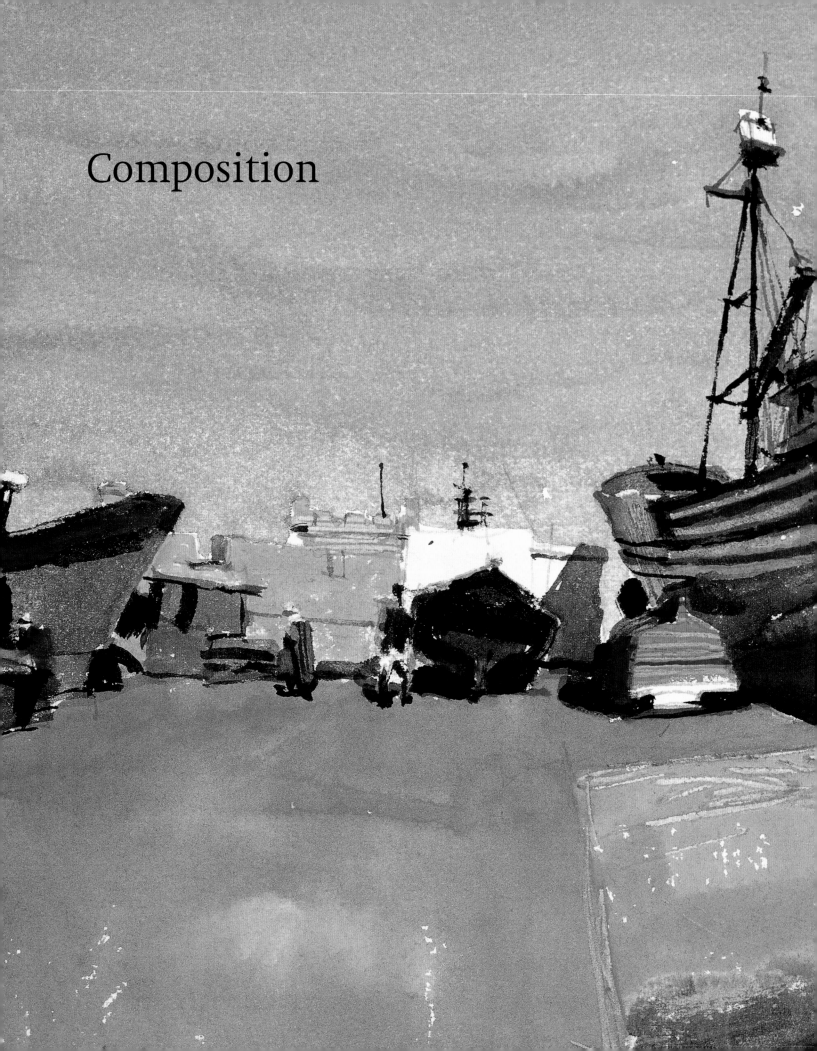

Composition

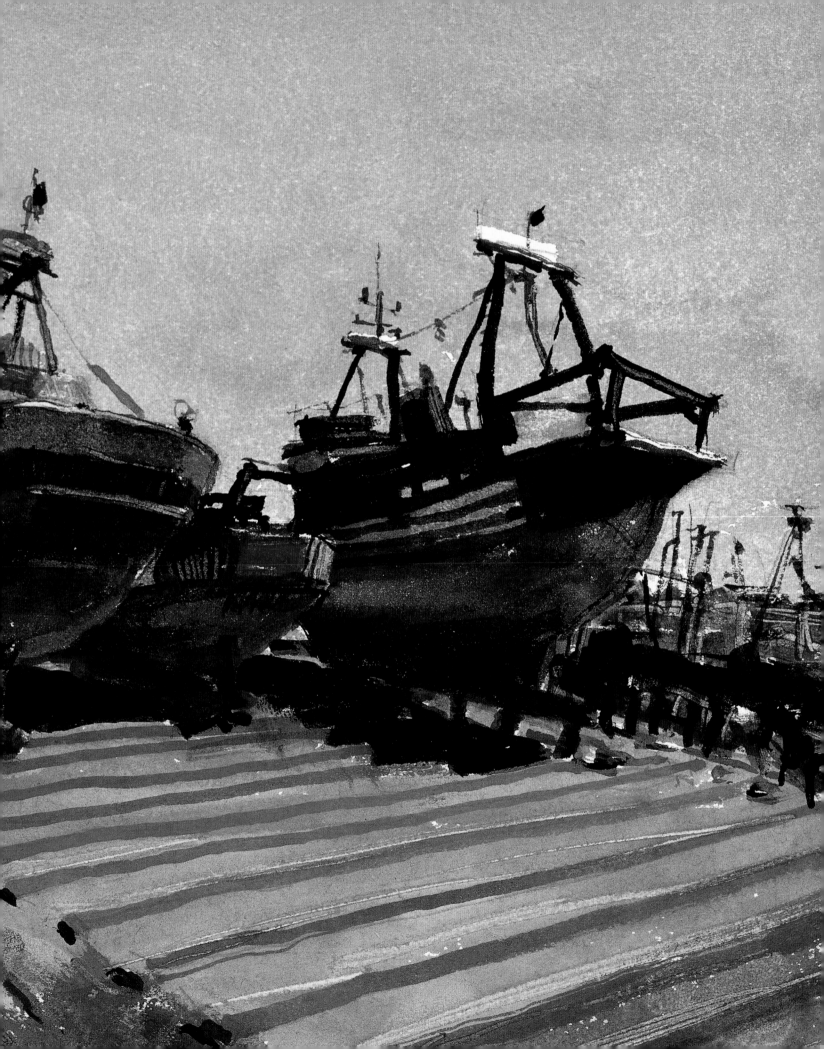

COMPOSITION

Trevor Frankland

Composition carries the soul of the painting. It can be described as the disposition of colours, tones, lines and shapes in relation to each other, as well as to the edges of the painting. It should give emphasis to the structure of the painter's intentions when creating the work.

Throughout the ages, methods of composition have been taught to assist the artist in his work. Amongst a plethora of books on how to paint, a manual was published in 1785 on *A new method of assisting the invention of original composition of landscape*. This was compiled by Alexander Cozens as a method of composing by blots. An amazing system for its time.

J M W Turner's *Liber Studiorum* was published in the early part of the 19th century and became known as 'Turner's Drawing Book'. It is on record that John Constable was asked to study that book 'to learn to make a whole'.

It is by looking at particular works that ways of composing can best be understood. In Simon Pierse's painting (see opposite top left), there are two main clumps of green in the foreground, with two main trees on the horizon and a third clump to create the face, in perspective, of a die with five spots. The effect is space-enhancing. The detritus in the foreground attracts the eye, which then scans upwards to give a greater impression of distance. Turner frequently used this device, which led Ruskin to call it 'Turner's foreground litter'.

Formal perspective is frequently used to create an illusion of space, and in Kenneth Jack's painting (see opposite below left), the eye is led inwards to the two 'tower-like' structures, one red at the top, the other red at the bottom. They are situated each side of a gap which is blocked off by a building and trees, effectively sealing in the space so the eye is stopped from going to a vanishing point. The sky is similar in tone to the land, and this helps to create a hermetic effect. The two lamp posts pointing inwards also help towards this feeling of claustrophobia. If you place your fingers over them, you can see the important role they play in this context.

Composing parallel to the picture plane, with everything happening in a shallow space and no distant view, is another way of making an event more immediate. Karolina Larusdottir's painting (see opposite below right) shows the shapes of the elements and the heads of people grouped to form blocks. The bottom edges of their clothes also tends to flatten the picture. The light 'L'-shape marking the top of the door is echoed in reverse by the standing figure of a man with outstretched arms and the light

enveloping the heads of the women, creating a strong hypnotic effect. The group of women form a compact mass, the front sloping away from the outstretched arms and the rear sloping towards them, thus locking the group together in a tight controlled mass.

My painting *Museum Night Rider* (see top right) demonstrates how echoing and linking shapes can create a pictorial whole. To give the horse the illusion of movement but at the same time of hanging in space, the slope of the animal is aligned with similar sloping lines across the picture plane, while the nose of the horse is touching a vertical light band to hold it in space.

A common form of composition is that involving an object against a background which creates, in most instances, shallow space. Michael McGuinness's painting (see opposite) is an example of this. Here the interest is concentrated on the intricacies of the tree with the background having a slight tonal modulation.

The art of composition can be intriguing and exciting but always essential. John Varley, a founder member of the RWS in 1804,

wrote, 'The true exercise of art consists of contrasting the round with the square, the light with the dark, the hard with the soft, the far with the near, the local and distinct with the general and indefinite.' This formalist description could have been written yesterday!

OPPOSITE: *Michael McGuinness,* The Winnold's Tree *(see page 92).*

TOP LEFT: *Simon Pierse,* Desert Morning *(see page 98).*

TOP RIGHT: *Trevor Frankland,* Museum Night Rider *(see page 86).*

ABOVE LEFT: *Kenneth Jack,* Old Port Adelaide, Australia *(see pages 88–89).*

ABOVE: *Karolina Larusdottir,* Receive the Holy Spirit (St John 20.22) *(see page 90).*

PROPORTION AND COLOUR

Clifford Bayly

*Having grown up in the art world with a continuing background of design –
mainly of a two dimensional character – I have come to regard the underlying
structure of a painting as an essential and creative element in the overall
production process.*

I see the structure or composition of the picture as a framework
into which I can build areas of visual activity or, conversely,
areas of passivity. This basic activity alone can suggest a mood.
The structure of the image panel itself – its proportions,
height, width and number of images – can set up the overall
character of the work. Then the proportions of the first divisions
of the image panel are considered in relation to the subject. I
consider this basic activity as a very creative act – a method of
'stalking' one's subject in order to create the most appropriate
context in which to present and express its visual qualities
to the maximum.

Not only am I greatly moved by space in its physical sense, ie the
illusionary aspects of painting landscape – vast distances, aerial
perspective and scale – but I also find it very absorbing to employ
other methods of expressing spatial relationships in a more
intimate form, such as the use of bodycolour inter-relating with
transparent or translucent colour. The use of warm and cool
colour can also suggest spatial relationships.

Although some of my work is the direct result of particular
visual experiences, I prefer to bring back this visual material
to the studio environment where I can reassess its value and
essential significance, away from the mass of inessential detail
that can dominate one's vision when working on site. In this
'liberated' atmosphere I am free to develop my interest in the
more historical context in which many of my landscape subjects
exist. In this connection I can introduce the written word as an
integral and creative element in my painting.

Whilst exploiting the fact that warm colours – reds, oranges,
yellows, browns – appear to advance, while cool colours – blues,
greens, greys, mauves – appear to recede,
I like to utilise another aspect of colour,
that of mood. Warm colours are more
dynamic and active, while cool colours
express quieter, spatial and passive
qualities. To me, working in this area
presents infinite possibilities for the
development of my paintings.

The Long Man Proclaimed (2001), watercolour, 56 x 106 cm (22 x 42 in).

CHOOSING A VIEWPOINT

Jane Carpanini

Contemplating the subtle effects of viewpoint adjustment might seem a prosaic activity when the artist also has only a limited time to get the image down, but an objective consideration of the possibilities can make all the difference to the success of the final piece.

A largely empty expanse of foreground in front of the real source of interest can be much reduced by using a low eye-level to foreshorten that plane, even if it means standing up to draw the rest of the scene. Similarly, there is no need to remain rooted to the spot: moving around within roughly the same area is much nearer to the way a view is actually taken in, and can provide all sorts of useful information to enhance the picture's purpose. Some of Canaletto's views of Venetian piazzas have an expansiveness that suggests the use of a swivelling viewpoint to record as large a scan of the architecture as possible.

My own work makes deliberate use of the concept of viewpoint to create a particular relationship between spectator and subject matter, implicit to the meaning of the picture. A path through a forest, or a shady street lined with the receding façades of buildings, is an invitation to enter in terms of composition. The viewpoint is established by considering the route into the subject matter and the eye level gained from sitting or standing allows the spectator to identify naturally with the pictorial content.

Being sensitive to various aspects of what could be described as a common visual currency is fundamental to the effectiveness of some pictures as a means of communication. But one might not be using a viewpoint solely to provide ready access to a vicariously pleasurable record of a journey through street or vale, whether site-specific or drawing upon the emotive allusion of landscape in general. Many know Caernarfon Castle (see right) from views across the straits or the estuary, but fewer will be familiar with the commanding outlook from the towers or indeed their vertiginous height above neighbouring streets.

Choosing a high vantage point has enabled me to respond to the abiding strength of the masonry and architectural structure, while the unusual view forces the spectator to reassess the Castle's physical presence and its overwhelming effect.

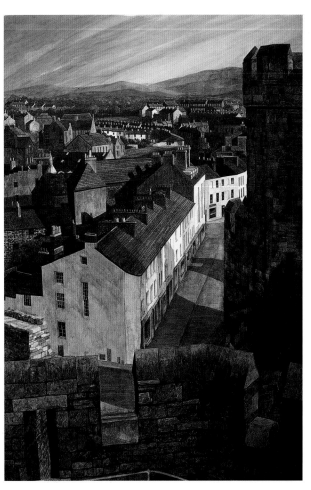

Eagle Tower, Caernarfon Castle, (undated), watercolour, 77.5 x 53.5 cm (30.5 x 21 in).

RELATING SURFACES

Olwen Jones

While a student at art college I became interested in interiors as a source of material for my painting. From this base my future work as an artist has developed.

I try to paint the feeling of a particular space, be it a room, conservatory or passageway. Not tying what I see and feel to a single viewpoint gives me scope to construct the design in a more imaginative way. Much of my work is dependant on the observation of reflective surfaces, mirrors, windows and often the interiors of greenhouses. Conservatories are a constant source of stimulation to me, the sheets of glass give off light and illusion, constant change and mystery.

Collecting information in sketchbooks has always been my method of starting work. I draw my subject from various angles, getting to know the core of my interest. From these studies I develop the painting's composition back at the studio. I organise the paper size and palette, working within a limited colour range. I try to convey an emotional reaction to the subject and not paint literally. By starting to paint freely with large brushes or sponges I work in the broad areas quite fluidly. Sometimes I mask out passages using resist fluid and stencils, to leave a pattern of white paper. Part of this will be painted over later, but I always retain some white areas in the finished painting. The rather abstract beginning is then developed from my drawing reference; retaining a compositional balance is very important. Repeating shapes within the picture strengthens this.

In my painting *Night Magic* (see below), the circle containing the flower head, which is also a continuous curved shape, is offset by the triangular shape of the opening window. The crossing lines are repeated into the centre picture by the uprights and counterchange pattern of the blue-grey and white forms reflected on the window panes. This again contrasts the complexity of the curved shapes in the foliage around the flower circle.

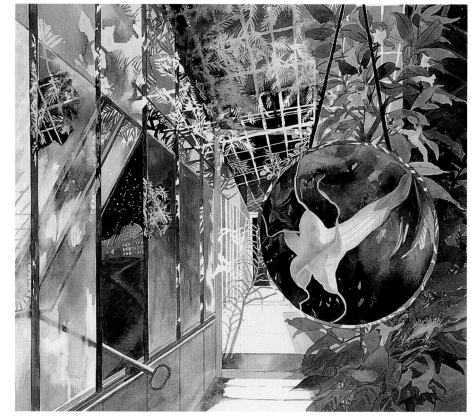

Night Magic (2000), watercolour, 44 x 55.5 cm (17.3 x 23 in).

CREATING DEPTH

Jonathan Cramp

For several years I have been absorbed in executing a series of watercolours of inshore seascapes and estuaries, particularly at early morning and late evening on calm days. This subject is absolutely right for my style and way of working.

Instinctively, I use a strong horizontal and vertical structure as opposed to a more flamboyant rhythmical one. The horizon, stretches of sand and water, breakwaters and masts of boats and even reflections are at hand for me to use. I have looked long and hard at Vermeer, who certainly knew how to use a geometric construction in his work.

Vermeer was also a master of organising shapes, including those between forms. I take great care in deciding on the area sizes of sky, sea and land. And in the same way the placing, direction and size of forms such as boats, buoys, ropes and shadows are of great importance.

I prefer using large relatively empty areas of sky, sea or sand, and play these off against the much smaller detailed ones of boats, etc. The large areas help to convey a sense of spaciousness.

Colour and tone are dictated by the light peculiar to the sea and the sea shore and go a long way towards giving an illusion of depth. This is of great concern to me because it contributes enormously to the feel of the picture.

I would like my pictures to be completely satisfying in their organisation so that nothing could be moved or changed without upsetting the balance. However, quiet static pictures can easily be dull (it is more difficult to sing quietly than loudly). But when a composition achieves this sense of order, it has a tautness and vitality of its own.

These are the contributory factors, coupled with the laying on of washes with assurance, but without slickness, which the work of Cotman has shown me. These things make my pictures what they are – though not completely. Along the way a little magic occurs. As Matisse is reputed to have said, 'The most important thing about a picture cannot be explained.'

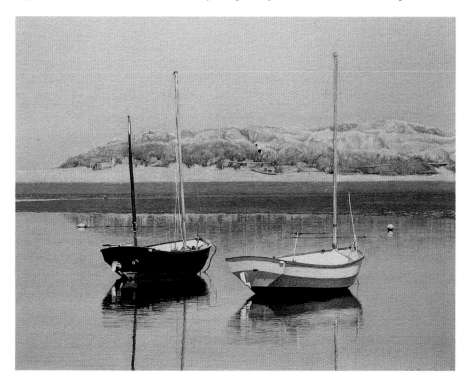

Two Boats, Newport (1997), 37.1 x 46.3 cm (14.6 x 18.2 in).

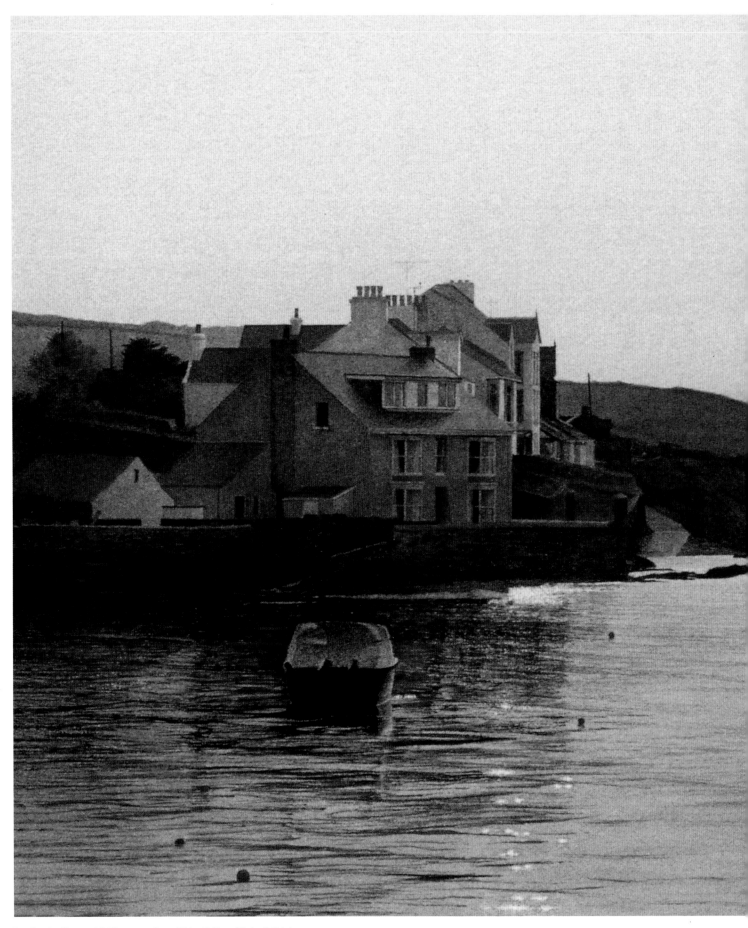

Late Evening, Newport (1993), watercolour, 34.6 x 61.7 cm (13.6 x 24.3 in).

USING COLLAGE

Trevor Frankland

Many artists in the past have created three-dimensional models of interiors and landscapes. These were used to fix an arrangement that otherwise might have been difficult to resolve. Poussin created models so that different lighting effects could be tried out for his figure compositions.

In working out ideas for my paintings, I combine drawn and photographic images fastened to thin card to create what could be called three-dimensional collage. This can help to bring to fruition strange combinations of images that can be more effective in creating a blend of things that we have seen and things we hope to see.

Although my approach is complex, the foundation for each work is a separate large Conté drawing based on the three-dimensional collage. This establishes the tonal contrasts over the whole surface of the composition.

The drawing is then photocopied to provide a number of A3 prints which form a basis for colour experimentation. Variations in colour are then used to help to create a mood and articulate space using warm and cool colour.

For the final piece of work I use a heavyweight watercolour paper, usually Waterford 638 gsm with a Not surface, as I prefer a tough paper that can withstand the scrubbing of the paint onto the surface with a hog hair brush. I do use a variety of brushes but fine pointed sables are indispensable for much of the work where detail is involved.

Once the basic composition has been drawn in, I tint the whole paper with a flat wash of colour and then establish the main tonal arrangement with a mixture of burnt umber, monestial blue and a small amount of black. This relatively monochromatic underpainting is commonly called 'dead colouring'. I then add other colour using thin glazes of paint, and to achieve a richer

effect I stipple areas with alternate layers of warm and cool colour. This stipple effect is one that J M W Turner used with consummate skill, creating subtle effects in many of his detailed watercolours.

When I believe the painting is finished, a coloured glaze may be applied to all or part of the surface to enhance the balance of colour in the composition and to maximise the effect I am trying to achieve.

ABOVE: *Museum Night Rider* (2002), watercolour and acrylic, 56 x 66 cm (22 x 26 in).
OPPOSITE: *Venetian Villa No 1* (2002), watercolour and acrylic, 36 x 28 cm (14.2 x 11 in).

WORKING LARGE-SCALE

Kenneth Jack

Australia is my birthplace and where I have lived all my life. It is vast in area and the most impressive thing is the space; it often seems overpowering. Subject matter for my art is landscape and architecture – natural and man-made forms, and it ranges over the whole continent.

Watercolour is my favourite medium. I believe it can be as powerful as any other medium and more satisfying to express my aesthetic aims, whether in small or large format.

My work is realist and depends on sound draughtsmanship. I believe one must continue to work outdoors on the motif to properly understand the large aspects and underlying rhythms of the landscape and forms in space. The feeling for the third-dimensional comes from this practice, not from the photographs which I also use as references when working in the studio.

I like the extra challenge of large works and have painted several watercolours measuring 3.7 m (12 ft) in width and many others that are 1.5 m (5ft), 1.2 m (4ft) and 90 cm (3 ft) wide. Sometimes these take weeks to complete. From my preparatory studies and references, I make several small alternative pencil designs; then comes a full-size cartoon on brown paper drawn in charcoal. On this I decide the final composition, making alterations and corrections. From the cartoon I trace an outline onto my 300 or 600 gsm watercolour paper, which for larger works is already mounted to board. I do not like working on unmounted paper which undulates when washes are applied. Brush sizes range from 12 mm (0.5 in) to 76 mm (3 in) flat and No 2 to No 20 round.

I am not a watercolour 'purist'; sometimes I combine watercolour with oil pastel, pastel, gouache, pencil, ink, sandpapering, scraping out, using masking fluid and working on coloured paper. My pictorial aims or vision require skill and sensitivity, but technical wizardry I try to avoid.

When painting, I aim to control the large important aspects of the composition and then attend to details (which must be meaningful and enhance the overall effect). An important aim is to obtain atmosphere, light effects and a mood without being impressionistic. Forms in pictorial space must be fully realised. Usually I invent colour and tonal schemes as I proceed; this gives a sense of adventure to the act of painting which is most important.

Tenacity Bog, Simpson Desert (1998), watercolour, 76 x 114 cm (30 x 45 in).

Highway Floodwaters, Barkly Tableland (2000), watercolour and gouache, 103 x 154 cm (40.5 x 60.5 in).

USING A FRAME

Karolina Larusdottir

I would perhaps describe myself as a figurative painter. Almost all my ideas come from Iceland, my home country. Iceland is amazingly beautiful with landscape that can be awe-inspiring. I tend to go back to my childhood and paint memories. I think back and walk into people's houses where I have been and go from room to room or into their back gardens. Sometimes I sit down and just look at some pictures or see something in a newspaper that sparks off an idea...

...and then sometimes an idea just sometimes just pops into my head uninvited – they are usually the best ones.

Another thing which is so unusual about Iceland is that it is a huge country with a very small population. It is a very daunting feeling standing in the middle of the wilderness; no wonder people were superstitious and believed in elves and all manner of beings in the landscape.

When I was growing up Reykjavik after the Second World War, it was like a world in microcosm. A small community where everybody knew each other and everybody was trying desperately not to step out of line. Then in a few minutes you could be out in the country with mountains all around and not a soul to be seen.

Iceland has changed out of all recognition now. It has moved with the times and prospered faster than most countries. So in a way the Iceland that I came from and visit in my thoughts does not exist any more.

I love imagining situations with people and intertwine the imagined world with everyday life. The simple everyday scenes where people are sitting around in ordinary domestic surroundings. There is always a drama lurking somewhere near. I love that.

I work the paintings up in many layers but find it very helpful to have a frame with glass and a mount that I can slip them into. A painting changes so much once it is under glass. Then I can see more clearly what still needs doing or where I have done too much, which is so easy to do with watercolours.

Receive the Holy Spirit (St John 20.22) (2000), watercolour, 70 x 100 cm (27.5 x 39.5 in).

As these are my paintings, I feel I can do whatever I like. I like putting angels and magical occurrences into the paintings and somehow they seem to fit in naturally. My angels represent something good in our lives – something good which we don't see or recognise because we are not looking out for it. If that were true, just think how many angels there must be all around us!

Very often I use black and white to bring out the colours. I use my memories of my grandparents' grand hotel, the Hotel Borg. My memory of the waitresses in black-and-white starched aprons and the waiters with the linen serviettes over their arm. When you entered the kitchens, through the steam you saw these huge figures of the cooks, all in white with their big hats, standing over vast steaming pots.

The Baker's Shop (2000), watercolour, 80 x 100 cm (31.5 x 39.5 in).

Mostly I make little sketches in a drawing book – usually very small ones to see how they work out. Often, when I start one idea it sparks off another. Almost all my ideas come from some place within me. I suppose they must be memories, probably childhood memories. But they come easily when I concentrate. Some years ago I mostly did still lifes. I really enjoyed putting these together and think I might start doing them again. I have never wanted to be a straight landscape painter, but who knows what I may do in the future.

I start the painting by drawing the image on the white paper with a very heavy metal pencil. Then I always do a very diluted wash all over the sheet. It just gets rid of the glare without losing the light at a later stage. Then I put down very dilute colours with a large brush. I feel it is so important to protect the light in the painting and not go too far. I know there are remedies like mopping up or using white gouache, but I feel it is never quite the same. I love gouache and its vibrancy of colour, but it is just a different method altogether.

I use large black metal pans with space for lots of colours. I only buy artists' colours in tubes. I fill up all the little compartments with different colours, although, thinking about it, I actually use very few of them. But they look nice!

DISCOVERING THE PICTURE

Michael McGuinness

Composition, in my experience, is not a first step but a continuing adventure which takes place throughout the making of a painting. There are many theories and ideas but no rules to rely on. For me, the process begins when I see something which interests me and only ends when, after the painting is finished, I cut two L-shaped pieces of white card to form a mount and move them around until the balance of the picture looks right.

In between comes a series of experiments, first (crucially) to determine my viewpoint in relation to the subject, then playing with contrasts and sympathies to establish colours, forms and balances: the search for order in a vast array of impressions.

When I decided to paint the red lamp (see opposite) which had been sitting around in my studio for some years, I knew I wanted to make a study in contrasts of colour and geometry, specifically red against green and circles against angles. The first step was to make a box shape (two sides and a base) and try various shades of green for the background. Next, I positioned the box between two light sources so that the lamp and the shadows made interesting geometric contrasts: circles to ellipses, curves to angles and so on. Then I began measuring proportions and shapes and drawing outlines with a fine brush before applying layers of diluted colour. As the painting progressed, more and more relationships of tone, form and texture were revealed.

Only when drawing the tree (see left) did I notice its similarity to diagrams of the blood vessels of the brain linking it to the spinal column, which led me to use an undefined background rather than the actual setting.

Over the years, I have come to realise that composition is a process of observation and discovery rather than an attempt to impose any preconceived idea or structure on what I see.

Winnold's Tree (2003), watercolour, 21 x 23 cm (8.3 x 9 in).

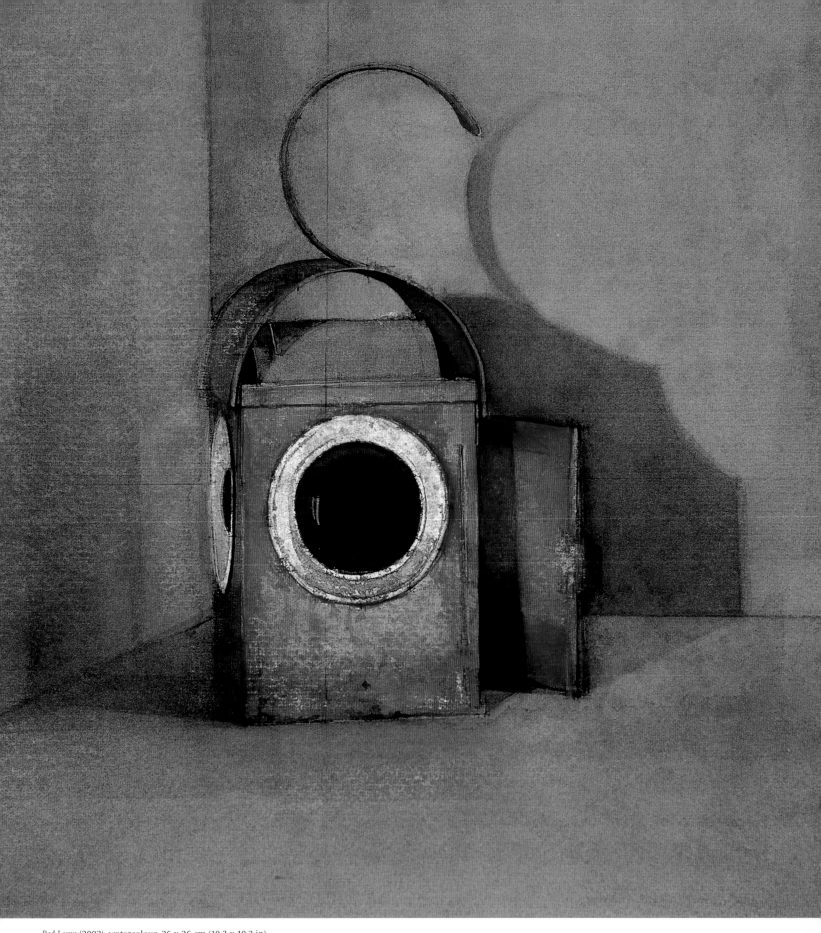

Red Lamp (2003), watercolour, 26 x 26 cm (10.2 x 10.2 in).

RESOLVING COMPOSITION THROUGH SKETCHES

Agathe Sorel

Watercolours are of primary importance to my work, feeding ideas into other areas such as prints and sculpture. Through observation, they provide links with nature, the essence of which can later be integrated into a more abstract or conceptual presentation.

Most of my watercolours are from Lanzarote, where we spend the summer. There, one can experience a unique intensity of colour and light, where the effects and conditions change dramatically throughout the day. All my watercolours are done on location, battling with the elements, the strong wind and sun, which can have stylistic consequences.

Initially, I make small diagrams or sketches, with pencil or crayon, so by the time I start painting the composition or structure is more or less resolved. I can then apply paint very boldly, with a large brush or a ball of kitchen paper, to capture the mood or overall effect. After this, I can zoom in and deal with the detail.

Previously I tried to finish the paintings on the spot, in a single session, but increasingly I tend to take them back to the studio, where I can reflect upon them in calmer conditions.

If the painting needs drastic change, it often ends up in the bath, where it can be thoroughly damped, or even scrubbed, after which tones and washes can be applied more liberally.

Figures are frequently added after this stage. They come from former studies, from the beach or other locations, and appear like mythical characters asserting an archetypal presence.

When the figures represent the main theme, and take up a large part of the composition, the method is somewhat different. The initial sketches of figures and landscape are assembled in the studio, and worked on under similar outdoor lighting conditions.

I often use collage methods in these compositions, experimenting with the scale of each element and trying out different ideas. I like to treat each painting as a new challenge.

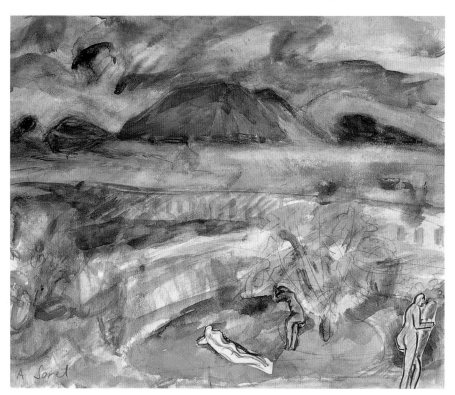

Birds Soaring over Red Ash (1987), watercolour collage, 45.5 x 57 cm (17.9 x 22.4 in).

FINDING A VIEWPOINT

John Newberry

If you work out of doors in front of the landscape, as I do, the composition, the pattern of things on the paper, is the first, the major, consideration. Any fragment of what you see has the potential for a painting.

My response to this myriad of possibilities is spontaneity. I do not fret over the best design, but when and if I see something 'asking to be painted', I sit straight down and work fast until the picture is done.

I allow no time for second thoughts – you might call it the Cartier-Bresson approach. I believe that the subject I see is better than one I might contrive or adjust; hence there is no moving about of bits and pieces, no leaving things out, and no trimming at the edges afterwards to improve the design. Everyone has an innate sense of placing; with practice this develops and strengthens naturally.

The two examples shown here (see below and following pages) were painted in the same harbour on consecutive days. They show the same group of boats drawn up out of the water for repairs but from different places on the same quay, about twenty-five paces apart. The tide is out in one; the other includes the long row of fishermen's sheds on the sea wall to the left. Each picture is its own composition.

I sit on the ground to paint, which gives an unusual, low viewpoint. In fact, finding somewhere to sit often determines everything. In these examples I was in the sun, which was not too hot, but in some countries it is essential to find shade. I also employ a wide angle of view, sometimes as much as 180 degrees, and this means it is essential to decide exactly where one is looking; if this centre of vision is established and held to (in both these paintings it is the small square white building), the perspective and the pattern fall into place together. The more the elements lie side by side on the surface of the paper, the better the composition.

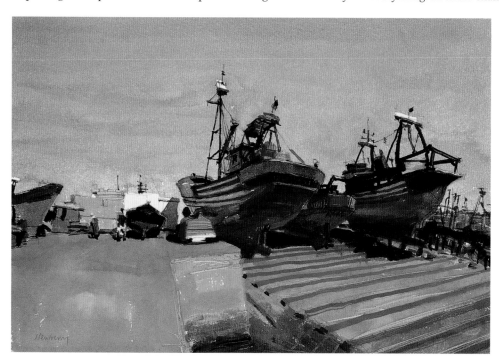

Fishing Boats, Essaouira, Morocco (2003), watercolour, 23.5 x 32.5 cm (9.3 x 12.8 in).

Composition

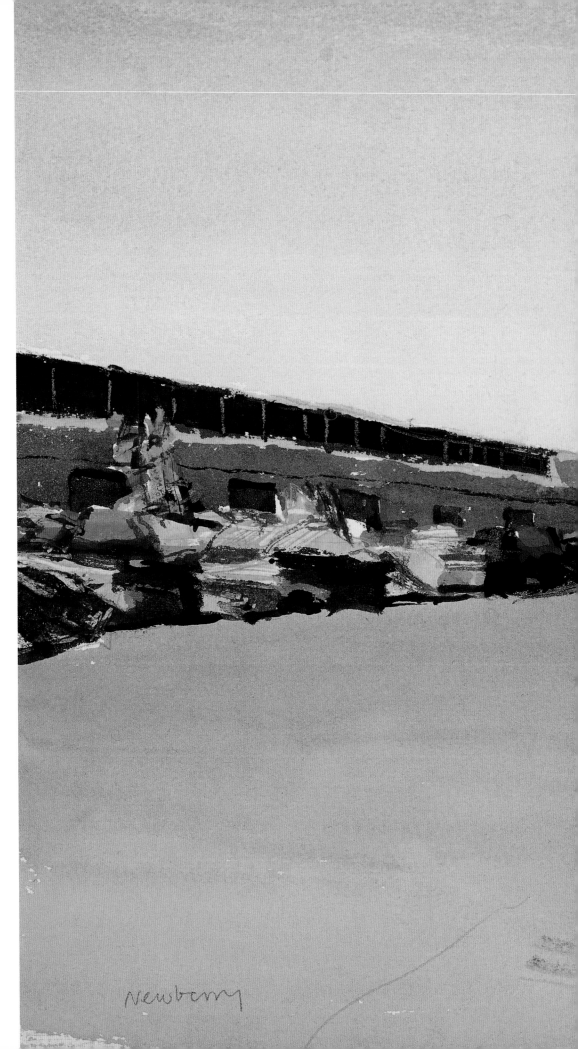

Quayside, Essaouira, Morocco (2003),
watercolour, 22.1 x 32.9 cm (8.7 x 13 in).

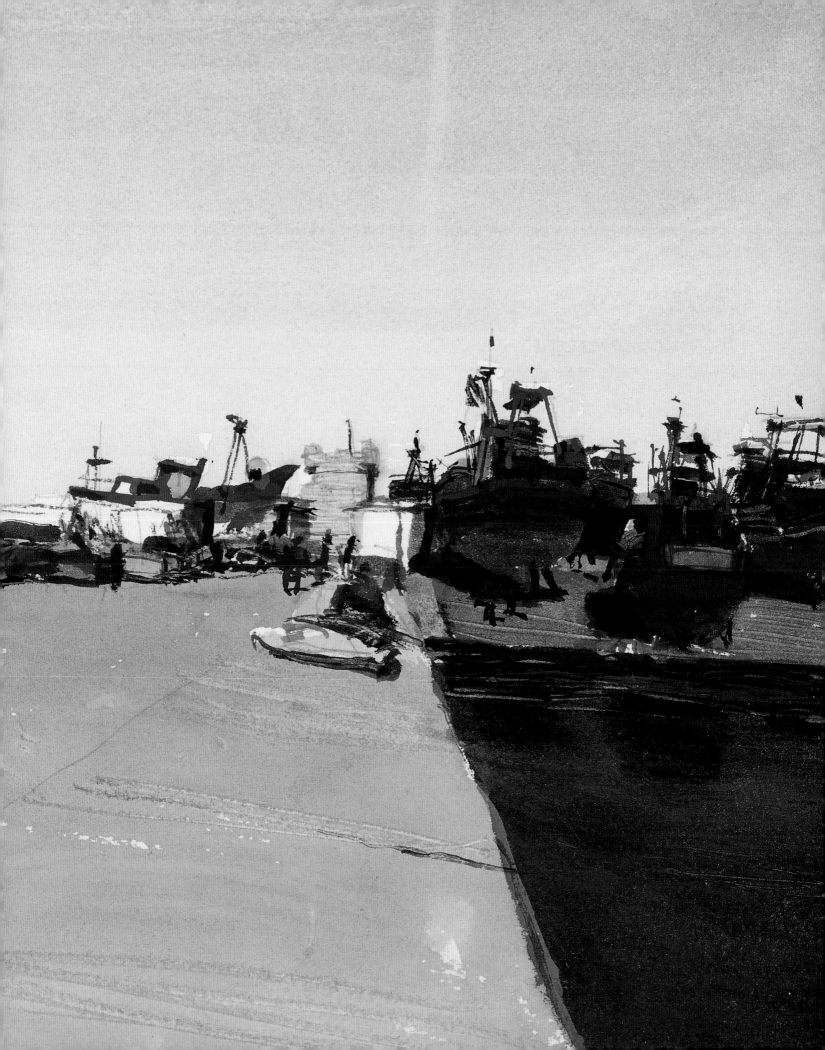

CREATING DISTANCE

Simon Pierse

I am very conscious of the long tradition of landscape in watercolour and, in the subjects I choose, I try to avoid what I would call a traditional landscape composition. Partly, that is why I am attracted to deserts, since on the whole they have few trees and often are quite flat. Therefore, the sense of distance I try to create has to be achieved just by placing objects in space and without recourse to traditional devices such as repoussoir (having a high-toned foreground).

Many desert landscapes have a strangely manicured, almost Zen garden quality about them; an environment where every clump of spinifex bush or prickly pear, every rock and pebble seems to have been positioned in the landscape with care and precision. Painting in such a landscape feels like being within a vast natural still life. *Desert Morning* (see below) was painted in the studio from photographs taken on a journey to central Australia. To open up the composition and bring the viewer into closer proximity with small foreground details such as pebbles and

bleached twigs, I made use of slides taken with a wide-angle lens and close-up photographs of what was at my feet.

More than anything, colour and light are my reasons for choosing a subject to paint – not just sunlight from a clear sky – but any unusual or striking effect of light or shadow. The thin, dry air in Ladakh, a Himalayan desert in north-west India, creates a brittle, magical light. Ladakh's landscape is very arid – a sort of buff colour – but occasionally enlivened with emerald patches of irrigation and the crimson robes of Buddhist monks. *Novice Gelugpa Monks, Tikse* (see opposite) is a painting about sunlight and the characteristic colours of Ladakh – my attempt to sum up a sort of visual essence of place. I used a lot of Naples yellow and some cerulean blue and cobalt violet for the background – all of them quite opaque watercolour pigments – on stretched, heavy Whatman paper. Rewetting the paper and some scrubbing with a housepainter's brush produced the back-ground, while the monks were built up in layers over a reddish brown wash, the highlights scratched in afterwards with a razor blade.

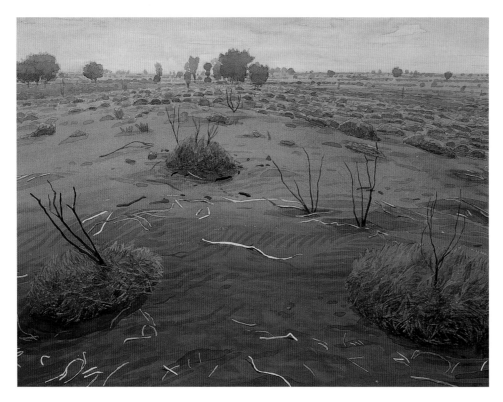

Desert Morning (1995), watercolour, 50.8 x 71.1 cm (20 x 28 in).

Novice Gelupga Monks, Tikse (Ladakh) (1998), watercolour, 38.1 x 55.8 cm (15 x 22 in).

REMOVING PERSPECTIVE

William Selby

My interest in drawing started as a child, but I did not paint until until my early twenties. My style of painting seemed to develop quickly and painlessly, taking the Yorkshire winter as my subject, working from drawings and painting somewhat in the manner of Sickert, though at the time I had no knowledge of this great artist's work. During the Sixties, a move into figure painting took place, with nudes, musicians, pubs and beaches.

This period continued until the mid-1980s, when my style underwent a dramatic change in the move to still-life painting to explore the use of strong colour. These still lifes are never 'set up'. Every flat surface in the studio is solid with a variety of mainly household objects: vases, bottles, pots, pans, plates, knives, etc. When a certain shape is required in a given area, an object of similar shape is chosen – though not removed from its place – and put down on the support as a starting point, to be developed as the painting progresses and often away from the original shape and colour. Many objects are recognised by their outline: a bottle, vase, mug, knife, etc, so can be put down in any colour that relates to the picture as a whole. A pear can be blue, an apple white, and so on.

The removal of perspective was very difficult for me to accept, but necessary to allow each object held within the frame to command equal importance and inspection, and by careful placing to open up a space to explore their relationship to each other, as in *Brixham Trawler Vigilance* (see below). The lack of perspective, with strong colour and tone makes a still life of a few objects into a powerful image. Having no wish to paint flat, like Matisse, I maintain depth and form. The mixed media of watercolour, bodycolour – that is, ground pigment with gum arabic solution – and acrylic also help in this, giving added texture. My colours these days are strong and powerful but not strident, and the removal of perspective allows reds, greens, blues and yellows to be placed in one image.

Fifty years on, I am still in the learning mode, but learning is knowledge; it is this continual discovery that makes painting so exciting and satisfying. It is what puts a spring in my step as I stride down to my studio in the early hours for another day to paint.

Brixham Trawler Vigilance (2001), mixed media, 76 x 91 cm (30 x 36 in).

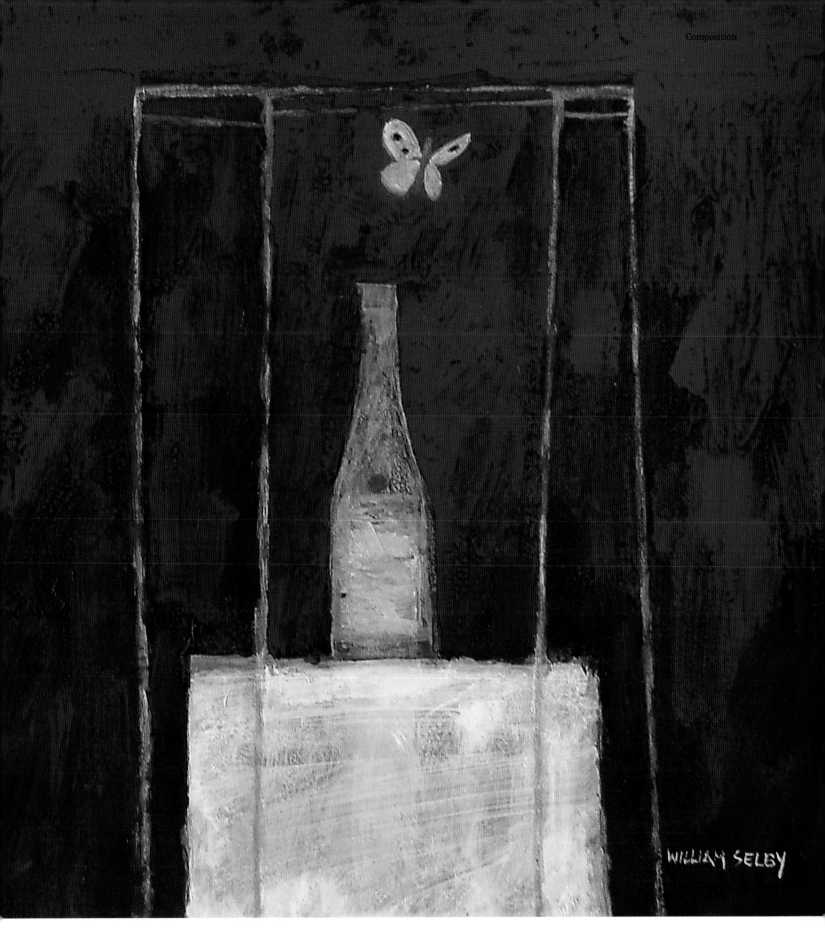

Caged Bottle (2001), mixed media, 86.4 x 86.4 cm (24 x 24 in).

LEADING THE EYE

Michael Whittlesea

I have very little idea of how a painting will look before I start. Subject matter is seen and noted. (In winter, I make small drawings and notes.) I try not to forget what it was that first attracted me to the subject. This can be very small – for example, the red handles on a wheelbarrow in a bleak winter landscape (see painting opposite). It can be as little as that. I try to avoid the 'grand' subject matter, such as a sunset over Venice.

My method of working usually involves stretching paper on five or six large boards. I almost always start by drawing in the main shapes and the general composition in pencil. Basic composition is important. If I place something in the middle of a painting, it has to be interesting. Putting the main point of interest a little off-centre is usually a safer bet, and makes a better composition. Horizons are better placed well above or below the centre of the painting. A picture divided up exactly down or across the middle can be unsatisfactory. I also try to avoid a composition that leads the observer across and through the painting too quickly; the eyes are directed to the left or right and then arrive at nothing. I want to engage the onlooker in travelling around the painting and making it worthwhile to look.

Drawing is so important. I try to adopt an uncompromising attitude, constantly reworking the initial drawing. It can change dramatically. I avoid using an eraser. It can damage the surface of watercolour paper, only too apparent when a wash goes on later. I like to see the first marks, and how they progress and change. It's a 'diary' of the work. There is also a delicate balance to be kept: if the drawing is too tight and detailed, the subsequent painting can become a 'colouring in' exercise.

I prefer the work to be logical. Hiding nothing, even mistakes, progressive and open to change. I feel then I can take risks with the watercolour in an effort to produce an image which isn't too predictable.

Having mapped out the composition, I work 'flat', going from board to board, allowing washes to dry before overlapping them with another wash. The water is changed constantly to avoid muddiness. I try to avoid 'overworking'. Working on several paintings has the advantage of coming to each board with fresh eyes. (I fiddle too much, and lose the plot if I concentrate on only one painting.)

There is also an element of the law of averages. If you start with six, there is a good chance one of them will work out well. I also feel that I can take more risks if I have more than one painting to work on.

Very often I reach a stage of feeling comfortable with a painting. It's OK but I always want to push it a bit further, in the hope of getting a more unexpected, interesting and unusual picture. There is a high wastage factor! But I think it's worth it, just to attempt to get something out of the ordinary.

The Garden in Winter (2002), watercolour, 43 x 57 cm (17 x 22.5 in).

Colour & Wash

COLOUR & WASH

Francis Bowyer

A knowledge of colour is fundamentally important for any approach to painting. Generally speaking, it is better to work with a familiar, if limited, range of colours and an understanding of how they relate and mix with one another.

An artist's selection can alter as time goes by, and as different locations dictate; the palette one uses will be very different for cold, northern scenery than for hot Mediterranean landscapes, for instance.

We cannot talk about colour and wash without referring to the paper it is to be applied to, as the quality and make-up of the paper will affect the success of a wash or any other application of paint. There are many quality watercolour papers which can have quite different characteristics from one another, from the materials used to create the paper, eg from wood pulp to cotton and linen, to the way the surface is sized, mostly with gelatine. These different constituents can have many effects, from the way the paint sits on the surface to its absorbency. Artists will find that, with trial and error, there will be papers with which they will be happy and others which they are uncomfortable using purely because the paper is made to a different recipe, or even just sized more heavily or lightly. Even the surface texture may affect an artist's response to the paper and its interaction with

the paint. Artists often argue the merits of one paper against another, but in the end it is a very subjective matter.

Colours can often be described as either warm (red, orange, yellow) or cool (blue, green, violet), both when they are used alone and when groups of colours are mixed together and applied as layers over one another. This is especially evident in the picture by Denis Roxby Bott (see opposite top right). He uses his fine drawing skills to combine the use of line and wash delicately and lightly so that the light surface of the paper comes through to play an important and intricate part within the overall image, giving a cool stillness to the painting. In contrast, David Whitaker's beautiful abstract image (see below left) conveys a warm sense of glowing, vibrating colour. His paintings are based on ideas using passages of light as the motif, eg candlelight or light from a window. He starts with the

preliminary drawing-up of lines. Then each line has to be completed in one go to maintain the fluidity of the watercolour, using brushes of the finest quality, to maintain the constant point needed for his precise work.

Space and shape within pictures can be created through the use of colour. This combination is shown well in the work of Sheila Findlay (see opposite right), whose well constructed still-life picture uses strong colours which bring objects to the fore, but also flattens them and uses space to convey a sense of pattern and balance.

One of the most exciting qualities of watercolour is the use of layers of colour over one another on the white of the paper. This utilises a transparency that can be employed to a greater or lesser extent. James Rushton's sensitive study of a head (see above left) has been built up with washes on a 300 lb paper and then washed right back with a sponge, a tissue, or whatever is to hand. He has then re-drawn and re-established over the same image using white bodycolour and a limited palette. This is often how this artist works, and in doing so he gradually builds the drawing and the tones, harmonising the picture.

Many implements can be used, such as a brush, a sponge, or a spray. Flat washes are often difficult to achieve as it requires the watercolour to be as fluid as possible in its application and applied generously to the paper. A tentative approach to a wash can result in an uneven, unconvincing patch of colour. It can be applied onto dry watercolour paper and can be moved across the surface with anything from a brush to a finger, blending the

colours with one another. The other way is 'wet into wet'. Here the surface of the paper needs to be dampened before the wash is applied (again this can be done with a spray, a sponge or a brush), and watercolour applied while the paper is still damp. Sophie Knight's powerful picture (see above centre), worked 'wet into wet', uses pure watercolour, with some bodycolour for highlights. She discovers the composition as she works, allowing her intuitive response to the subject to guide her. As the work progresses, each step dictates the direction of the picture.

OPPOSITE LEFT : *This beautiful abstract image by David Whitaker (see pages 136–137) conveys movement and light through the use of warm colours, and the juxtaposing of complementary colours to create visual vibrations.*

OPPOSITE RIGHT: *Sheila Findlay's still-life picture (see page 117) uses strong colours which bring objects to the fore, while also making use of the spaces to work as strongly in the design as the objects.*

ABOVE LEFT: *This detail of a head by James Rushton (see page 134) reveals a subtle and sensitive study built up with a series of washes.*

ABOVE CENTRE: *Sophie Knight's painting (see page 127) is a fine example of working freely wet into wet, using pure watercolour and occasionally bodycolour for highlights. Sophie allows her intuitive response to the subject to guide her to create a powerful picture.*

ABOVE: *Denis Roxby Bott (see page 108) uses skilful line and fine wash, allowing the white paper to show through, to create a delicate image.*

LINE AND WASH

Dennis Roxby Bott

I begin my work with a line drawing in pencil. At this stage the impression given by the image is necessarily fairly flat. Contrast and depth can only be implied by heavier or lighter marks and lines.

I enjoy applying washes at this stage because they can better express feelings and responses to the scene as well as giving depth and form to the subject. In the view of the Morris 1000 (see below), the slanting shadow on the back of the car was an essential aspect of the picture. Choosing the exact time of day, when the sun is in the right position, obviously becomes part of the planning.

Watercolour has always seemed to me the ideal medium to express the atmosphere of a scene. The change in intensity and colour caused by reflected light in a shadow can be so perfectly depicted by the dilution or strength which can be varied within a wash, and this is what largely gives a painting its atmosphere.

When I first viewed the hay cart in its barn (see opposite), I was unsure of the outcome of the picture I planned. It was quite dark inside the building, and unfortunately no wonderful shaft of light was going to come in anywhere to create an interesting highlight, but I felt it was too good a subject to miss.

The brightest part of the composition, which was the open doorway, covered such a small area of the picture that I was concerned not to make the whole thing a dark dirty grey, and I felt that the blue of the cart could easily merge into it. It was essential to find ways of

expressing the diffused light which made its way through the door. This made it necessary to concentrate on the shadows within the shade of the interior.

There was also light from a door on my left, so the upright wall on that side threw a shadow on the floor which helps to give depth to the scene.

These two examples show how every subject has different problems to solve and has to be approached differently.

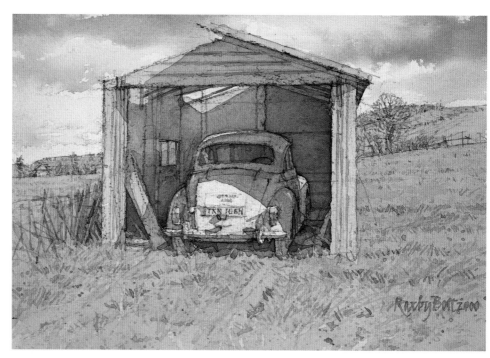

Morris 1000 (2000), watercolour, 16.5 x 25.5 cm (6.5 x 10 in).

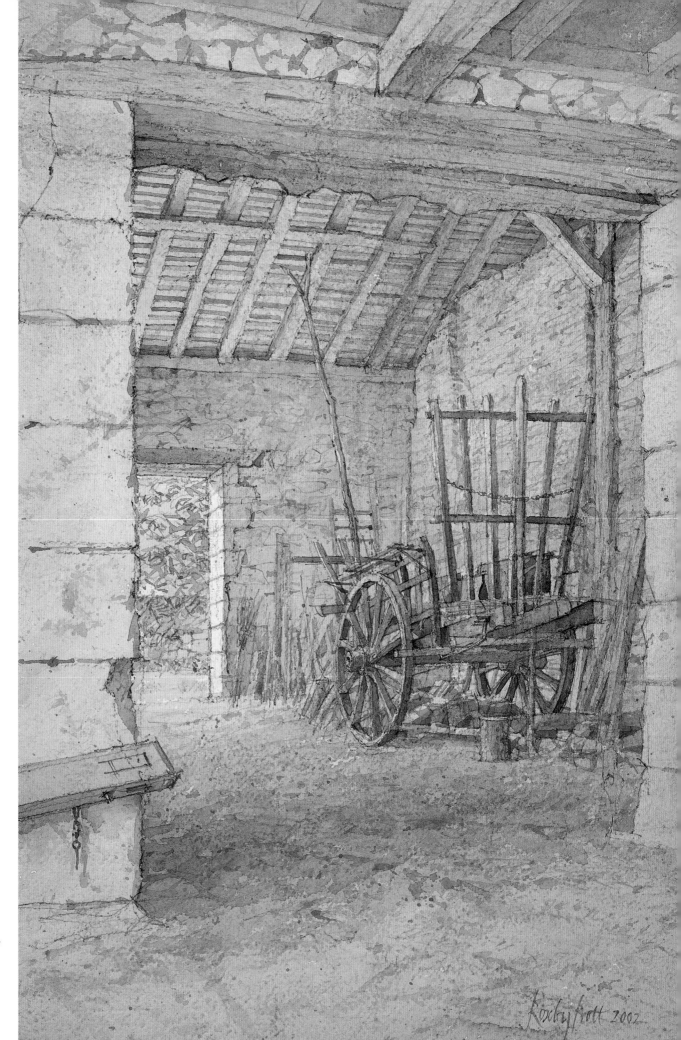

Barn Interior near Brantôme
(2002), watercolour,
51 x 30.5 cm (20 x 12 in).

LIGHT AND ATMOSPHERE

Francis Bowyer

I have always been fascinated by light and the part it plays in the atmosphere of the subjects I have chosen to depict. While observing the corner of my studio, I started painting pictures of the sunlight that filters in from a skylight window and moves across that part of the studio throughout the day.

Initially I made studies of the butler sink in the corner of the studio, trying to copy accurately what was before me, under-standing the shape of it as the sunlight fell directly down on to it at mid-morning. By late afternoon this light had progressed to the corner of the studio. What may be considered as a rather mundane subject slowly started to offer up a series of fascinating visual possibilities. Against this painted white interior, colour, structure and balance of tone became increasingly important. The less complex the subject, the subtler it becomes. I find that looking at the subject through small sheets of grey acetate (similar to half-closing your eyes, but more effective) eliminates the complications that colour presents and simplifies the tones.

I start work on five or six pictures at a time, using RWS Watercolour paper dampened and stretched tight as a drum with gum strip. Using watercolour from the outset, I draw with a fine brush, making sure I understand the structure of the shapes I am observing. I build up the intensity of colour in layers of washes (wash brush, sponge) on water-colour paper kept wet with sprayed or sponged water. I mix gouache white (bodycolour) with the watercolour to create cool or warm areas of light, occasionally using chalk pastels within the picture if necessary (or when desperate, to save it!). As my under-standing of the subject increases, the more I am able to let go and give a stronger and more expressive personal vision of the subject before me. In and out of abstraction; it's very exciting. It is a process that requires you to have a strong visual idea of what you want to say, but also allows you the freedom and space to change your mind in the process. In other words, it's a fine balance of intention and intuition.

ABOVE: *The Studio at 3 O'Clock* (2002), watercolour and bodycolour, 41 x 61 cm (16 x 24 in).
OPPOSITE: *2 O'Clock Summer Sunlight* (2002), watercolour and bodycolour, 37 x 28 cm (14.5 x 11 in).

WHITE GOUACHE WASHES

Jane Corsellis

I always find that the quality of light is a decisive factor when choosing a subject. I look for the angles the light casts and the patterns the shadows make on the surroundings, not only in still-life but also landscape subjects. In these two paintings, although very different in subject matter, the initial excitement was the same – the light falling in a special way.

The still life of the breakfast table (see opposite) was one of those subjects which I found immediately interesting and needed very little rearranging. I liked the delicate pinks against the dark background, counterbalanced by the fruit in shadow against the lighter rectangle. The subtle diagonals added to the strength of the composition. I painted this in one sitting. It needed very little reworking. I used a number of white gouache washes. These I am careful to dry completely so that I can lay colour on top. If the gouache is still even slightly wet, it will mix with the transparent colour and become an unattractive opaque 'sludge'. I used a paper called Turner Grey which has a very slight grainy texture. I have to soak and stretch it firmly onto a board in order to prevent it from buckling, but even so it tends to rise and fall considerably when laying on a very wet wash. This means that a lot of time is consumed drying the paper between washes. However, it takes gouache washes so well that it is worth the effort.

The winter landscape of Kensington Gardens (see right), with its almost monochrome quality, was particularly fascinating because one minute the subject was dull and grey and the next it was brought to life with a flash of creamy winter sun. In this landscape I used a fine-grained white paper, and unlike the still

life mentioned above I reworked considerably with a lot of sponging and washing out.

I like to start a painting with just a suggestion of the subject. I draw quickly using a very weak solution of a Payne's Grey, just line and wash. I like to build up the painting with loose washes, gradually increasing the strength and continuously redrawing with colour. Finally I bring in finer and sharper brushwork to define and strengthen the drawing and compositional accents.

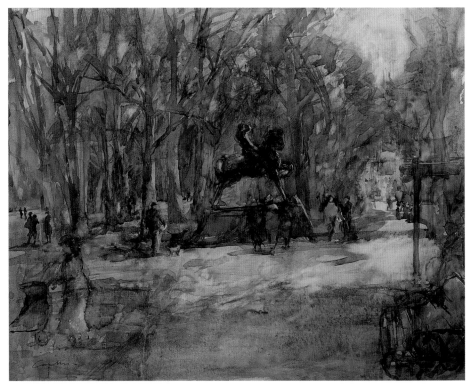

Kensington Gardens, Winter (2000), watercolour, 51 x 61 cm (20 x 24 in).

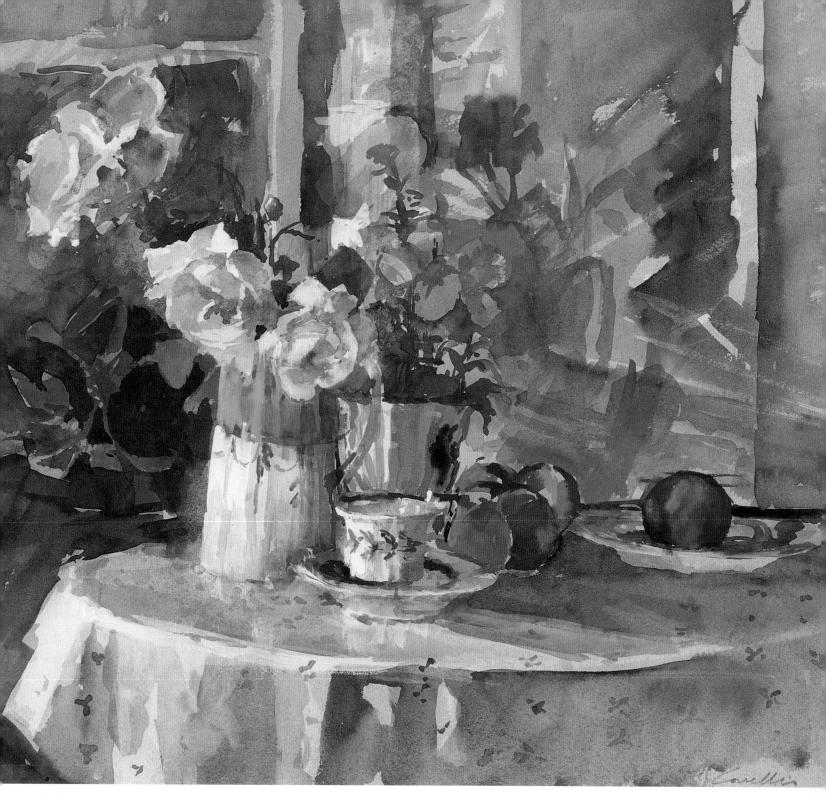

Pink Roses and Peaches (2000), watercolour, 30 x 38 cm (12 x 15 in).

LETTING THE COLOUR RUN

Catherine Ducker

Feeling, emotion and colour are entwined with the desire to use paint to express a reaction, a feeling, a moment of inspiration. I paint spontaneously, which means the marks are not planned.

The source of my inspiration comes from living and working in an environment which challenges me. Currently, I am living in the depths of an arable landscape and working with organic food production. I am deeply immersed in rural issues, and the love of nature, aiming to translate some of these fragile concerns into a two-dimensional piece of work.

I discovered the joy of watercolour after art college. It was very exciting to me to use a medium which is not widely used in contemporary painting. I intended to explore the potential the medium has for my personal painting language. Watercolour has great flexibility, a sense of transparency and purity of colour. I worked for a long time with wet paper, letting the paint run freely into the wet areas, working the painting more and more as it dried. Preparing the room before painting is for me like a religious ceremony. Everything is cleared away, with no colours to distract the eye. The pots, my clothes and the walls of the studio are white. Then I am 100 per cent focused on the painting and the experience, working until the painting is resolved. I work intensely with the image.

The first image shown here is *Field Line*, an abstract version of the landscape and field patterns which surround my home. Marks which are broad and marks which are fine give the rhythm, some areas appear soft and floaty and some are harsh, like the footprint of man on the land. Colour and

transparency is the main focus on this abstract. It is a small and intense painting.

The second painting is *Helenium and Verbena*. The composition evolved after a few sketches on small paper, then I start with the painting, enjoying the space in between the stems and petals and thinking light. The flowers painted, I grow, there is a connection between us. Sometimes they are painted while still in the soil, sometimes when freshly picked and sometimes when dying. I am inspired by Elizabeth Blackadder for clarity of image, the simplicity of the background, the focus on the flowers. I enjoy letting the paint run, the flowers have their own freedom on my paper. The colours must sing together, and this is my challenge, to find colours which create a tension and some a harmony.

Field Line (2001), watercolour, 30 x 40 cm (11.8 x 15.7 in).

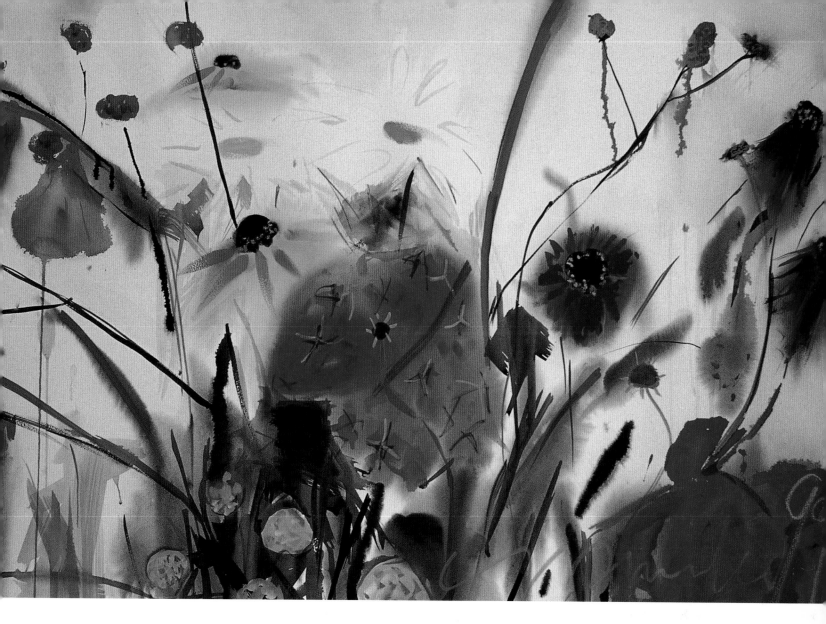

The third painting is *Souk*. This was inspired by my travels in Morocco, The colours I observered, patterns and light, layering of colours like fabrics. This picture to me was like a window into another world.

Without the support of fellow watercolourists, I would perhaps not have been such an enthusiast. But I really love it, because it is such a versatile medium. It is very instant, not too messy, although normally it gets in my hair and round my face where I put my brush to ponder a thought! Everyone should try it. Painting is a journey of expression and this is my tool.

TOP: *Helenium and Verbena* (1999), watercolour, 70 x 120 cm (27.5 x 47.2 in).
ABOVE: *Souk* (2000), watercolour, 70 x 90 cm (27.5 x 35.4 in).

LAYERING COLOUR

David Gluck

My landscape and still-life watercolours, whether executed totally before the subject or finished in the studio, are a translation and a transformation of things observed. I try to retain and develop the excitement of my initial response into the finished painting, concentrating on a sense of place and a particular moment in time, using coloured, layered washes.

I start a painting by assessing various parts of the subject colours and try to decide upon the first colours for the underpainting for each area. At this point the choice of colours cannot be based on any prescribed laid-down formula but on experience and hopeful anticipation. To me this uncertainty is where the real challenge and interest lies. For example, if I wish to achieve a green area in the final painting, I might start with with a wash of raw sienna, anticipating that further layers of blue or green might possibly follow to make the final colour. Usually washes are worked from light to dark with up to four applications in the darkest areas. After a few different colours are applied, I know the colour relationships will look crude and unrelated but I try to continue confidently, but on a knife's edge, until eventually the colour is resolved.

Because I work in a spontaneous, direct and energetic manner, it is of critical importance that the vigorously applied washes do not disturb and dissolve the dry underpaintings. To prevent the colour lifting off I use paper with a medium size content which allows the colours to sink in slightly. Most importantly I use a lightly applied large brush when making washes, as repeated touching with a small brush easily results in a mud of re-dissolved paint and a dead painting. The surface, weight, sizing and colour of papers, together with the range and transparency of colours, significantly affect the outcome of the painting.

Watercolour is sometimes referred to as being tentative, wishy-washy and 'retro'. I believe nothing could be further from the truth. While it can be frustrating, erratic and unpredictable, it is powerful, flexible and exciting. This all keeps my interest in a medium which is very much alive today.

Bella Vista, Petrognano, Lucca, Italy (1998), watercolour, 56 x 76 cm (22 x 30 in).

MINGLING COLOUR

Sheila Findlay

My painting is based around the themes of still life, landscape and interior that I render through a combination of observation, memory and imagination. I find my inspiration around me in the familiar objects which I have collected over the years, in my home environment in Kent, and the landscape of Scotland where I grew up.

I love the richness and fluidity of watercolour, the spontaneity it allows, and the way one can draw the brush – establishing the rhythm and balance of the composition. I also like its flexibility. At Edinburgh College of Art I was taught watercolour and still life in the Scottish tradition. John Maxwell encouraged me to work freely, in a poetic and lively way, washing out and plunging the entire image into watercolour if necessary. William MacTaggart taught me to lay watercolour directly onto the page, letting the colours run and mingle with each other. This inspirational teaching, and my subsequent work in stained glass and mural painting, still informs my approach to watercolour and my choices regarding colour, composition and scale.

I begin each painting with a freely painted, full-scale 'rough'. This method of working out the colour and composition enables me to attack the final image in a direct way, working on the ground with bold washes of colour. I mix up plates full of pigment, and attack the image rapidly. When it is dry, I place it on an easel. I take great time to contemplate and consider the design of the image, making adjustments to the colour, shape

and placement of the objects to provide rhythm and mood (see *The Kitchen Table*, left). During the process of painting I may move from my initial point of reference. I make changes at any stage in the painting, by sponging out, or by adding entirely new elements. In *Still Life with White Tulips and Onions* (see following pages), I applied a rich dark wash to the raw sienna of the table's surface to give greater anchorage and enliven the image in its final stages.

ABOVE: *The Kitchen Table* (2002), watercolour and acrylic, 71 x 102 cm (28 x 40 in).
FOLLOWING PAGES: *White Tulips and Onions* (2001), watercolour, 61 x 94 cm (24 x 37 in).

Sheila Findlay

A SYMPHONY OF CHROMATIC GREYS

Tom Gamble

Having developed as an artist at the height of the Neo-Romantic movement, country houses and ancient churches were my initial interest, but these quickly gave way to the imagery and environment of my own birthplace, which was an industrial town in the North-East of England. Docks, steel-smelting emporiums, small streets of dusty plum-coloured brick, gin pavilions, Wesleyan chapels and corner shops displaying strident public lettering were all around.

The atmosphere was always menacing but at the same time compelling and so I became a committed spectator – a voyeur repelled by what I saw and yet totally absorbed by it. Within this downtrodden and shabby world of greys I discovered another world of colours of great subtlety.

Basically, I never quite understood the artistic game plan so I was compelled to make up the rules as I went along which, in the end, gave me unbridled freedom. In any imaginative work, the initial stimulus comes from whatever one is looking at. In my own case, I put together both drawn and photographic records, using them as reference. The compositions are then developed through drawings kept in a large sketchbook.

In the painting illustrated, a back lot in the St Pauli district of Hamburg, I was drawn to the broken-down nature of the mobile dwellings in front of me and the raw colours applied by the squatter inhabitants, set in contrast against a background of fairly genteel and ordered houses. It was a visual explosion slightly softened by nature in the form of the tattered remnant of a shrub, the scene being covered by a glowering November sky.

Practically, I use pure watercolour. As a medium, it adapts perfectly and produces passages of sublime expression I could not achieve in any other way. In quite a lot of my industrial paintings, watercolour produces the sort of silk-like mistiness which is ever-present in late autumn and winter. Washed-over washes, a form of glazing technique which can only really be produced in pure watercolour, create depth and subtle colour variations – a symphony of chromatic greys. This can be seen here in the over-washing of the buildings behind the temporary dwellings.

ABOVE: *The Washington Bar* (1995), watercolour, 38 x 52 cm (15 x 20.5 in).
OPPOSITE: *The Washington Bar* (detail).

COLOUR AND MIXED MEDIA

Janet Golphin

Pure watercolour is a constant challenge, but if you add other water-based media to it, each with its own individual reaction to a paper-based support, then all manner of interesting portals open. Painting is not just about what I see so much as what I feel. Creating mood and depth with an inner vision, so that a painting becomes something far beyond the obvious, has its own fascination and challenge; this is the objective I seek.

Using colour with a mixed-media technique has become a magnetic impulse, which enables me to push my own boundaries, taking my work to another dimension.

Using strong colour composition does not necessarily mean using bright colour, but colour which 'sings' and gives the painting a magnetic glow, capturing the viewer's gaze until the arrangement of objects is acknowledged and considered.

Attention then focuses on the craft of the painting as the eye fixes on how it is put together, how the painting makes it work.

Acrylic paint, dried between washes, gradually builds up the intensity of colour and becomes an ideal ground, sympathetic to additions of juicy watercolour paint, gouache or basic dried pigments, which artists' quality paints are made from.

Brushstrokes of paint, often held as they are laid or randomly dispersing in an erratic reaction, find their own level and create an unusual illusion of texture. This ad-libbing with paint is almost the key player, adding the fascinating secret ingredient which places subject, composition of shapes and colour, often in a gentle and unassuming way, into a state of completion which needs nothing more.

Creating mood and attitude with the collaboration of colour and mixtures of paint makes my adrenaline 'zing' so that every painting becomes a wonderful adventure. The paintings hold a story to be told by the viewer. *Lily between Daisy and Lavender* (see below), with its tongue-in-cheek humour, is sumptuous and sensual in colour and texture, while *Cherries on a Plate* (see opposite) is simple and uncomplicated, holding the gaze and drawing you into a meditative state, ethereal and undimensional.

This is my fascination with colour and mixed media. The possibilities are endless.

ABOVE: *Lily between Daisy and Lavender* (2002), mixed media, 76 x 81 cm (30 x 32 in).
OPPOSITE: *Cherries on a Plate* (2002), mixed media, 91 x 71 cm (36 x 28 in).

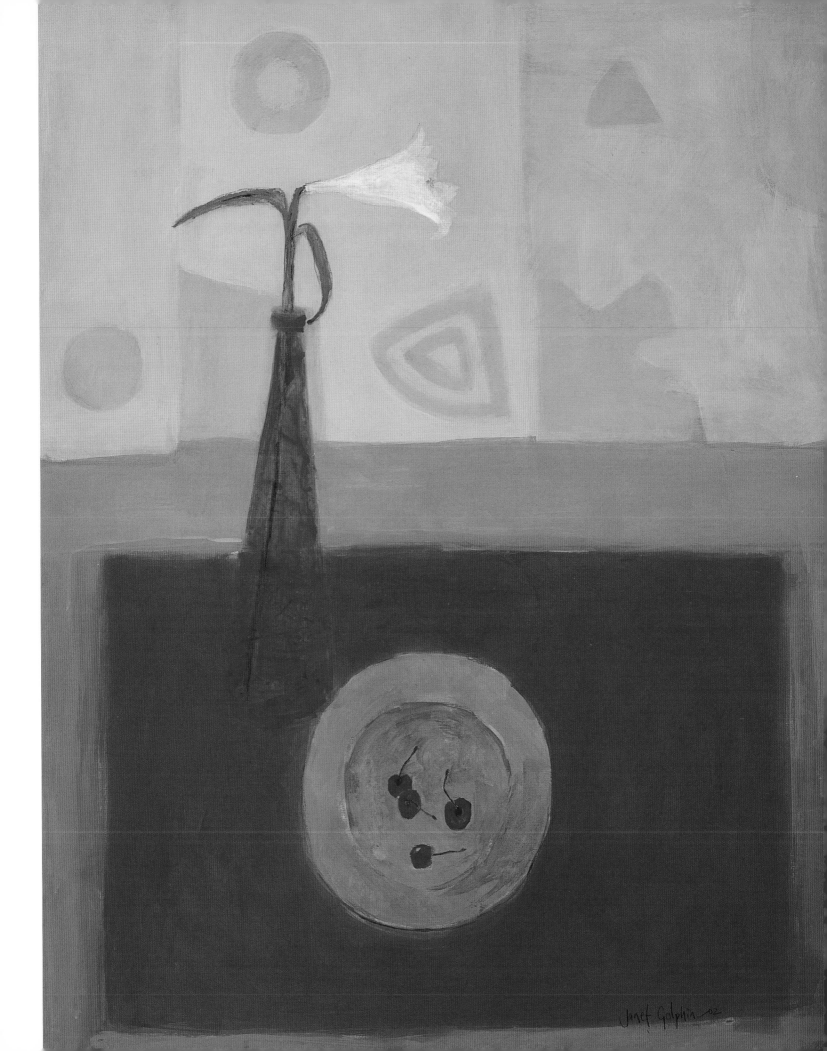

BUILDING COLOUR

Sarah Holliday

My work is all about hidden depths, and layers of time and meaning, in the urban environment. Cities are constantly in a state of flux, with buildings going up and being pulled down. Through this process, layers of the past and of our own time are revealed and hidden again, and we become part of this as we move through the city.

I go out and draw things on building sites and in scruffy corners, or the hieroglyphics and scars left on the roads. Everywhere, there is something to see and to draw, though it is not necessarily a full, topographically detailed drawing that will result. What I am looking for is an accurate, often brief note of something that was very exciting to look at, and that I might use later in a painting. It is the looking at and seeing these small details, and understanding how they all go together, that is important, not the warts-and-all portrayal of a building. I am using the bricks and mortar to stimulate new ideas of how I can put things together in a painting. To me they build a portrait of a place that is every bit as real as using the whole scene in front of me in a conventional sense.

The way that I paint reflects these thoughts. I will start with a fairly well-planned tonal drawing (which may or may not change quite a lot as the painting evolves), but with no idea of how the colours will work out. That is a battle for later. I work with many, many layers of paint, some transparent and some gouache used in a semi-opaque state. I start off with a set of possibilities for colours. Once these are down, I can begin to make decisions, and build colour on colour, gradually carving out the shapes. I move freely between hues and degrees of opacity, allowing the colours on the paper to develop a richness, a sense of not quite knowing where one colour stops and another starts. This way, some of the sense of ebb and flow of the subject can be injected into the painting. There are layers of paint, layers of things represented or suggested, layers of possible interpretations. That keeps you guessing, and I like that.

ABOVE: Drawing for *Day Out in Oxford Street* (2002), pencil on paper, 19 x 13.5 cm (7.5 x 5.3 in).
OPPOSITE: *Day Out in Oxford Street* (2002), watercolour and bodycolour, 47.2 x 31.3 cm (15 x 12 in).

ESTABLISHING A MOOD

Julie Held

I choose a subject because I am attracted to its colours and shapes and the emotion it suggests to me. Having selected the the subject, I proceed in the following way:

Firstly, I work with broad washes to establish the relationships of light and dark tones and colours. I define these washes by looking at the shapes they suggest to me and refine them in my mind's eye before placing them on paper. The mood of the picture is now established using tone and colour.

Secondly, I begin to narrow these broader washes by next working with smaller shapes, which defines the 'drawing' whilst further depicting the atmosphere and mood. For example (see right), by establishing the table inside and the balcony outside, the space is 'made' and the basic shapes and planes arrived at.

Thirdly, I depict the pattern that the trellis and its growth make and further develop the drawing, the vertical plane of the trellis and the rhythm of the vine and ivy. Also, by selecting a few of the pattern shapes in the tablecloth, I fix the plane of the table (its surface) and create a further set of relationships: this time between the decorative and the structural, which helps to make the painting's rhythms.

I further suggest an atmosphere by a presence through the shadow cast on the table, and at the same time continue with all the elements mentioned above: colour, tone, vertical to horizontal, surface, pattern and rhythm, hoping that the painting finally gels together. To use a metaphor which sums all of this up: imagine a drawstring shoe bag. My process is like closing this bag until it is closed tightly and its contents are all inside.

In the Night (2003), watercolour and gouache, 33 x 22.5 cm (13 x 8.9 in).

WET ON WET

Sophie Knight

I work directly from the landscape or cityscape, working in situ, and my paintings convey a direct response to the excitement of what I am seeing, hearing and even smelling.

I use watercolour in a fairly physical and energetic way. I like to keep the paper flat when working wet on wet, and therefore work on my knees, leaning over the paper placed on my upturned portfolio. By spraying the paper with a mist of water first, then squeezing from tubes of paint directly onto the paper, I can start the painting in a speedy and urgent manner, making compositional decisions quickly and usually without any previous drawing. I like to discover the subject in my paintings, drawing by moving the paint around, and constantly keeping the image on the move. I am able to do this by respraying with water and therefore keeping the image 'unfixed'.

A lot of my recent work has been inspired by the subject of water. *Moonlit Bay, Ardnamurchan* (see following pages) was painted in Ardnamurchan, a magical place on the west coast of Scotland. I painted the bay many times, in different light, but this view was inspired by moonlight. As in much of my work, I have used a small amount of collage: sand and broken rose petals create small notes of vivid colour, adding interest to the foreground.

Following a painting trip to North Wales, I began a series of paintings in the studio based on the waterfalls I had visited. In my painting *Force* (see right), I tried to convey the sheer physical force of the water splashing onto the rocks beneath. The subject of water allowed me to follow my natural empathy for abstraction and inspired a series of very large watercolours worked in the studio from a roll of paper.

I am constantly inspired by new places and images, but mostly I think my motivation comes from within myself and my ongoing involvement and commitment to the act of painting. My paintings are of places, but hopefully are not anchored or catalogued by the place, and convey a more personal vision in which mystery, mood and suggestion play a large role.

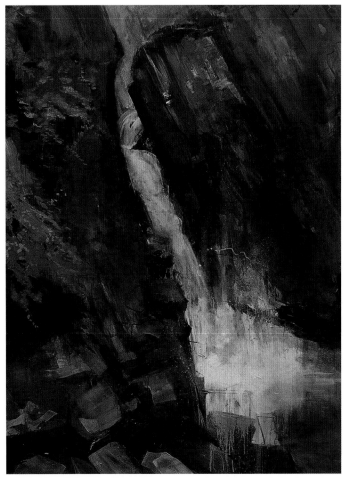

Force (2002), mixed media and collage on canvas, 214 x 148 cm (84 x 58 in).

127

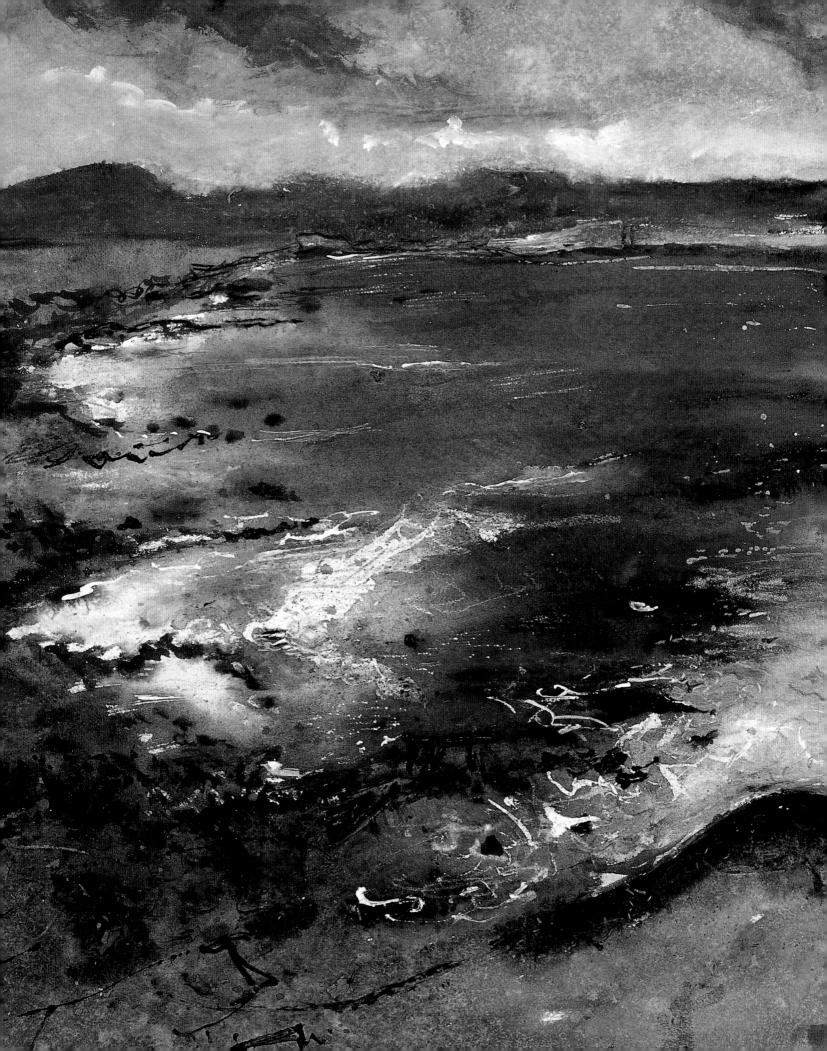

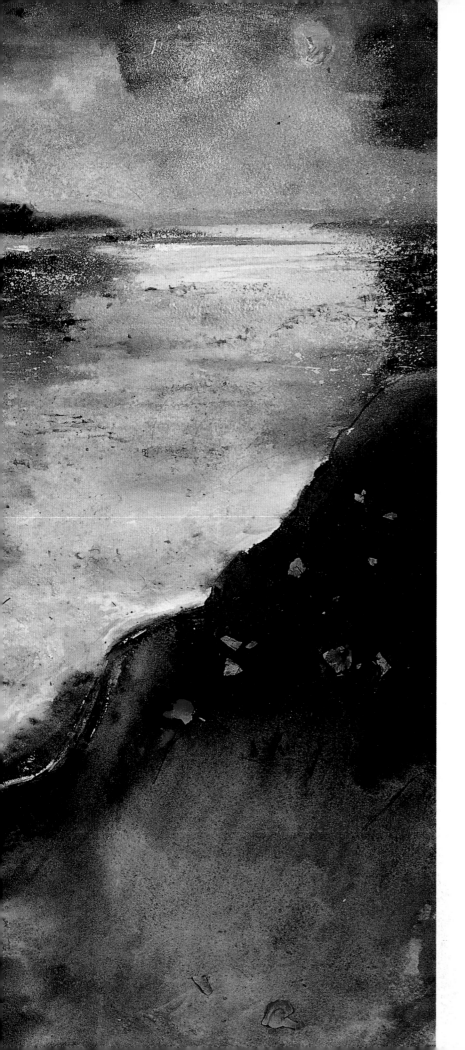

Moonlit Bay, Ardnamurchan, Scotland (2002), watercolour and collage, 56 x 76 cm (22 x 30 in).

COLOUR AND TONE IN LANDSCAPE

Alison C Musker

Rhythms and shapes that create a landscape are most intriguing, and it is one's own interpretation of this that is so beguiling. With just a few lines, jot down your ideas by making simple maquettes and sketches, you can then extract and abstract from them the foundations of a painting.

In the words of Henri Matisse: 'When I have found the relationship of all the values, the result must be a living harmony of tones, a harmony not unlike that of a musical composition.' With drawing comes tone. Tone is derived from the Latin word *tonus*, meaning a stretching, as in variations of lightness to dark. Look through half-closed eyes and you will see the relationship of tones more easily. A close-toned work can give an air of mystery and intrigue.

Hills are a source of unending facets and textural surfaces. In the Himalayas, the clouds in the wind make racing shadows that create swift lights and darks, capturing the atmosphere of the mountains. Chiaroscuro is the art of arranging the light and dark areas to produce an emphatic effect. Contrasting tonal values help to give a painting depth.

Take the eye for a stroll through the landscape, a journey up into the far distance. Sometimes a light graze of a shadow, brushing the surface of the ground, will catch onto the vertical thrust of a foreground rock, thus joining and unifying a part of the composition.

Colour in the design can be used to create a feeling of depth and to make a painting appear three-dimensional. Warm hues tend to come forward whereas cool colours recede, going back into the distance. Colours become paler and duller and objects less defined as they recede into the background. The luminescence is closely linked with aerial perspective. Complementary colours are mutually enhancing, that is, any complementary pair of colours has the effect of intensifying the other. It is the colour around an object that makes it sing out.

The Distant Hills (2003), watercolour and gouache, 58 x 77 cm (22.8 x 30.3 in).

The main inspiration for painting is light, and this is ever-changing. The early morning and during the evening, when the light is lower, striking the edges of the ploughed fields and trees, and when stonework shows its texture in raked light – these to me are the times to cherish.

In *The Distant Hills* (see above), I laid on a dilute initial wash of raw sienna with additional warm or cool tones. Then I mixed french ultramarine and violet for the far distance and raw umber, cadmium yellow pale and burnt sienna for the foreground. Purple madder was added later. A restricted combination of colours is aesthetically pleasing to me.

COLOUR AS EXPRESSION

Ann Wegmüller

Colour is very important to me. It is probably the subject of my paintings. The painting itself starts from my feelings for a particular place, and the colour is the mood. It is like music: different sounds are like different colours.

Each colour has its own beauty and strength but can be enhanced or toned down by another colour. The excitement for me comes from doing the unexpected with this. To put down a loaded brush of cadmium red, then sharpen it up with shapes in pale magenta, or paint some cool dark yellow and put beside it some warm pale blue instead of the other way round.

The painters I get a real buzz from are Matisse, Nicolas de Staël and Richard Diebenkorn. The Matisse exhibition in Paris in 1993 liberated me from any literal translation and gave me the courage to put colour down as I felt it should be and not as it was. This way of working makes me an intuitive, expressionistic painter, which leads to the difficult question of composition or structure. It took me some time not to be colour-drunk but to get my act together and compose, which for a while made me think I had lost my new-found freedom. To find out about underlying structure, I had to make black-and-white photocopies of paintings that I knew spoke to me through colour alone. This was a fascinating process and taught me that a little discipline in life is no bad thing. Also, if I was clever enough, I could ignore the Golden Section and other long-standing 'rules' about composition, and try to make my paintings harmonic or edgy and disturbing through my own composition.

The subject of my paintings is what I have seen, the land around me, the land beside the sea, and weather conditions upon it. They are about a kind of place rather than a partic-ular place. They are generally not figurative and any hint of human habitation comes from the shape of a building, boat or pier rather than the shape of the human figure itself. Above all else I try to communicate to others my feelings about what I have seen.

Summer Estuary (1999), gouache, 54 x 76 cm (21 x 30 in).

EVOCATIVE COLOURS

Jenny Wheatley

To some people, music is the source of all emotive response. For me, colour is all-important, or rather the relationship between colours. The layering and history of colour, one on another, or one next to another, is a constant reason to produce imagery and a constant reason to repaint the same subjects.

In these two paintings of Mas Gouge, colour has been used quite differently. In the view through the trees (see opposite), I have tried to reproduce the colours that I see accurately, bearing in mind the strong form of the building, and the way that, whilst still in shade, it appears to be so much warmer than the patterned tree trunks in front of it. I have left the sky blank so that one concentrates entirely on the subject in its space, and because the weather whilst painting it was quite mild and the light diffuse. It is, in a way, a drawing of discovery of the subject in its environment, a passage of looking through which I have been able to start to assess and see the reason to continue, the way to manipulate colour to a particular end in the future.

In the other view (see below), I have moved to the other side of the building and painted the elongated shape looking through the maison d'entrée. I chose to change the viewpoint because I was interested in looking at the building in its simplest form and from a viewpoint where the trees did not create a spacial element. I also liked the format of a small square inside the rectangle that the entrance gave inside the whole wall. In terms of colour, I feel that this is a much hotter and more complete painting. I underpainted the sky in a deep vermilion nearest the horizon and a slightly cooler rose of the same strength as it moved higher into the air. The building was underpainted in rich oranges and ochres, also aiming at an underlying glow in what had by now become a much hotter climate. By overpainting the sky in an opaque series of blues, I felt that the heaviness of the French summer sun pushed down better into the buildings and cut them out of the landscape. The heat always makes the sky seem to me more solid than specific forms, and making it more opaque than the buildings adds to this idea. I left the red underpainting of the sky as it approached the horizon line in order to add to the shimmer of the heat, and painted the areas of opaque blue roughly so that the red had a chance to show through and influence the finished colour balance.

Because this image was largely to do with the flattening of space and the saturation

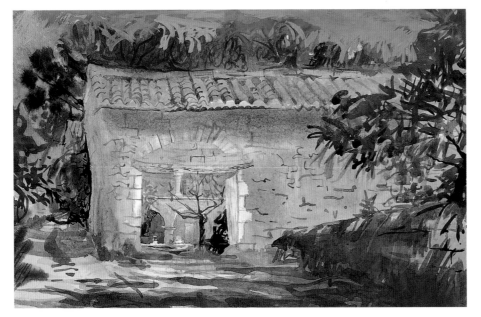

Maison d'Entrée (2003), watercolour, 33 x 48 cm (13 x 19 in).

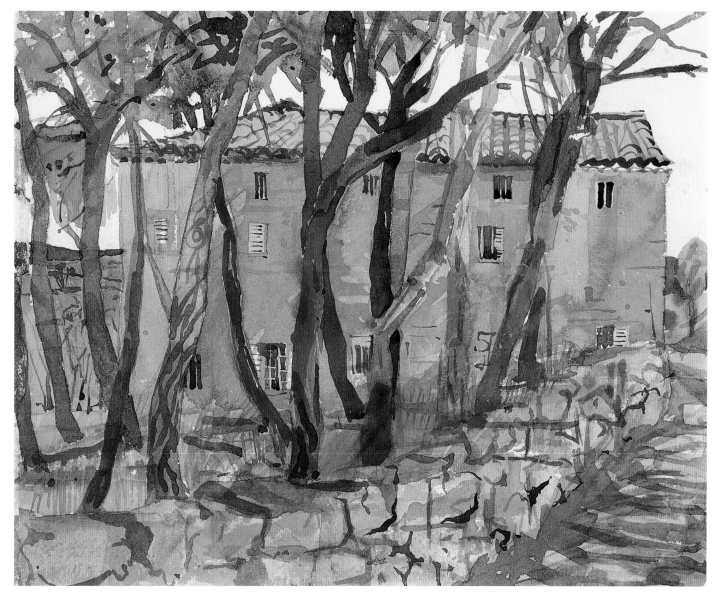

Mas Gouge through the Trees (2003), watercolour, 27 x 32 cm (10.5 x 12.5 in).

of emotive colour to give the viewer the feeling of the design element in this hot environment, I felt it necessary at the last moment to deepen the shadow in the foreground in order to push the eye into the building in its mathematically pleasing space.

It is important for me that the subject emerges out of the method of painting and that links and rhythms are formed.

From looking briefly at these images, hopefully we are brought back to the opening statement about the effect of music being akin to my response to, and love for, colour. The rhythms created could be compared to musical statements, or to poetry that interlinks and resonates. This, at least, is my reason for continuing in the endless and frustrating struggle for a colour that might one day evoke a response similar to that felt by people who listen to notes and relationships of music, and cannot help but be moved.

WORKING WITH TONALITY

James Rushton

When I was a ceramics student at the Royal College of Art, my Professor thought a stint in the Painting school would be of benefit, and when I presented myself to Percy Horton he could see that I was a rank beginner and allowed me only to paint from black, through greys to white. Although I did not think so at the time, I now think of it as one of the most rewarding periods of my painting life.

Since then I have had a particular liking for close harmonies of tone and colour and an aversion to strong colour and violent contrast, especially when it becomes visually incoherent. I recognise that there are dangers here, and because of the seductive nature of watercolour I have to be on my guard. I remember a music critic, a passionate Wagnerian, once described the music of Delius as 'pink blancmange'. Sometimes I feel the same way about my painting, but not for long, otherwise I would not continue.

For me, watercolour is an ideal medium for responding to fugitive and momentary sensations, especially those remembered from childhood, and occasionally relived. Trying to interpret these sensations is difficult. One cannot disentangle tonality from the other qualities which go to making a painting, but it is central to my work and my attitude to painting in general, and I find that *close* tonality generates a sense of stillness and extreme subtlety of value.

Whilst there are many examples that one could quote, the work of painters like Chardin, Giorgio Morandi and Peter Greenham spring to mind. Disparate as they may seem, they all have the quality I am trying to describe. It is claimed, rightly I think, that talking about one's own work is difficult, because so much depends on intuition, but intuition is more than just feeling; it is dependent on learning and our own past experience, and that, at the end of the day, is all we have.

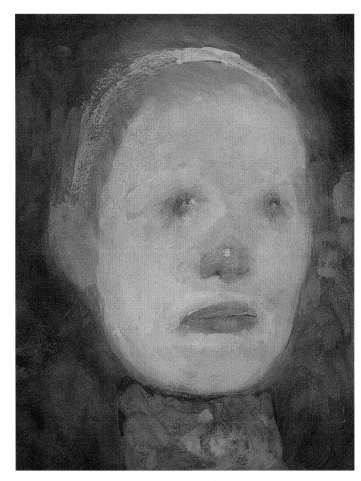

The Mime Artist (1994), gouache, 28 x 21.5 cm (11 x 8.5 in).

COLOUR AND ABSTRACTION

David Whitaker

There is a strong element of conceptualism in how I go about creating images. But countless experiences throughout my life have made their contribution and will continue to do so for as long as I live. It intrigues me to pause every once in a while and try to put into words this odd activity of ours. Endless hours of putting colour onto a surface in quiet solitude with a dog watching your every movement and the sound of Beethoven coming from the radio.

All the while there is the physical act of controlling the hand and eye, and the difference between horizontal, vertical and diagonal movements, whether used together or separately. I turned my back on the world as it is seen by the photograph or the movie film in the early 1960s, and believe there is another world of images that comes from inside us, as with Mark Rothko and what I believe Turner was moving towards.

Colour theory is also a strong element in my thinking. I am a studio-based artist who works best first thing in the morning. I see myself as a composer, colours being my keyboard and media, the instruments through which I embellish ideas and create meaning. I often refer to the studies of colour in nature by Leonardo, Goethe, Ruskin, Chevreul and, in recent years, Ilten. I am fascinated by atmospheric conditions, natural phenomena, aerial perspective, chiaroscuro and, above all, sfumato. After-image is another fascination – a colour seen with one eye when closed can be completely different from one seen with the other and yet both are simultaneously definable. This is much like two or more instruments combining harmonically to enrich a general theme. Colour is form, and I try to compose it in movements across surfaces as well as into and out of space.

Although I am deeply concerned with subliminal experience, I avoid the tragic and concentrate on more uplifting themes. Where do my themes come from? Waterfalls; shafts of light in cathedrals and forests; memories of Egypt; coastlines; the wind in the trees; rainbows; sunrises and sunsets; cloud formations; America.

Rise and Fall No 6 (2003), watercolour, 97 x 61 cm (38 x 24 in).

Sunrise – Sunset (2002/2003), watercolour, 49 x 97 cm (19.3 x 38 in).

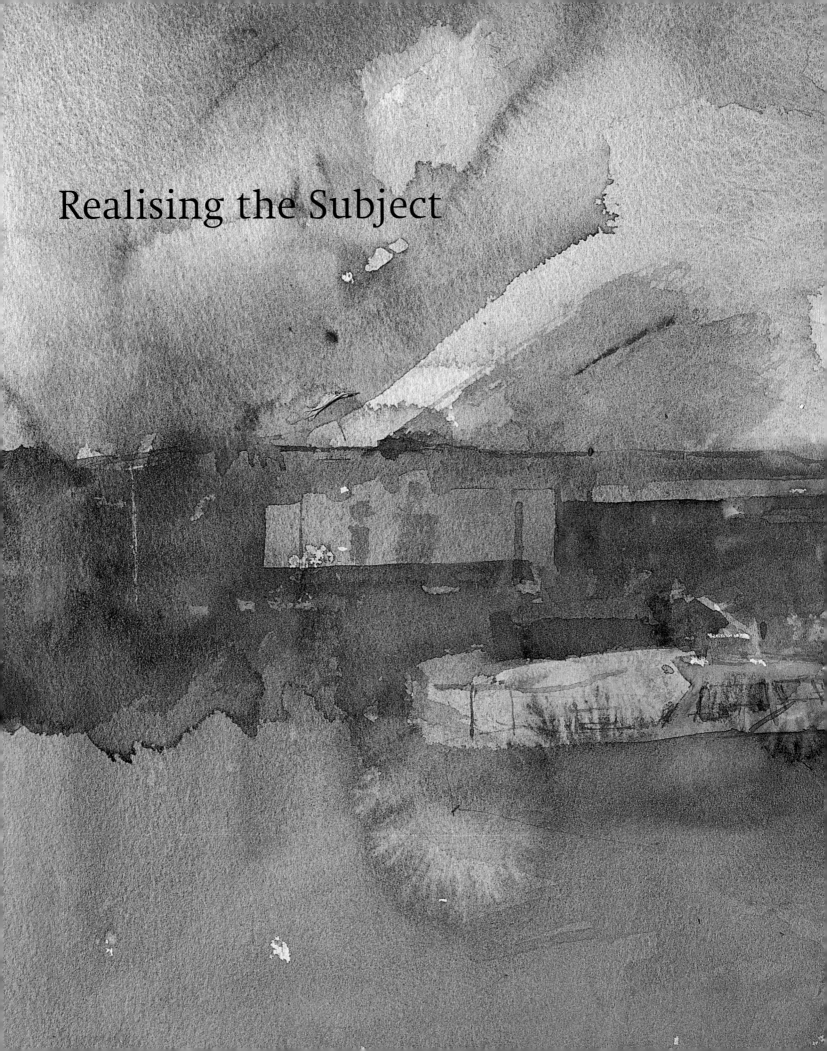

Realising the Subject

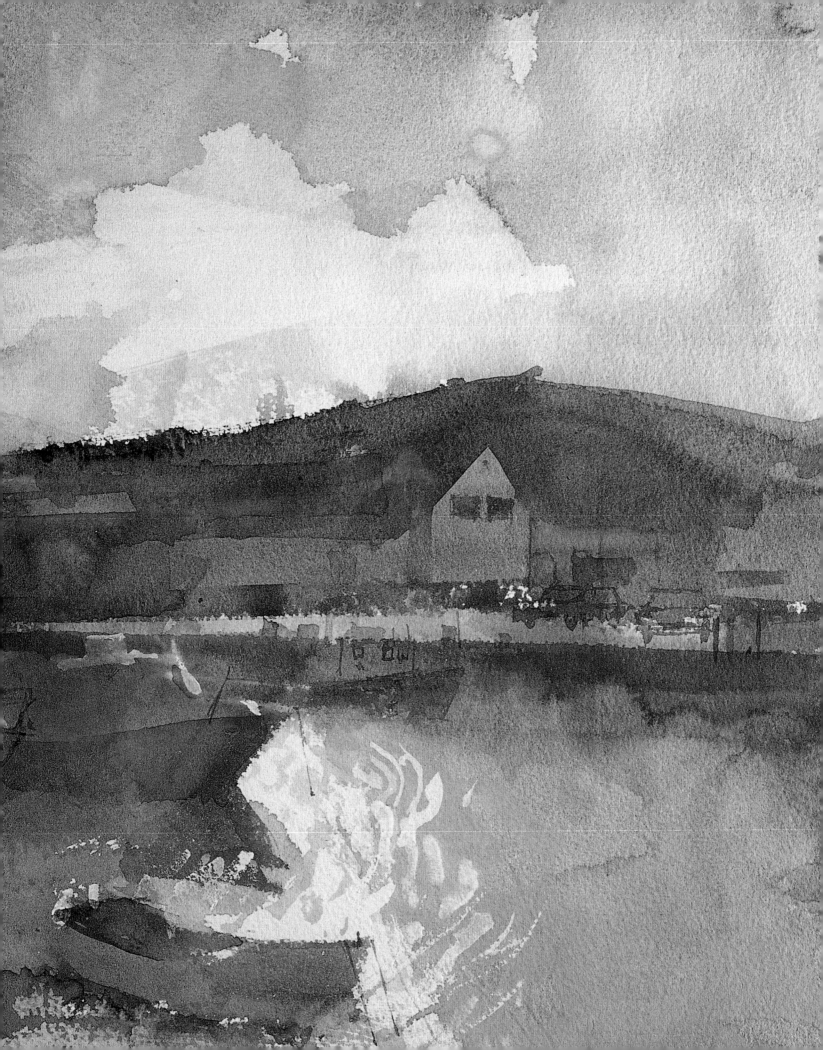

REALISING THE SUBJECT

Liz Butler

Like handwriting, the language an artist uses in the making of a painting is very definitely his or her own. Even if the materials they use and their working methods have much in common with those used by other artists, there is always something in their paintings which defines their identity.

That said, artists have generally developed their working methods and choice of materials to suit their temperament and their subject. Some artists prefer to work out in the field while others prefer to work in the studio, and some like a combination of both.

How one gathers information, either drawing first or combining drawn and photographic reference, or walking in the landscape and returning to the studio to work from memory, or working entirely *in situ*, these all are entirely personal and relevant methods of gathering information to make paintings.

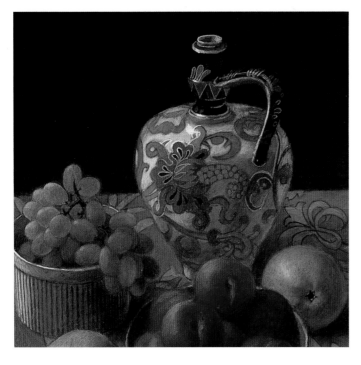

Choosing the right kind and weight of paper, often arrived at by trial and error, again is all part of the artistic process, as is finding the right paint for the job in hand, or the right brushes. Most of these are discovered in the working process of making pictures, although sometimes, and this is a good reason to be a member of the Royal Watercolour Society, artist friends sometimes suggest materials one could try that they have found worked for them. The playful element of discovery in the working process is very important and to remove that aspect would destroy something very fundamental that artists need to keep them progressing and developing their work further. It becomes an essential part of the dialogue or relationship we have with our work.

Another essential ingredient, and possibly the most important one, is the passion an artist needs to feel about their chosen subject and the wish to express it and share it.

Richard Pikesley (see opposite top left) clearly feels passionate about capturing fleeting moments in time when the light is doing something very special to the landscape. His paintings, worked on a largish scale (a half sheet of watercolour paper), strongly evoke climatic condition and time of day and are worked rapidly on the spot.

For the painting illustrated here, he has used heavyweight paper, fabriano artistico, with a hot-pressed surface on which the watercolour paint can be moved around for quite some time. He had drawn in the same spot the day before to aquaint himself with the landscape. This gave him enough forethought to begin his

some restraint in the early stages of his paintings. This is really important, otherwise one can end up with a muddy mess. Watercolour is quite an intellectual process, and there is always a dilemma between keeping control and letting the paint happen. You have to know the medium well enough but not so well that life is lost in the finished pieces, and it is never lost in Anthony's paintings, which are very lively and full of vigour.

Claire Dalby (see opposite) is a most meticulous artist who uses watercolour in many different ways – pure and transparent and on white paper for her plant studies, watercolour and body-colour on tinted paper for her still lifes.

This painting is an excellent example of the incredible depth and richness of colour that can be achieved by building up layers of transparent watercolour. Many Dutch and Flemish artists used their oil paint in this way – gradually working by overlayering their glazes. Claire has used some opaque white in her paint, especially to describe and define the surface textures – hard sharp shines and highlights on the jug, soft bloom and sheen of the plums, the silky smoothness of the pears and the dull bloom on the grapes.

OPPOSITE: *Detail from Claire Dalby's meticulous still life (see page 144).*

TOP LEFT: *Richard Pikesley, catching the light before it changes (see page 168).*

TOP RIGHT: *Detail from Charlotte Halliday's study of spring flowers (see page 154).*

ABOVE LEFT: *Detail from Anthony Eyton's lively* Nurses' Report *(see page 146).*

painting by making some swift pencil points of measurement on the paper. With the paper unstretched, he then proceeded to 'skitter' about the paper with very wet paint, using mostly round sable brushes with good points, allowing some areas to dry as he moved across the paper to other parts of the painting. He finds a clean wet hake brush very useful for keeping surfaces wet and uses tissue for lifting out undesirable accidents. If he loses luminosity in the sky using pure watercolour, he uses opaque white to rework it, and bring the luminosity back. Opaque white, in combination with pure watercolour, adds another surface dimension, and can create a kind of ambiguity.

In *Spring Flowers*, Charlotte Halliday (see above right) has maximised the effect of grey paper showing through the yellow watercolour of the daffodil petals by painting an even darker grey background, bringing a beautiful translucency to the petals that is almost tangible. The hard, shiny ironstone surface of the jug enhances the range of textures in this piece.

Anthony Eyton (see above), another artist who enjoys working *in situ*, abandons the use of pencil and talks about exercising

SEEING PATTERNS

June Berry

My paintings come from observing small-scale events in people's ordinary day-to-day lives. I am an inveterate people-watcher. I find all my subject matter around me, either in South-East London or in deepest rural France where I spend part of the year. The momentary juxtaposition of two figures, a glimpsed gesture, a partial view through a door or window revealing figures in an interior or a garden – these are my starting points.

I am equally concerned with the abstract pattern that appears on the paper as I paint. The piece of paper is of particular interest as it too is an attractive object. I use it unstretched so that I can paint across the whole surface, keeping the fluid movement of the deckle edges. The picture will be float-mounted within a window mount so that none of the composition is lost or brush marks cut off beneath the mount. I admire the work of the Nabis, Vuillard and Bonnard in particular, where forms are flattened into decorative patterned areas following their discovery of these qualities in Japanese prints.

My paintings are made in the studio where I am not distracted by reality. Away from the scene it is easier to select from information drawings done on the spot and recollection of the excitement of the moment. In any case, the paintings are often made up of invented elements or others not existing together in reality.

The mood of the picture is very much affected by the season and the time of day. My favourite time is the evening, which represents a nostalgia for a disappearing way of life in rural France. It also brings a stillness, a tranquillity and a blurring of vegetation into half-seen patterns.

In *The Bird Watcher* (see left), the autumnal trees make a pattern of rectangular-shaped reflections. The heron rhymes in shape with the jogger, the tree reflections rhyme with the foreground vegetation. The energetic young jogger contrasts with the static, rather more elderly bird watcher. Another year passing.

Although I spend considerable time on preliminary working drawings, my aim is to paint in a loose and relaxed way, receptive to moments when the painting seems to take on a life of its own and new colour and compositional possibilities come into my head. I try to bring to life the excitement of what I see and retain the spontaneity of a fleeting moment within a well-constructed picture.

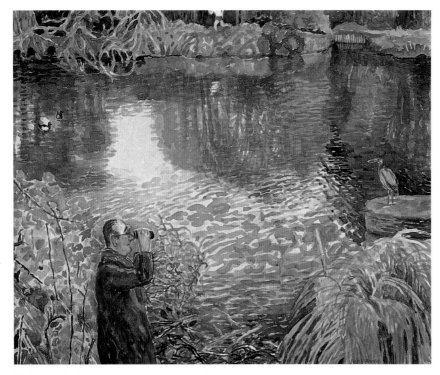

The Bird Watcher (2002), watercolour, 46 x 56 cm (18 x 22 in).

LIGHT ON WATER

David Brayne

I often return to the idea of a figure or figures fishing, an image which works for me on many levels. Placing a fishing rod in the hand of a figure adds to the dynamic – extending a gesture in a lyrical way, carrying a line or movement to form patterns and rhythms naturally and without effort. By this means a figure is connected physically to the sky, the surface of the sea or river and sometimes into the water itself.

I have looked many times at the Raphael cartoon in the V & A, where the Apostle fishermen lean over the side of the boat to haul in their net, suggesting the meeting of two different worlds; bridging the elements.

The sea has no specific hue and can only reflect or borrow colour from above or below. It is fun to use ochres, oranges and oxides, colours not generally associated with this subject, and to find they are readily seen as the sea. Staining the paper using natural pigments suspended in a water-based medium, either gum arabic or an acrylic gel, can catch the fragile and shifting nature of light on water and suggest what might lie beneath. Some pigments appear dull in their dry state, but when ground or even worked directly into the surface of the paper with an acrylic gel the colour can be transformed, becoming clear and bright. In *Three Fisherwomen* (see below), the sea was created in this way, with transparent iron oxides for the reds and oranges and a very small amount of ultramarine mixed with titanium white for the band of blue water. This painting, like much of my work, has a close and limited range of colour. Different tones and subtleties of hue are controlled by varying the balance of pigment and binder as well as straight-forward mixing.

My starting point is always the figure, drawn in pencil on to stretched paper. I draw from memory, often a person or people I know, and usually with a clear idea of a pose or gesture I wish to create. The drawings tend to be more detailed than the finished work. The act of drawing helps to clarify my thoughts and to keep at bay any feelings of panic. I use water-colour and acrylic gels, introducing raw pigments to achieve luminosity and purity of colour and apply a great number of semi-transparent layers of paint to build up its depth and range.

The paintings are still and quiet, their focus being on the figures and the places they inhabit. The shallowness of the visual plane and the often close tones of the colours emphasise this unity.

Three Fisherwomen (2001), watercolour, pigment and acrylic gel, 64 x 86.5 cm (25 x 34 in).

CREATING DETAIL

Claire Dalby

The jug in these images belongs to my aunt. I loved its colours and exuberant patterns and had my eye on it for years; the Crown Imperial patterned cloth remnant was an impulse buy. Together they seemed to demand a rather opulent assemblage to accompany them. I put the jug at the back (could I make one spot of pure white paint recede?). Bowls, grapes, plums and pears followed (could yellow and pink work together?).

The placing of objects was arrived at surprisingly quickly, considering it can take me a whole morning to arrange two lemons on a plain background. The light is natural daylight. I am preoccupied with the way light is reflected from different objects, revealing their solidity and distinctive textures.

The paper is Canson Mi-Teintes 'Cachou', which I find quite difficult and temperamental to stretch, but it has a friendly colour and is a resilient surface to work on. I start by drawing with a brush in transparent watercolour (eg burnt sienna) to define shapes, their relationship in space and an indication of their bulk. Some local colour follows, and the paper is nearly all covered. Eventually I introduce opaque white to the transparent paints and this ultimately pervades all the mixtures (which can still be very dark). The painting develops extremely slowly as colours are built up, edges softened or defined, and unsatisfactory areas washed out. As I work I see more and more ways in which the colours affect each other.

Detail is never an aim in itself, but results from my way of constantly refining the drawing. As a wood engraver, I work on very small, fine scale, while fine and accurate details are essential to my work as a botanical illustrator. Size 0 brushes with longish hairs (AS Handover Series 33) and points too worn to paint miniscule plant details are excellent for the drawing/construction stages of both my still lifes and landscapes. I feel no need to work on a large scale but aim to create the feeling of large spaces on small pieces of paper.

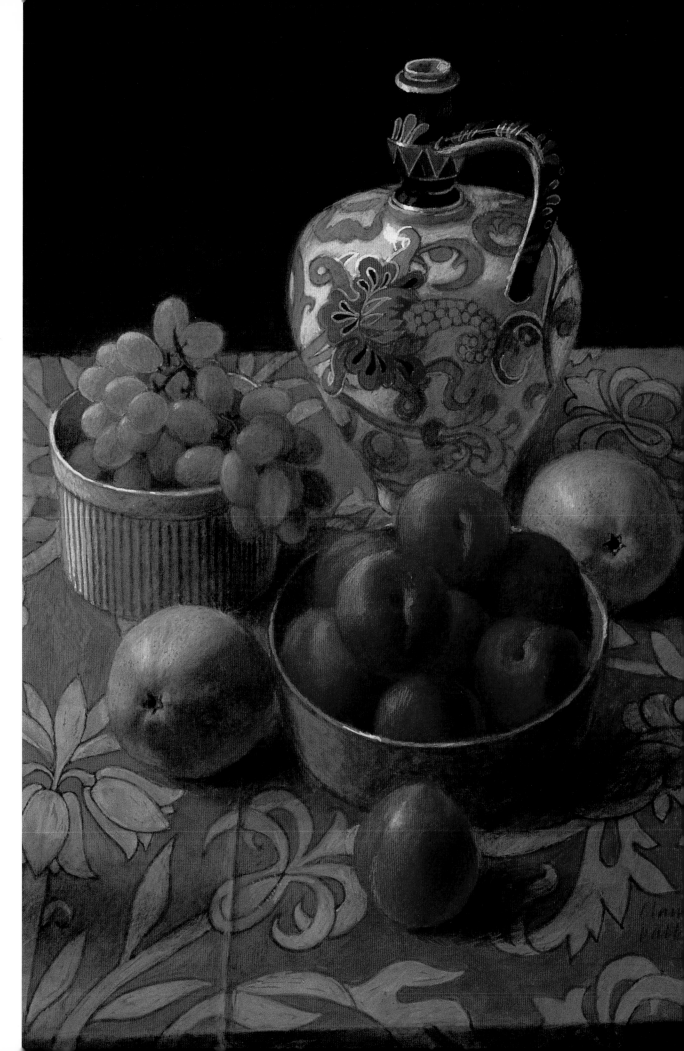

Hungarian Jug with Crown Imperial (2003), watercolour and bodycolour on tinted paper, 40 x 27.5 cm (15.7 x 10.8 in).

OPPOSITE LEFT:
Brush drawing defining the shapes.

OPPOSITE RIGHT:
Starting to work on the colour.

RIGHT:
The finished painting.

SPONTANEITY

Anthony Eyton

Faced with the subject, the impulse is to put it down as spontaneously as possible. This is not so easy with watercolour. With oil painting, colour more or less matches colour, and it is easier to push around. Darks can be put in with impunity. Not so with watercolour. I have to use the utmost restraint not to go straight for the black in case it would be in the wrong place and I would muck up that precious white paper.

I don't like the idea of doing a pencil drawing and then filling it in with the colour. Far better to capture the dynamic by going straight for the areas of colour. It is only by showing some restraint or judgment that the first colour washes can be made to coalesce into some sort of order, but remain fresh or spontaneous.

But sometimes restraint must go overboard and dynamics rule. With the *Nurses' Report, Leicester Royal Infirmary* (see opposite), the nurses were not going be round the table for long and the only thing was to go for it. The picture was painted in 1986 when I was artist-in-residence at Leicester Royal Infirmary. The event was called the Ward Report, denoting the change-over from the night to the daytime nurses.

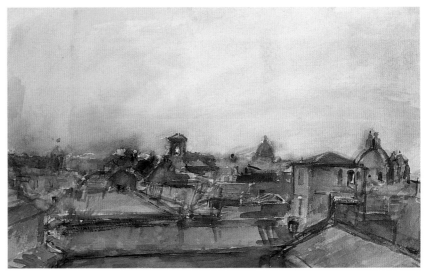

Rooftops, Rome (1981), watercolour, 40 x 61 cm (16 x 24 in).

In a large ward this seemed to me to be an important occasion both for the benefit of the patients and for its visual appeal.

There was no retouching in the studio. The scene was painted directly on the spot, probably in two to three sessions of say about twenty minutes each morning. In such a case it would be invidious to have any prescribed method or programme. This would only get in the way of grasping the impact of the white aprons and caps of the nurses and their relationship to the dark surroundings. The only way was to remain alert to what was static and what could suddenly happen when someone moved.

Working from the general to the particular, the preservation of the white paper had to be sacrificed to accommodate the changes both in drawing and in actuality. So white had to be put on, as a substance. In fact, at the back of my mind the nurses in front of me had a distinct echo of Courbet's marvellous picture of *The Preparation for the Wedding* (formerly called *The Toilet of the Dead*). I was doing a watercolour but Courbet's feeling for matter and heavy presence, though here in front of me it was so light and effervescent, was an example of how art can affect our vision.

I kept a diary and wrote, 'I took great pleasure in landing in on an Indian-looking nurse on the right who remained unchanged for twenty minutes, folds, bulges, awkward legs, etc.'

In the end it's an attempt to discover the space and light and, in William Blake's words, 'catch a joy as it flows'.

146

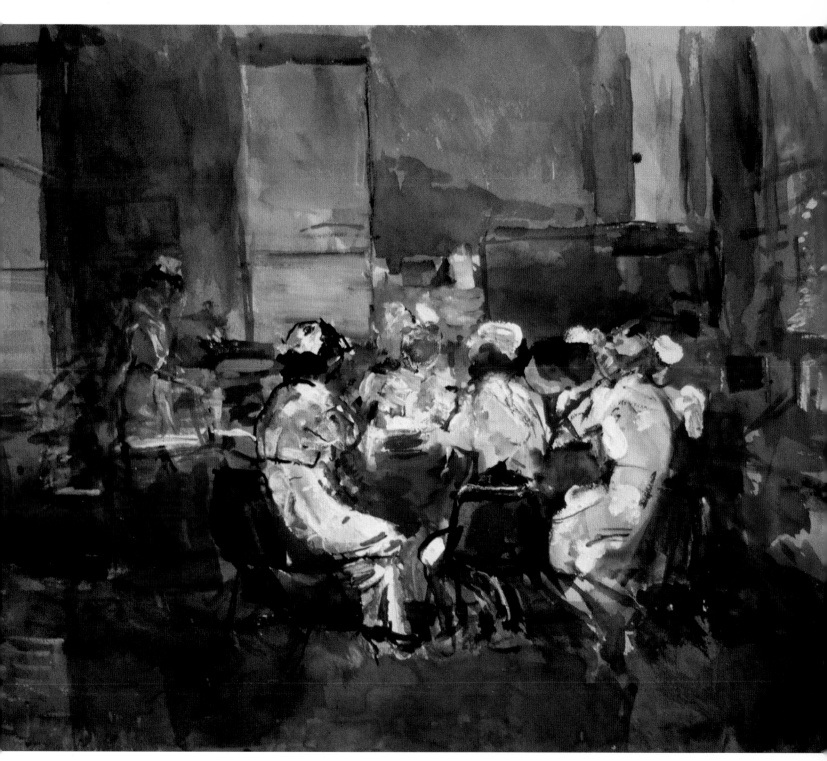

Nurses' Report, Leicester Royal Infirmary (1985), watercolour, 38 x 46 cm (15 x 18 in).

THE IMPRESSIONISTIC FIGURE

Phyllis Ginger

I have always liked recording everyday subjects and especially human activities in their everyday setting. For most of my professional life, I have worked as an illustrator for books with topographical views of London, recording people in leafy squares or in busy shopping areas such as Piccadilly, Leicester Square and Holborn. The bustle of ordinary life around us is interesting to record, the scene at cricket matches, flower shows or cyclists on the towpath of the Thames.

At present I am concentrating on local scenes around Kew Gardens in West London, for example the view across the river to Syon House from the Gardens or even just people watching the swans and ducks by the lakes in Kew Gardens itself. Informal records of the family's activities, such as reading, trying on clothes or in the garden having tea, are a constant source of inspiration too.

I usually start by wanting to catch the movement of the subject, often beginning with sketchbook and pencil, producing lots of quick sketches to become familiar with the shapes and characteristics of the subject. Then I'll get the watercolour paper and paints out. On the whole, I work in either of two ways. I might first use a pencil to do faint outlines of the whole composition, then block in the light and dark areas with a suitable warm or cold grey wash (a mixture, in various proportions, of burnt sienna and ultramarine) and then I will put in the specific colours and some detail of the people on top. Alternatively, I could start with a brush straight away, using a fine sable No 10 brush with a good point or a flat brush (long, one-stroke oxhair 16 mm) for the blocks of colour and tone, working quite broadly at first.

After a while the light might change, so I can either work on the composition back in the studio, using information and colour notes from my sketchbook, or return on another suitable day. The figures are treated impressionistically, conveying the movement of people to and fro; if I only manage to catch half of one figure, I can complete it with information from another later on, jotting them down using suitable-sized brushes. I like to keep the watercolour strokes quite loose to achieve a lively sense of composition.

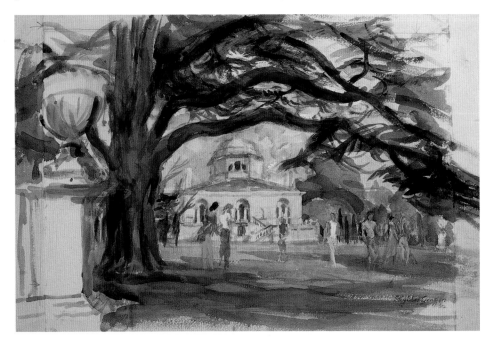

LEFT: *Chiswick House: A Setting for 'As You Like It'* (c 1985), watercolour, 31 x 47 cm (12.2 x 18.5 in).
OPPOSITE: *Portrait of Frances in a 'Marie Lloyd' Hat* (c 1982), watercolour, 35 x 23 cm (13.7 x 9 in).

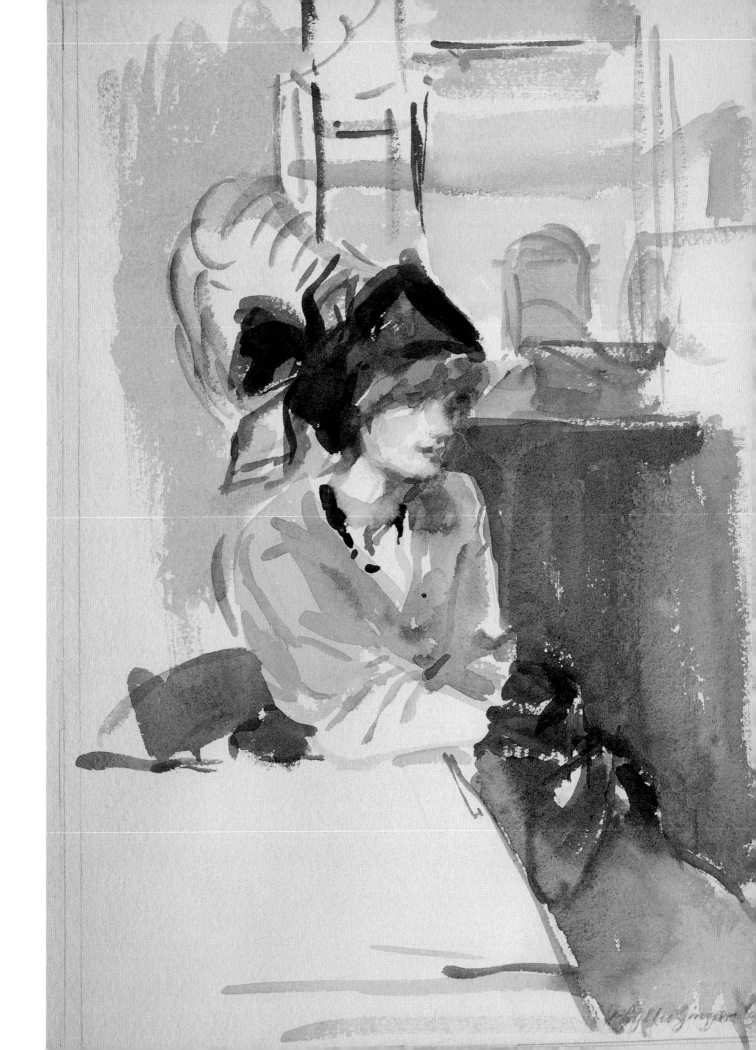

CREATING A PORTRAIT

Elizabeth Cramp

When painting a portrait, I like to have information about the sitter's background and main interests. This enables me to incorporate vignettes of those interests within the painting.

While I make drawings, I encourage the sitter to talk and move about freely, even to walk around, which informs me about their body language before I decide on a viewpoint from which finally to work.

Later, in my studio, in various-sized sketchbooks, I loosely draw out ideas for the composition, including vignettes of the sitter's interests that I think will help the portrait. I make colour notes to decide on the most suitable overall colour to best express the sitter's personality as I comprehend it.

Although I use a hot pressed paper, I like it to have a slight texture to give the paint variations in luminosity. I tape the paper to my drawing board, and measure on it the size of the composition I have designed for the portrait.

With my sketchbooks of drawings and ideas by my drawing board to refer to, I apply the first washes of colour over the areas needed to define the sitter. As I work, the rhythms within the the composition are emphasised in stronger colour/tone by building up washes to enable the lower washes of translucent colour to show through.

My work is basically linear. Although I paint forms, to some extent, with drawing, I need the knife-edge of excitement of drawing freehand with a brush, pen or a 4B pencil last of all, knowing the painting can be ruined if I falter!

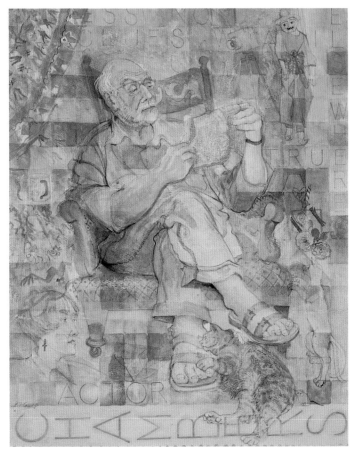

Brian (1997), watercolour, 51 x 40 cm (19 x 15 in).

THE LIQUID MEDIUM

Isla Hackney

It is the experimental and spontaneous nature of water-based media that fascinates me. I work in a bold and instinctive way, but with control and deliberation. Capitalising on chance effects, I aim to convey a sense of my subject by involving the viewer in the physicality of the medium and how I engage with it.

I love to use quantities of pigment suspended in water scooped up on huge brushes or poured from a height. My response to landscape is both physical and emotional. I prefer to work on large sheets of paper to capture the sweep, atmosphere and panoramic quality of my subject. Scale of mark, speed of application, directional emphasis and the way that one mark works against another all combine in the dynamics of building an image. I usually work on the floor of the studio with watercolour sketches, colour notes and drawings scattered around me, providing me with a sufficient range of stimuli. I might begin with a particular idea in mind – the memory of a place, a mood, and what it felt like to be in the landscape – but each painting evolves as I respond to events on the paper.

Filling the page with colour, I allow it to travel across the paper in precarious and

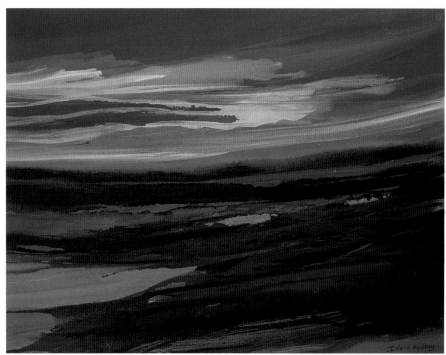

As Evening Approaches (2001), watercolour and acrylic, 56 x 76 cm (22 x 30 in).

unexpected ways. I like to improvise – allowing the pigment to suggest my subject – rather than attempting to follow some preordained plan. Taking risks – allowing one colour to run into another, brushing over entire areas and then sponging out to retain only trace elements of what is below – is crucial to my work. Layering up the image, I introduce large bands of colour which help to build the composition and provide contrast to busier passages, as in *Rocky Outcrop, Blue Sea, White Sand* (see following pages). The main lines of an image can be established

by letting paint run across the page, wiping away the residue. In *As Evening Approaches* (see above), the rhythm of the paint handling reflects the original sensations felt in front of the subject. In the foreground, cobalt blue shadows move rapidly across the green of the land as I brush on one colour and let the other run and mingle with it. In the distance, sponging out enables me to retain the surface of the page to give a sense of the changing light.

151

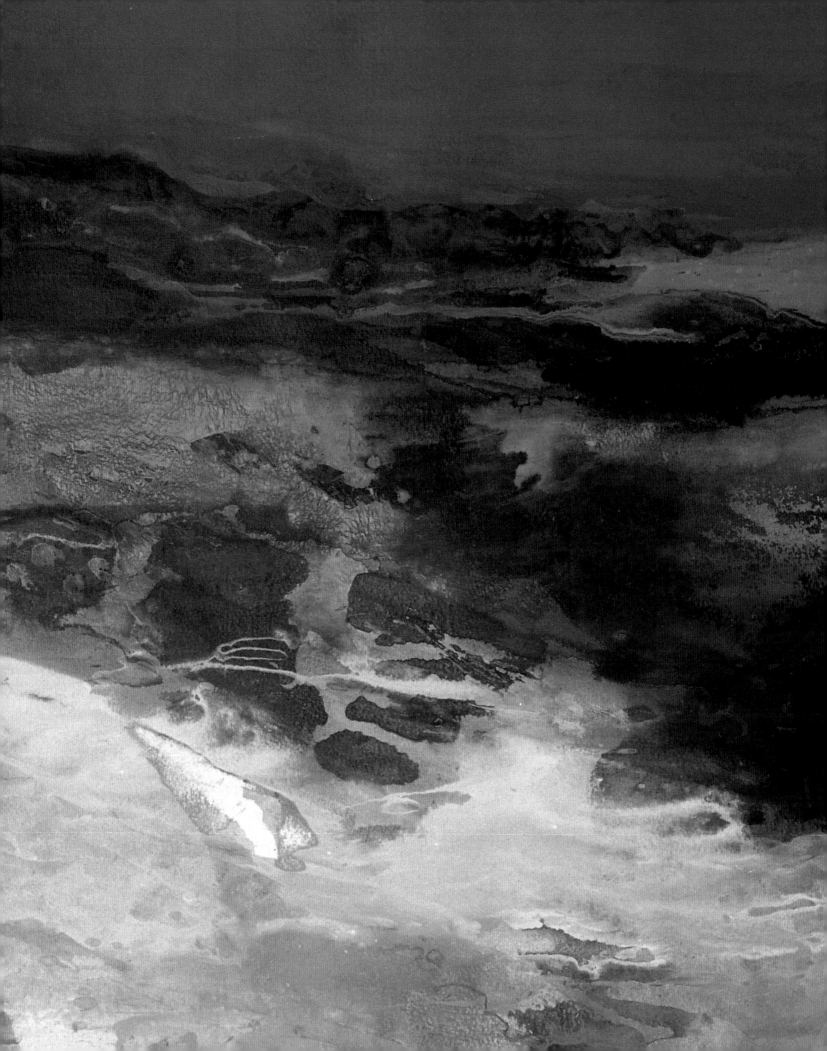

Rocky Outcrop, Blue Sea, White Sand (1999), watercolour and acrylic,
56 x 74 cm (22 x 29 in).

TOWNSCAPES

Charlotte Halliday

*There has to be something man-made in a subject for me to want to portray it –
which is why I do not feel moved to paint in the countryside (although I crave it
in other ways), unless there is a building in it. But townscapes give me a buzz:
light falling on brickwork, stone or stucco and architectural detail, the more
complicated the better. I relish tackling really intricate mouldings, and I care
passionately about getting them right.*

In recent years, I have found great satisfaction in painting flowers, but they must have a structure about them – soft smudgy blooms do not appeal at all, however lovely their colour. The definition and grace of snowdrops or primulas are compelling, but chrysanthemums are not!

Drawing is the basis of everything. Long ago I could commit myself to a direct pen line on white paper, but now I find that intimidating and prefer to draw in pencil, and with a fine brush in watercolour, on a toned paper and to add white gouache, which gives me, as it were, another dimension.

The Houses of Parliament are wonderful to draw and paint from every angle. My watercolour drawing of the Victoria Tower (see opposite) was commissioned by two friends who walked past it each day on their way to work and who, like me, felt that it was exciting to have it half-clothed in scaffolding. Perhaps oddly, I have always found scaffolding an added attraction – it seems to lend mystery to a building and to make you work harder to discover what is going on. Some years ago I did a big picture of Salisbury Cathedral emerging from a forest of it – the scaffolding itself an amazing work of engineering. (I felt quite sorry for Constable and Turner who had not had the same opportunity that I was given.) And I have often drawn St Paul's Cathedral with a haze of iron hiding some aspect or other.

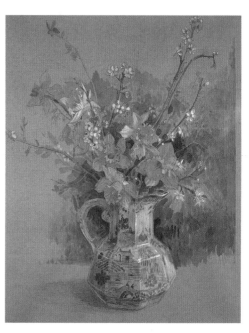

ABOVE: *Westminster Cathedral from Francis Street* (2000), pencil and watercolour, 48 x 28 cm (19 x 11 in).
ABOVE RIGHT: *Flowers from Barnyard Cottage* (1993), pencil and watercolour, 38 x 30 cm (15 x 12 in).
OPPOSITE: *The Victoria Tower, Palace of Westminster* (1993), pencil and watercolour, 50 x 40 cm (20 x 16 in).

The spring flowers (see above) were among the first that I attempted and were a great challenge. I was more at home with the blue and white ironstone jug – I am a lifelong collector.

Ever since I did illustrations for the magnificent biographical dictionary of Edwardian architecture, by the late Alexander Stuart Grey, I have found great delight in getting to grips with the multitudinous detail of that period. J F Bentley's Westminster Cathedral (see above) is a case in point. I do not always like Edwardian buildings, but they are delicious to draw!

TOPOGRAPHY

Barry Owen Jones

I live on the Channel Island of Guernsey, which presents a wide variety of subject matter for the topographical artist, ranging from seascapes to landscapes to architectural matter.

Through all the variety of subjects available, the most essential aim for me is to convey the atmosphere of the place in all types of weather and light; my painting should be more than just an accurate depiction of the scene before me. Sometimes this means very careful drawing, upon which I like to build my watercolour. However, in an effort to keep the painting interesting, I use the watercolour as freely as possible.

The picture accompanying this piece is not of Guernsey but an old monastery in Koroni, Greece. Set high on a plateau above the seaside town, the clear air and autumn light presented an interesting problem. I enjoyed the decorative aspects of the

domes on the right of the picture as well as the pattern and texture of the stones used in the building of the wall. You will see that there are some pieces of old Greek pediment used in the construction of the main wall – all this detail helps in creating the essential feeling of the place as well as being fun to discover and put in.

I needed to be careful to keep the white of the paper shining through, otherwise the feeling of the Greek light would be lost. The dark cypress trees helped to emphasise this light, making, as Van Gogh said, 'exclamation marks in the landscape'. Shadows were kept to a minimum and painted blue to echo the blue of the sky. The warm colour of the mid-ground grasses and vegetation helps to intensify the feeling of heat. I have visited this place several times and have produced paintings each time. Sadly, it now seems to be virtually abandoned.

Monastery of St John the Baptist, Koroni, Greece (1996), watercolour, 38 x 51 cm (15 x 20 in).

LIGHT AND SHADE: CONTRAST

Eileen Hogan

Light and shade have always been important features of my work, particularly shadows and the geometry of shadow patterns. Shadows hide and reveal; they break up space and simultaneously make it understandable, yet elusive. Drawing and re-drawing patterns, to leave echoes of what was there before, creates an ambiguity, which is what shadows are all about. It's clear that they are there, but hard to decide if they let you see more or less.

Patterns of light stay still, yet they constantly change; they are apparently calm, yet they have an unsettling quality, a feeling that something is about to happen. Mesmerising.

In 2000, Moniza Alvi wrote a poem, *Of Chairs and Shadows*, in response to my exhibition 'Chairs and Shadows' at The Fine Art Society. The poem was published with my illustrations by the Pit Pony Press to accompany the exhibition and in 2002 in Alvi's

publication *Souls* (Bloodaxe Books). It's a poetic parallel to the importance of shadows as source material for me, and also represents my interest in text and books. It begins:

Of Chairs and Shadows

When we tire of one another's conversation
it is such a relief

to let the chairs and shadows
take over in their unobtrusive way

But they are not so quiet
Chairs will converse with walls

the rugs, though chiefly
they're interested in their own shadows.

It's an uneasy relationship -
shadows are in love with themselves,

and so are chairs.

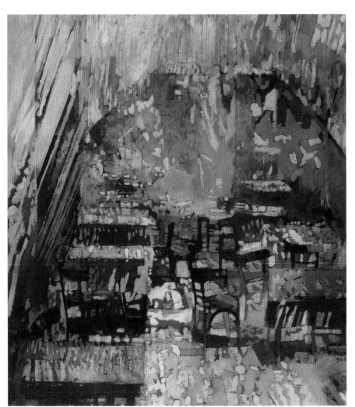

Shadows (2001), acrylic and watercolour on paper, 71 x 53.5 cm (28 x 21 in).

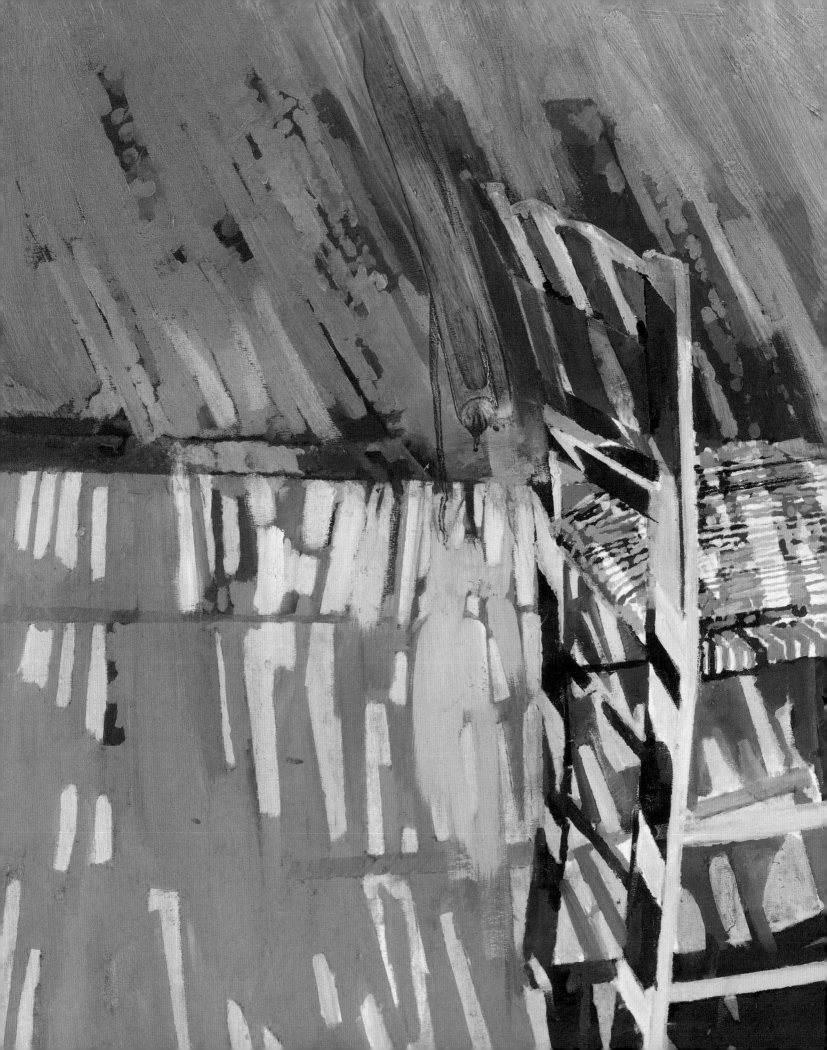

Chair (2000), acrylic and watercolour on paper, 51 x 71 cm (20 x 28 in).

WORKING WITH MUSICIANS

Mary Jackson

I'm going to refer to one of my favourite subject matters. I have been artist-in-residence at Glyndebourne Opera and The English National Opera. This doesn't mean I am an expert but I think I have a few tips I can impart.

Most importantly, I think about the venue beforehand. Working in an orchestra pit or an auditorium means you have to operate in a confined space compared to a studio or *en plein air*; so you can't arrive and then work things out. The orchestra manager will always help out; she may even have a spare music stand with a light.

The equipment I use is basically pencil, Conté and three watercolours – earth colours and black, water-based pencils; charcoal is difficult to control, and it may squeak! I use sketchbooks, cartridge paper and/or watercolour paper stretched in various shapes on boards (the largest I use is A4), a small watercolour box and a plastic water container. I always sharpen my pencils, say six, beforehand, and arrange everything beside me as I need to be as inconspicuous as possible.

I keep my eyes on the conductor and musicians, and try not to take the pencil off the page; these impressions are very expressive, giving you the attitudes of the conductors, violin bowing, singers' postures. I get these down in a flow, working fast. Colour notes come in here, not forgetting reference to the act, scene and any quotes.

Now for the composition. So many cameos. I decide on the subject matter and work from a central figure – it may be just one musician appearing in the background or a conductor. I look for various shapes, such as the angle of the instrument in relation to the figure and the stage, and measure things up all the time. I decide at which point a bow is being played and wait for that same movement, planning around the figure looking for negative shapes; the tonal masses. Like a jigsaw it will slowly build up. Look at some of Bernard Dunstan's musical works; he is a master of the genre, although he paints mainly in oils.

LEFT: Working sketch, Carole Wilson as Lucia in *La Gazza Ladra*, Garsington Opera (2002), pencil and watercolour, 23 x 19 cm (9 x 7.5 in).
OPPOSITE: *Newbury Festival Players* (1998), watercolour, 35 x 25 cm (12 x 10 in).

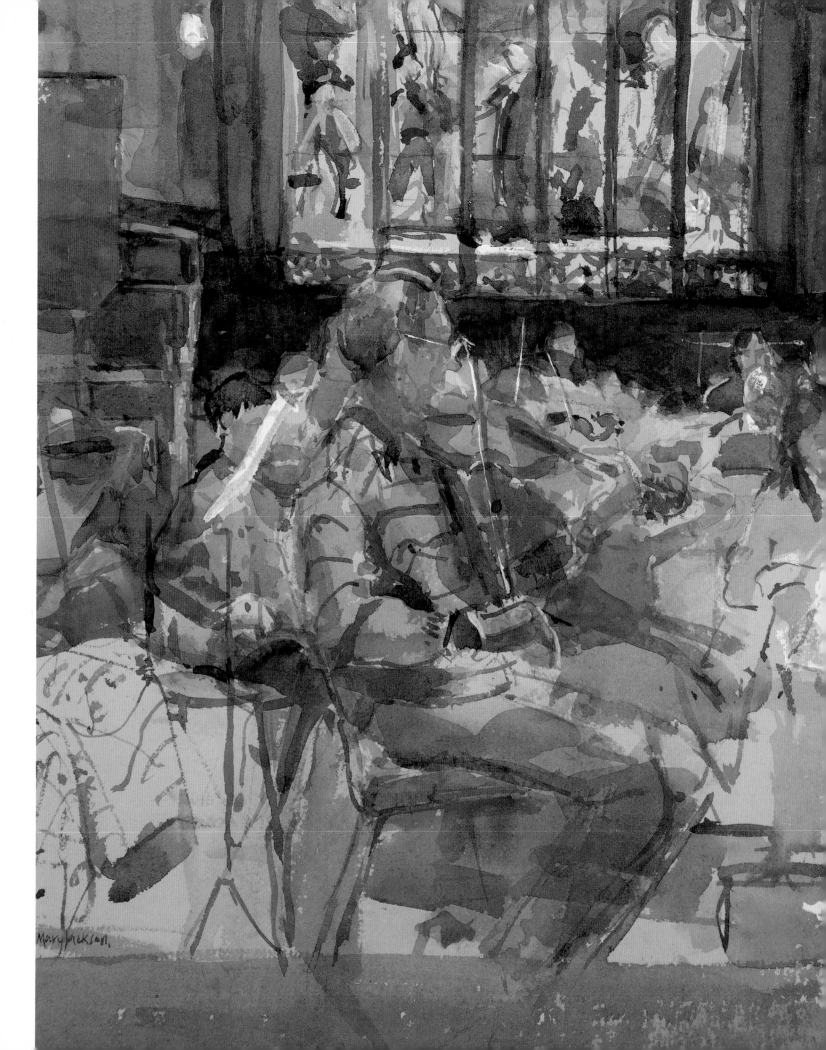

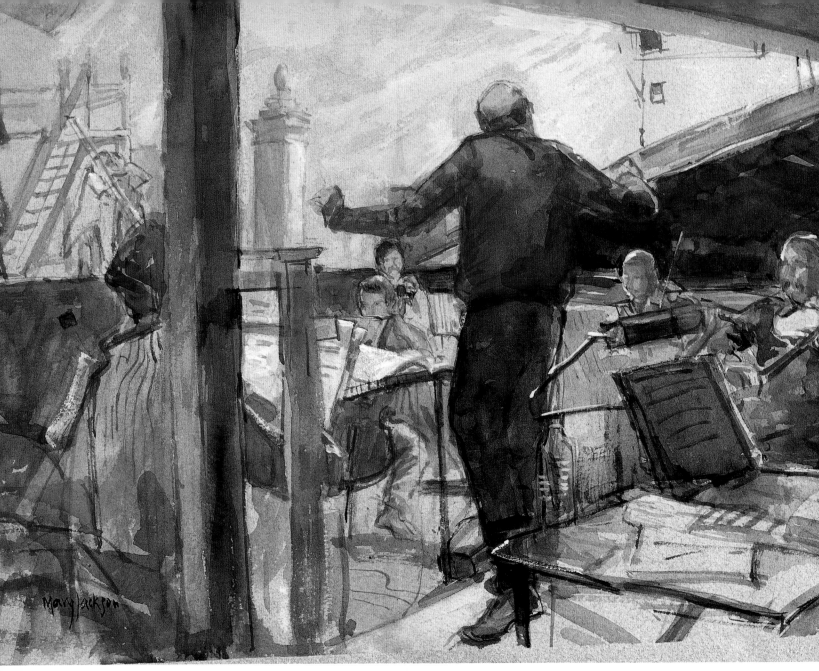

Rehearsal at Garsington Opera (2003), watercolour and gouache, 25 x 35 cm (10 x 13.8 in).

I use the time during the orchestra's breaks for my first washes or costume colours, or a single splash of colour to highlight the composition. I work on the backdrop, stage set, footlights, anything that helps to compose the end product. The good thing about working in rehearsals is that you can go back to a situation and continue. I never labour over a drawing.

I take the day's work to the studio, and while it is fresh in my mind I work up the paintings. The stage can be very cluttered, so I try to simplify the work to three values, not necessarily going with the ones already painted. Perhaps I will want to strengthen or reduce various parts or change the composition.

The palette should be limited. This will be governed by the local colour or my own choice. I work on at least two paintings at the same time, leaving one wash to dry while I work on another. If the painting looks disjointed at the end, I have to be brave and put a big wash over the entire work, lifting out any light areas I want with a brush. For the finished highlights I use Chinese white or chalk.

The paper I work on is tinted, so I have a mid-tone to guide me. The paper is placed on a light board and stuck down with masking tape. Ruscombe Mill in France have a wonderful range of paper. Framing is important and a personal choice. Sometimes I work to standard sizes and have the frames waiting for me.

SPACE AND LIGHT

Jane Taylor

I have always painted in gouache, using artists' watercolours with a mixture of Chinese white; but using transparent colour as well – as a basis and as a foil to too dense opacity.

Lyme Regis on the Dorset coast has been a favourite holiday resort for myself and family for a number of years, as indeed it has been for countless other visitors. The clear pearly light has drawn painters to the region for ages, from Turner and Constable to artists of the present day; all have fallen under its spell. Not that the serene pearly light is the only characteristic. Lying as it does in Lyme Bay, it is subject to a great variety of moods and weather, but it is perhaps the tranquillity of the long stretches of silvery beach which has attracted me most.

I think the painting below aptly describes what I felt about the subject. Small in size, I believe it conveys a sense of space and

light as faithfully as I could describe it. It has a high-keyed tonality, and the small figures stretching into the distance give a sense of scale and movement in what would otherwise be a rather featureless scene.

As one can see, my eye-level is low, the beach sloping gently upwards to the horizon, on which most of the pictorial interest lies. The difference in size from the largest figure approaching at middle right (one of my daughters) to the tiny figure beyond describes the distance between the two.

My equipment is simple, a sketching stool, which I don't often

use, a light drawing board on which I stretch some paper, invariably tinted to my own choice of colour. A simple range of watercolours which I use with a mixture of Chinese white, and a few brushes (0–7 or 8).

I choose my views carefully, but work intuitively trusting to my immediate response to the subject; my method is instinctive and difficult to describe. I work on the assumption that if it moves me, it will in some way, hopefully, move someone else.

September, Lyme Regis (1988), gouache, 18.4 x 28 cm (7.3 x 11 in).

THE MOOD OF LANDSCAPE

Janet Kerr

Living and painting on the West Yorkshire Pennine Moors for the last thirty years has undoubtedly had its effect on the direction my work has taken. It is a particular landscape. It has the appearance of being long-suffering, bleak and weather-torn. The treeless, sparsely populated moorland hilltops loom over the busy, once industrial valley bottoms; these are crammed with old textile mills, chimneys and housing constructed from local millstone grit.

I would like to stress the importance to me of drawing directly from the subject as a kind of meditation or a 'taking-in and storing' event. However, my paintings are most often developed in the studio from memory drawings. Unnecessary clutter is forgotten, and a simpler, more personal sense of order begins to emerge. It's difficult to work this way without using a fair amount of creativity, which I find harder to access when painting directly from the subject. My paintings aren't about what the moors look like, but more about the experience of them.

I notice that whilst I'm making visual memory notes, thoughts about what the location 'felt like' will surface, and will inform the painting. This mood or atmosphere will affect the key colour relationships, contrast, edge quality, etc, in the work. It's only when all these things have begun to settle down in the painting that I'll refer back to my original drawings, made on site, for any more specific information needed to complete the work.

In order to give a sense of the distressed nature of the landscape in *From the Steeps* (see above), I used a combination of water-colour, gouache, overpainted white tissue (pasted down with

From the Steeps (2000), mixed media, 36 x 42 cm (14.2 x 16.5 in).

acrylic medium) and charcoal. My approach to watercolour is not purist. Its very special atmospheric properties are vital to me and always form the basis of my work. Despite this, I feel the final image is paramount, and if I just need something else to describe a certain quality, I have no qualms about reaching for the medium that best serves that purpose.

NIGHT SCENES

Kenneth Oliver

I believe that some of my better work has occurred when I have worked on the spot, whether it be a still life or a landscape. In the case of the latter, the movement of clouds, causing a constantly changing light and a vibrant atmosphere, can infuse one with energy. There is an increased urgency to capture all that is being enacted.

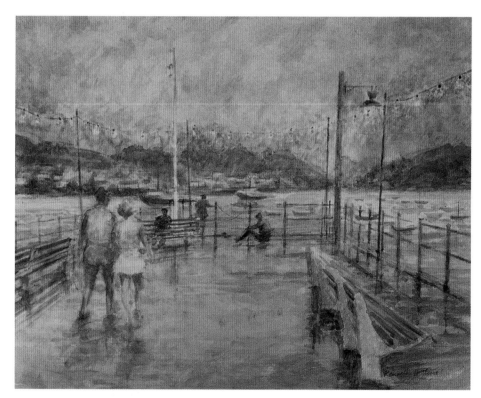

Towards Fowey (1998), watercolour, 28 x 37 cm (11 x 14.5 in).

However, this particular painting, *Towards Fowey* (see above), falls into a different category. I have always been intrigued by night scenes, for example in streets or at the seaside. Perhaps this is because of the element of mystery, and the unusual effects of colours. On this occasion, my wife and I were waiting on the jetty to catch a late-evening ferry from Polruan to Fowey. Standing there, I was enthralled by the almost magical quality of the coloured strings of lights and the more mysterious background formed by the far side of the estuary. A fleeting moment! A good visual memory is needed to hold the image in mind, and carry it right through the working process, so that this first impression remains fresh. Written notes can often help, or, as I did here, returning next day to make a drawing of the setting; this helped to provide a framework for the painting, to be carried out later in the studio. In addition, to jog my memory, I did take a photograph that evening. This gave some help, but as neither my camera nor my skill as a photographer are to be trusted, the visual memory combined with the drawing were of prime importance.

I have always felt that an artist must have a compelling reason for wanting to paint or draw a given subject, thus making a personal statement. Sometimes, when looking round an exhibition, I come across work which looks impersonal and lacking in vision.

I am not, myself, a prolific painter, but I do hope that every so often I am able to transmit to the viewer something of the interest and pleasure which caused me to make the painting.

WORKING WITH PHOTOGRAPHS

David Paskett

My watercolour technique is rooted in oil and tempera painting, with sound drawing as a base. I have collected numerous variations on the theme of oriental paraphernalia stacked on pavements, in markets and in sunlit corners around the streets and waterways of China.

I am intrigued by the 'still life' groupings arranged by 'the person in the street'. Families of impedimenta, including an occasional figure, displayed in unlikely juxtaposition. Stacks of baskets, rows of bikes arranged for storage. Rags, slippers, paper and noodles hung out in the sun to dry. Complex masses and rows of repeated objects beckon to me. A potent image will be the result of a long search.

When working from photographs for one of my kerbside still lifes, I orchestrate the composition, tone and colour as though I were a conductor: simplifying, clarifying, finding rhythms and determining where the emphasis and accents should lie. I look for focal points, internal groupings, abstract patterns and unifying structures. Often the image, welded to strong shadows, fills the space, backed up by the grid of an architectural structure enriched with surface pattern.

Sometimes, when painting at the road or waterside, I bring out the camera to capture a passing figure, boat or transitory shadow. My '*plein-air* studies' and photos are my source of information. I rarely add to work started *in situ*. In the later stages of a painting I may add white gouache to define edges and reinforce the tonal contrast.

In *Grain Sacks, Kunming* (see below), a cluster of sacks creates a flat cellular pattern with no horizon and little perspective. This apparently simple composition is based on circles overlaying a rectilinear structure with a slight squashing of sacks, angled labels and half-buried spoons helping to move the eye around. Chinese slippers add a sense of place and scale.

In the next picture, *Mounting Bikes, China*, a group of trishaws is presented as though dramatically spotlit on an elevated stage

Grain Sacks, Kunming (1992), watercolour, 50 x 65 cm (19.7 x 25.6 in).

Mounting Bikes, China (1998), 48 x 75 cm (19 x 29.5 in).

Mounting Bikes (detail).

against a blue backdrop. Strong slabs of shadow with the permanence of sheet metal underpin an interlocking pattern of circles and triangles. The overall triangular composition suggests gravity and permanence. The low angle from which the subject is viewed creates a feeling of monumentality.

THE DIRECTION OF LIGHT

Richard Pikesley

A response to light has always been a motivation for watercolourists. The high key of the white paper and the translucency of the colours lend themselves especially generously to conveying the luminous quality of the natural world. Spatial effects built up by subtle gradations of tone and colour are intimately connected with this quality. A sensitivity to aerial perspective and its effect on colour and tone is cultivated by getting into the habit of painting outside as often as possible.

As always in painting, one is concerned with many things at once, but it's the excitement of light that gets me going. Working out of doors, one becomes very sensitive to the way the quality of light changes with the seasons, the time of day and the weather. Often though, we do not consider the effect of the direction of light. Try standing in an open space outside, ideally early or late in the day. Turn slowly through 360 degrees, noticing the way the quality of light changes, and with it aspects like colour gaining and losing saturation, tonal structure changing, and modelling becoming more or less pronounced.

The painting illustrated here was quickly painted around dawn, looking straight into the rising sun. Forms are simplified and detail obscured by the back-lighting. Also the range of tones visible in such a subject may be less than you might expect. The brilliance of the sensation of looking directly into the light can bleach out the contrasts, which means that the tonal steps have to be very subtly pitched.

The direction and quality of the light are a constant preoccupation of mine. I make a lot of my paintings outside, painting early or late in the day. At these times the direction of light is made more crucial because of its low angle. With the sun shining from one side, modelling of clouds and trees is at its maximum, with a very full range of colour and tone and cast shadows streaming out to the side of each volume. Looking into the sun, the subject is backlit and the range of tones compressed and simplified. With the sun shining from directly behind you, colour can be very brilliant but there is a lack of modelling and shadows will be less visible as they fall behind the object which casts them.

The sun moves surprisingly quickly, and for a painting made on the spot to have a satisfying sense of unity it has to be either painted rather quickly or constructed over several days, working at the same time for a short period.

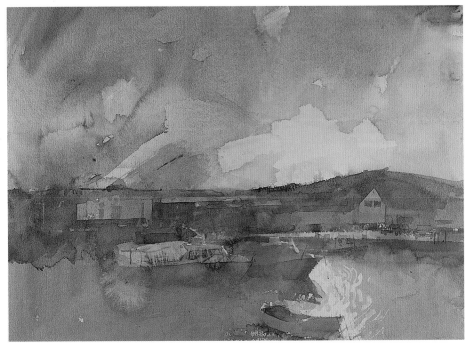

Sunrise 2, West Bay (2003), watercolour, 36 x 52 cm (14 x 20.5 in).

WORKING FROM THE IMAGINATION

Trevor Stubley

Composition is not something I dwell on. I like things to happen by accident, so I usually prepare the surface with a haphazard mixture of gesso and plaster filler. By examining this rough surface, I sometimes find images which get me working. I paint in acrylics, sometimes thickly, sometimes very thinly. The best results are not overworked. The painting illustrated came about using this method.

In recent years, much of my work has been based on Irish folk-tales, as related by the great County Kerry storyteller Sean O'Connaill (1850–1931). O'Connaill, a fisherman and part-time farmer, never went to school. He spoke only Irish, and only once in his life did he venture out of his home village of Cill Rialaig.

However, O'Connaill possessed a phenomenal memory which enabled him to retell over 150 folk-tales. He claimed that he only had to hear a story once to have it in his mind permanently. In the days before mechanical entertainment, such storytellers acquired big reputations and were in great demand to help pass the long, dark winter evenings on the coast.

At the same time as O'Connaill was plying his craft in Cill Rialaig, the Professor of Irish Folklore at Dublin University, James Delargy, used to take his holidays in County Kerry in order to improve his Irish accent. Delargy learned of O'Connaill and went to hear him speak. He realised that young people were finding their entertainment in other ways, and that the folklore tradition personified by O'Connaill would die out with the exponents of that craft unless something was done about it. So, over a period of years, he took the stories down verbatim from O'Connaill himself. Later, these stories were translated into English and published. This is the book I use as the source of the subject matter for my paintings.

He let the horse go its own way (see above) concerns an eloping couple. The girl has jumped from a window on to the back of the horse and she is riding pillion. The young man is so entranced by the girl that he turns in the saddle to face her and lets the horse

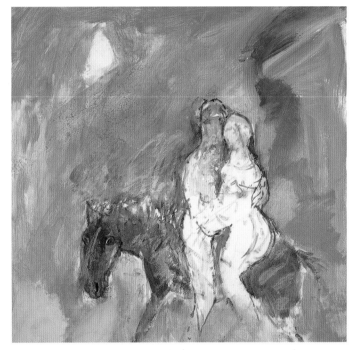

He let the horse go its own way (2003), acrylic and pastel on board, 66 x 66 cm (26 x 26 in).

go on its own way. Needless to say, by nightfall they are hopelessly lost and have to spend the night in the open.

The two figures were sketched in first on the rough ground in a pinky-ochre colour using a sable brush and a very watery paint. They immediately came out well. Then, using a one-and-a-half-inch house painter's brush, the background was loosely brushed in using a very thin acrylic in blues and greens. A few touches of pastel on the horse, a quick spray with fixative and the job's a good 'un. The whole thing took less than an hour.

169

TOWARDS ABSTRACTION

Salliann Putman

My inspiration may come from anywhere: the landscape, an interior, the clutter in an old boatyard, a group of figures, or simply from two colours which sing together. The resulting work may have a figurative element or it may be non-figurative, but always it is the abstract concerns which motivate me: colour, light and space.

The figurative work usually grows out of a simple preliminary tonal study, made in front of the subject, which is then developed in the studio, memory and imagination playing a major part in the creative process. It was Pierre Bonnard who said that he felt 'weak in front of nature', and I feel totally in sympathy with this reaction.

My landscapes are often 'architectural'. I grew up in London where I saw the narrowest band of sky, and this is reflected in many of my landscape paintings. The sky is often low-key and serves to bring the eye down to the pattern of the terrain, closing off the possibility of escape into the distance. It is the picture plane which interests me. These landscapes often grow out of a series of drawings made on the spot. By painting in the studio,

I can be free to transcribe remembered or emotional colour. Colour is simply the most important element in the work – it is my reason for painting, it is the painting.

My non-figurative work is most often a watercolour completed in front of nature. By 'zooming in' on my subject matter the shapes lose their identity; they can only be read as abstract forms. The excitement for me lies in the relationship of these forms, which can be allowed to speak for themselves, without any recognisable reference to nature.

More and more I find that I want to be released from subject matter when painting. Whereas I can paint a 'figurative' subject from memory, a more abstract work depends on nature.

Aldeburgh (see left) was painted on the beach where huts, ropes, discarded, rusting machinery and the usual detritus provided a rich source of inspiration. This little study, painted directly from nature, recalls for me that morning on the beach though none of the elements is recognisable.

Aldeburgh (2003), watercolour, 12 x 21.3 cm (4.8 x 8.4 in).

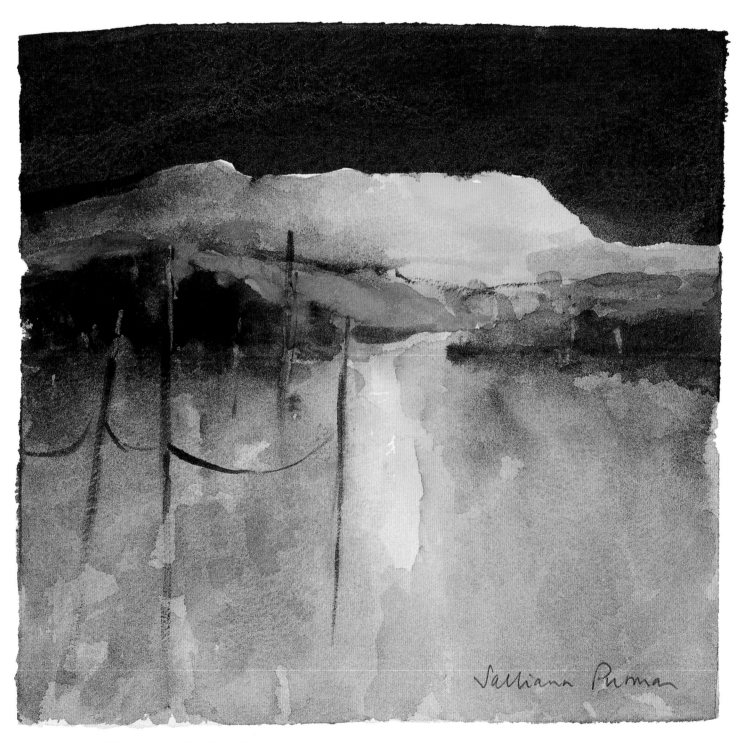

Landscape – Tuscany (2003), watercolour, 19 x 20.3 cm (7.5 x 8 in).

STILL LIFE

Annie Williams

I like the intimacy of still life and the fact that one can concentrate in the privacy of the studio, where I can work directly from the subject in front of me. Setting up a still life often takes me quite a while, finding a background and objects that work together.

Although I often work with lots of patterns, I try and keep the image simple, concentrating on the relationship between the objects. I strive to portray what it is that has attracted me to this particular subject in the first place. It may be to do with the light or shadow and the mood this creates, or just the arrangement of a few objects I am attracted to. It is about playing with shapes and pattern and colour until I get a composition that feels right.

Here I have chosen to paint pots. I have been collecting ceramics for some years. I love the variety of shapes and different surface finishes. I make a very simple pencil drawing, often with the use of a viewfinder, for me an essential tool for positioning my composition correctly on the stretched paper. I build up the colour using a series of thin washes, making sure each one is dry before applying the next. This prevents it turning into a sort of mud. I often use fabrics as a background, they give me a basic pattern to play with, but I often change the colours and alter or simplify. I sometimes cover the whole painting with a wash, then just blot the areas I wish to keep as before. This helps to soften the image.

In *Studio Still Life* (see above and detail, opposite), I used an old exhibition catalogue, its darker areas helping to enhance the shapes of the pots, and some rather yellowed newspaper for the base, which gives me a slightly rough-and-ready look and a faint pattern so as not to distract from the pots. I've used mostly watercolour and a little bodycolour to pick out highlights or add solidity.

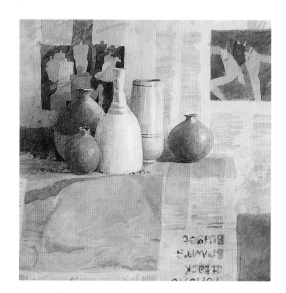

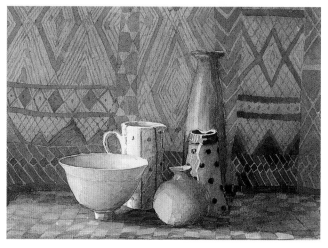

TOP: *Studio Still Life* (2003), watercolour, 34.5 x 32.5 cm (13.5 x 12.8 in).
ABOVE: *Country Pots* (2003), watercolour and bodycolour, 21 x 28.5 cm (8.3 x 11.2 in).
OPPOSITE: *Studio Still Life* (detail).

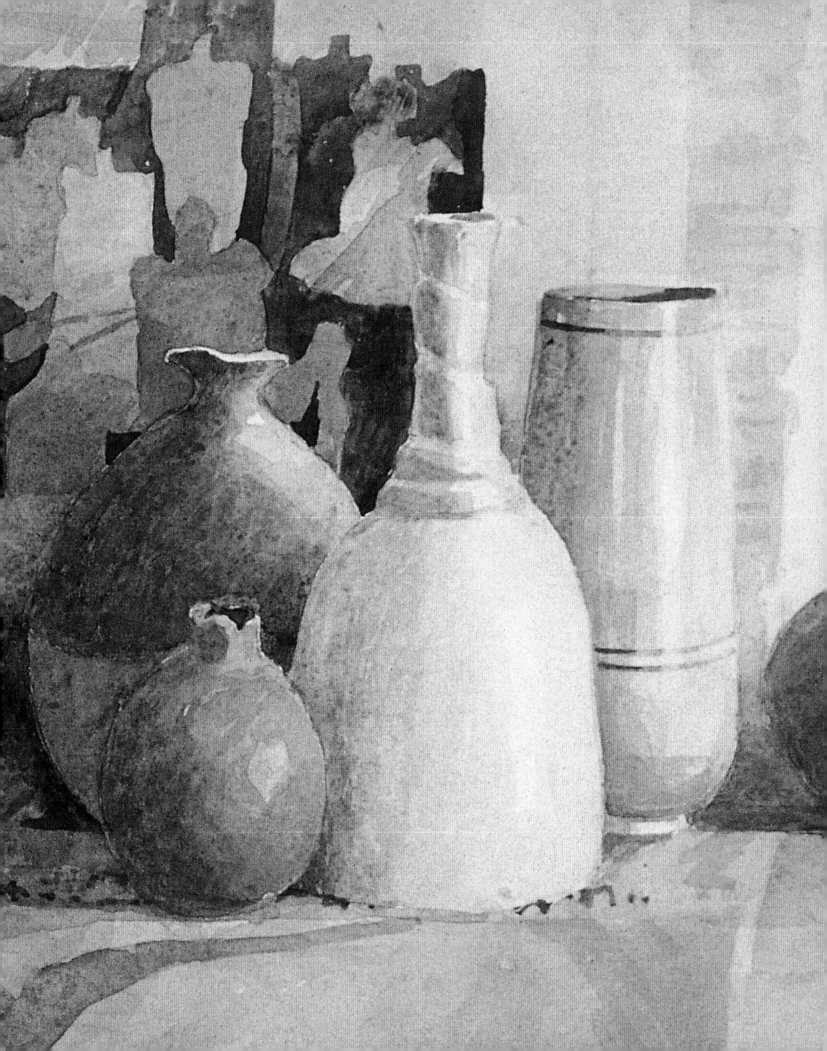

Select Bibliography

Primary Sources (mss, newspaper cuttings, etc)

The principal source for the history of the Royal Watercolour Society is its own, very full archives which date from the Society's foundation in 1804 and continue until the present day. They include Society minutes, correspondence, exhibition catalogues and photographs. A catalogue was published as 'The Business of Watercolour, A Guide to the Archives of the Royal Watercolour Society' by Simon Fenwick and Greg Smith (Aldershot, Hampshire and Vermont, 1997).

Other sources of relevance to the development of watercolour societies in the early 19th century include:

Associated Artists in Water Colours, 'Letters, Minutes, Etc., Relating to Associated Artists in Water Colours, 1807–1810', National Art Library, Victoria and Albert Museum, London.

Society of Painters in Water Colours, 'Papers, 1808–1821', National Art Library, Victoria and Albert Museum, London.

Published Sources

The fullest account of the Royal Watercolour Society in the 19th century, which includes many individual biographies, is John Lewis Roget's *History of the 'Old Water-Colour Society'* (London and New York, 1891).

The other principal accounts relating to the Society's development and membership are:

Antique Collectors' Club, *The Royal Watercolour Society, the First Fifty Years 1805–1855* (Woodbridge, Suffolk, 1992).

Fenwick, Simon, *The Enchanted River, Two Hundred Years of the Royal Watercolour Society* (Bristol, 2004).

Holme, Charles (ed), 'The Old Water-Colour Society', *Studio* special number (London, Paris and New York, spring 1905).

Huish, Marcus, *British Water-Colour Art as Illustrated by Drawings Presented to King Edward VII by the Royal Society of Painters in Water-Colours* (London, 1904).

Spender, Michael, *The Glory of Watercolour: the Royal Watercolour Society Diploma Collection* (Newton Abbott, 1987).

The fullest and foremost general history of the art of watercolour is Martin Hardie's *Water-Colour Painting in Britain* (3 vols, London, 1966–1968).

Other sources of interest include:

Bayard, Jane, 'Works of Splendor and Imagination: The Exhibition Watercolor, 1770–1870', catalogue (New Haven, 1981).

Bury, Adrian, *Two Centuries of British Water-Colour Painting* (London, 1950).

Holme, Charles (ed), 'The Royal Institute of Painters in Water-Colours', *Studio* special number (London, Paris and New York, spring 1906).

Lyles, Anne and Hamlyn, Robin, 'British Watercolours from the Oppé Collection', catalogue (London, 1997).

Mallalieu, H L, *Understanding Watercolours* (Woodbridge, Suffolk, 1985).

Mellor, David, Saunders, Gill and Wright, Patrick, *Recording Britain, A Pictorial Domesday of Pre-War Britain* (London, 1991).

Newall, Christopher, *Victorian Watercolours* (Oxford, 1987).

Noon, Patrick (ed), 'Constable to Delacroix, British Art and the French Romantics', catalogue (London, 2003).

Pyne, W H, writing as Ephraim Hardcastle, 'The Rise and Progress of Water-Colour Painting in Britain' in *The Somerset House Gazette* (London, 1823–1824).

Smith, Greg, 'Watercolourists and Watercolours at the Royal Academy 1780–1836', essay in 'Art on the Line', catalogue, ed. David Solkin (New Haven and London, 2001).

Smith, Greg, *The Emergence of the Professional Watercolourist, Contentions and Alliances in the Artistic Domain 1760–1824* (Aldershot and Vermont, 2002).

Wilton, Andrew and Lyles, Anne, 'The Great Age of British Watercolours 1750–1880', catalogue (London, 1993).

Numerous autobiographies and monographs have been written by and about watercolourists. H L Mallalieu's *Dictionary of British Watercolour Artists* (3 vols, Woodbridge, Suffolk, 1976) is a particularly valuable source of biographical information. The Old Water-Colour Society volumes, published between 1923 and 1994, also include essays on the art of watercolour and on individual watercolour artists.

Index of Artists

Page numbers in italics refer to illustrations.

Index of Subjects

A Sears Pocknell Book

Editorial Direction	Roger Sears
Art Direction	David Pocknell
Editor	Michael Leitch
Designer	Jon Allan, Pocknell Studio

First published in Great Britain in 2004 by Cassell Illustrated,
a division of Octopus Publishing Group Limited
2–4 Heron Quays, London E14 4JP

Distributed in the United States of America by
Sterling Publishing Co., Inc.,
387 Park Avenue South, New York, NY 10016-8810

A CIP catalogue record for this book is available
from the British Library.
ISBN 1844031497
Printed in China

Site of Bankside Gallery, home to the Royal Watercolour Society

Royal Watercolour Society
Bankside Gallery
48, Hopton Street,
London SE1 9JH
Tel. 020 7928 7521
Fax. 020 7928 2820

rws@banksidegallery.com
www.royalwatercoloursociety.com
Registered Charity 293194